BURN YOUR PORTFOLIO

STUFF THEY DON'T TEACH YOU IN DESIGN SCHOOL, BUT SHOULD

MICHAEL JANDA

POLISHING TURDS

THE WIND

JUMP

BE A WALL PAINTER

FORGIVENESS POINTS

HAIRY MOLES

NO MORE FLYING SOLO

HOW TO EAT AN ELEPHANT

TOOT YOUR OWN HORN

NEXT WORRY DATE

"I wish I could take every designer I've ever worked with and smack them over the head with this book…which would hurt, because it's big! After that, I'd tell them to read it cover to cover, because Michael Janda will show them how to stop making the business mistakes nearly everyone in design is making."

—**Dave Crenshaw**
Author of **The Myth of Multitasking** *and* **The Focused Business**

"*Burn Your Portfolio* is an enjoyable, substantive gallop through an inventive guidebook for designers and programmers who envision themselves with a thriving business. It should be on every designer's must-read list. Michael draws in the reader by "showing" rather than merely "telling." He gives the book a human, personal touch by sprinkling the text with his own adventures. And though he is primarily speaking to designers, his message about honing interpersonal skills is imperative for ANY enterprise. As a client, that, more than anything, keeps me coming back."

—**Cheryl Saban, Ph.D.**
Author of **What Is Your Self-Worth? A Woman's Guide to Validation** *and founder of the Self Worth Foundation*

"I went to school to learn to be a designer. I went to Mike Janda to learn to run a design business. He is incredible. I've never met anyone who literally understands everything that I've ever struggled with since the day I graduated from school. From freelancing, contracts, and proposals to making the best business decisions and standing up to any kind of client, Janda tells you everything you need to know. His life lessons are quick, in layman's terms, and so amazingly valuable you will use something he teaches you every single day."

—**Lorilee Rager**
Owner, Thrive Creative Group, LLC

"Do you want to supercharge your design career? Drop that Wacom pen and immediately pick up *Burn Your Portfolio*, and read it cover to cover. Michael Janda clearly outlines practical, actionable advice that will make your design business better, your clients happier, and your teams more productive. Even if you're a freelancer just striking out on your own—no, especially if you are—the insights, truisms, and humor in this book will prove to be valuable tools in your design arsenal."

—Marc Siry
SVP, Media Products, NBC Universal

"This one's on fire! *Burn Your Portfolio* is hands-down the most entertaining, helpful, and hilarious insider's guide for creative professionals out there. Janda is an absolute genius when it comes to managing client expectations, creating production processes that actually work, and running a thriving and vibrant design business. He and I used to work together at Fox—I owe much of my own success to his brilliant and zany methods."

—Allison Ellis
Owner, Hopscotch Consulting

"Michael Janda is the one person you want to listen to when it comes to advice about succeeding in a creative field! He has more creative talent, street smarts, and people skills than anyone I have ever met. What this book presents the reader with is an inside-track to those secrets in an appetizing collection of goodness!"

—Jeff Jolley
President, Riser

"The starving artist cliché has never been in greater danger. *Burn Your Portfolio* gives creative professionals the tools they need to succeed in today's competitive marketplace, a marketplace where many relying on talent alone have failed. Creatives…READ THIS BOOK!"

—Mark Long
Founder, RetouchUp/Hollywood FotoFix Studios

"I've worked with Michael and Riser for many years, and the thing that differentiates Michael and his team from other agencies is their ability to speak my language versus design speak! Michael and his company Riser are not only super-creative, they are total professionals. Communication is a big reason why Michael and his team are so successful at what they do. They are good at not only listening to a client who is not a designer and is trying to convey the details of a project, but also on working with the client to get the job done well, on time, and also on budget. I can't think of a better person to give advice to designers who need to work with clients in the real world."

—Melissa Van Meter
VP, Marketing & Advertising, TV Guide Network

"Wow! Mike Janda has delivered truly invaluable insight and real-world tips on how to be a rock star in the creative industry. He describes genuine experiences and conveys practical know-how—beyond what any web browser or art school could offer. With memorable detail and a sassy tone, this book will continue to inspire you for a lifetime."

—Lynda Hodge
Freelance Graphic Designer

"Mike Janda knows that a successful career isn't built on talent alone; that it takes certain skills to actually stay in business. With this book he shares the fruit of his experience in a fun, concise, and memorable way."

—Lawrence Terenzi
Director, Product Development, Crackle

"It takes more than just mad skills and skinny jeans to thrive in this industry. Finally, a book for creatives with tangible and proven ways to be a successful designer. After 13 years of professional design, this book makes me feel like a newb; I am recommending it to all of my designers and developers."

—Josh Child
Vice President, Creative, Riser

"As a design professional with over 16 years of experience in the industry, I can speak to the importance and wisdom of the principles addressed in this book. Not only do they help designers early in their careers but they also apply to those who have been in the industry for many years.

There is a lot more to being a creative professional than simply having talent. This book will help you make an honest assessment of your abilities and discover areas that need improvement. As you implement the things Michael talks about in the book, you will find that your creativity and problem solving will strengthen a lot just by improving some of your non-design–based skills such as client communication, business strategy, and work ethic. All of these things are connected. I learned a lot about myself during this process and have been able to create a game plan that has helped me connect better with my clients and employees.

I have always had a great deal of respect for Mike Janda as a seasoned creative, strategic thinker, and successful business owner. After reading this book and hearing him speak about the things he's learned throughout his career, my respect and admiration have only increased. I recommend this book to any creative professional regardless of medium of expertise or level of experience."

—John Thomas
Principal/Creative Director, Blue Tractor Design Company

"This is much more than a book; it is a survival kit for creative professionals. In its pages you will learn how to create and run a successful creative business that is both creative and a business. Each chapter is replete with practical, hands-on advice that anyone, in any business, can apply to make their business more successful."

—Kris Kristensen
Senior Director, Global Learning, Alexion Pharmaceuticals

"I've known Mike Janda for over 13 years. I've seen his company grow from a small mom-and-pop web agency to a full-fledged industry-leading agency. I can still remember the first time I met Mike when he was our creative director, and I was a fresh-out-of-college intern. My boss at the time sent me to retrieve a booklet from Mike. To this day, I can still remember my conversation with him. He treated me with the utmost respect and sincerity. He didn't have to be nice to me, but he was. And he most certainly didn't treat me well based on my job title. And that is why I believe Mike has all the qualities that all bosses should emulate. He is honest, smart, responsible, and most importantly, conducts business with a smile. In such a fast moving industry, it's hard to find people you trust—but I've always trusted that Mike has had my best interest in mind. It's not a trade secret to be nice, and you can't buy or download that in an app!"

—**Thuy (Twee) Tran**
Senior Content Producer, ABC Family

"My introduction to Mike occurred as he interviewed me for a job. He immediately proceeded to deconstruct my portfolio and find the nuggets of talent contained in it (small), and then on the fly proceeded to help me formulate my pitch to him. Somehow I still got the job. From Mike I learned everything I know about beating the procrastination monster, along with so many other useful things, all skills I use to this day. And fortunately for the rest of the design world, Mike has put all of these tips into a designer's guide to getting along in the real world, with all his humor and insight intact."

—**Ray Woods II**
Director, User Experience, NBC Universal

BURN YOUR PORTFOLIO

STUFF THEY DON'T TEACH YOU IN DESIGN SCHOOL, BUT SHOULD

MICHAEL JANDA

New Riders | VOICES THAT MATTER™

Burn Your Portfolio: Stuff they don't teach you in design school, but should
Michael Janda

Peachpit Press
www.peachpit.com
To report errors, please send a note to errata@peachpit.com

Peachpit Press is a division of Pearson Education
Copyright © 2013 by Michael C. Janda

Editor: Nikki McDonald
Production Editor: Danielle Foster
Design Manager: Charlene Will
Development and Copy Editor: Jan Seymour
Cover and Interior Design: Michael Janda
Illustrator: Nick Jarvis
Proofreader: Emily K. Wolman
Indexer: Emily Glossbrenner

Quote on page 127 from READY FOR ANYTHING by David Allen, copyright © 2003 by David Allen. Used by permission of Viking Penguin, a division of Penguin Group (USA) Inc.

Quote on page 180 from THINK AND GROW RICH, REVISED AND UPDATED by Napoleon Hill and Revised by Arthur R. Pell, copyright © 2003, 2005 by JMW Group, Inc. Used by permission of Jeremy P. Tarcher, an imprint of Penguin Group (USA) Inc.

ISBN 13: 978-0-321-91868-0

ISBN 10: 0-321-91868-1

5 17

Printed and bound in the United States of America

This book is dedicated to my family,

Jodi, Max, Mason, and Miles.

Thank you for your amazing support

and allowing me to chase my dreams.

I love you more than my Jeep

and the Chicago Bears, combined.

CONTENTS

SECTION 2: ART SMARTS

The best designers take "luck" out of the equation. Smart processes, strategies, and techniques will help you create a masterpiece every time.

SECTION 3: TWO EARS, ONE MOUTH

Sometimes a creative professional will actually have to take off their headphones and interact with another human being.

SECTION 4: HAPPY HEAD HONCHOS

Everyone has to answer to someone. It might be a boss. It might be a client. It might even be your mom. Learning how to handle superiors tactfully will open the doors of success.

SECTION 5: MIND YOUR BUSINESS

Working as a designer without any business training is like jumping from an airplane without parachute training. Something bad is going to happen.

BURN YOUR PORTFOLIO...REALLY?

With my diploma still warm from Indiana University, I grabbed my enormous, faux-leather student portfolio and hit the streets. I knew my destiny would land me at a hoity-toity agency where I would be a star designer, dazzling clients on high-profile campaigns for the most recognized brands in the world.

One tearful month later, after the humbling task of job hunting—applying to agencies, getting a few interviews, and landing nowhere—I accepted my first job in the industry: prepress coordinator for the local AlphaGraphics copy center. At nine dollars per hour, I was the star designer all right. Nobody could center text on a perforated sheet of business cards and feed them into a photocopier better than me.

With a Midwest work ethic and a motto of "OCD Is an Attribute," it took me four short years to progress from my illustrious copy center job to a senior creative director position at Fox Studios. At Fox, I managed the design, development, and editorial elements of the Fox Kids and Fox Family websites.

The dot bomb and the dismantling of our division at Fox launched me into a four-year freelance stint that would provide me with an income level well beyond any expectations I had upon finishing my college degree and that afforded me all of my "wants" as well as my "needs." When the freelance load became too much to handle on my own, my wife forced me to hire people. Seventeen salaried employees later and over a decade of history, my acclaimed agency, Riser, boasts clients like Google, Disney, NBC, National Geographic, and Warner Bros.

I have been privileged to interview, manage, and hire hundreds of designers and programmers throughout the course of my career. One thing I know for certain is that your graphic design portfolio is a critical element to get you in the door of prospective employers and clients. Design schools know it and spend 90 percent of their efforts teaching students the skills they need to put together an awesome portfolio prior to graduation.

The other thing I know for certain is that, while a design school spends 90 percent of their effort making students capable of creating a killer portfolio, once you're in the door your portfolio is not 90 percent of what will make you actually successful in a creative career. In fact, it isn't even close to the only thing that will lead you to success.

Teamwork, client skills, communication, social aptitude, production speed, and business savvy all play a GIGANTIC part in what will make you successful as a graphic designer, whether your aspirations include freelancing, working for an agency, or managing your own firm. This book is dedicated to teaching those types of skills…the stuff they don't teach you in design school, but should.

Burn your portfolio? OK, so maybe that statement is a tad extreme. However, the lessons I've learned that are contained in this book are every bit as critical as your ability to create award-winning design. Learn them. Apply them. Couple these techniques with your killer portfolio, and find a new level of success in the real business of graphic design.

ACKNOWLEDGMENTS

As I walk down the memory lane of experiences that led to the creation of this book, I see faces attached to moments in time. A few of these require mentioning here.

First and foremost to my wife, Jodi, your undying support of my addiction to ambition has not gone unnoticed. In the brief moments that you have not been consulting with me on every aspect of my professional life, you have been managing our family, allowing me the freedom to achieve my successes in life. I would not be who I am without you. "Thank you" is an understatement. I love you.

To my parents, Dennis and Nancy, thank you for teaching me good principles, instilling in me an expectation of success, and encouraging me to do something I love for a living.

My in-laws, Gary and Connie Allen, you both have taught me life lessons that are referenced in the book. Thank you for supporting me as "one of your own."

Alan Rogers, in my early twenties I learned to be a leader, teacher, and manager under your great example and tutelage. Much of my success has come from the foundation you helped me establish.

Sara Robbins, my high school art teacher, you made art so much fun I chose it as a career.

Several coworkers (past and present), family members, and forever friends require mention. Jeff Jolley, Rachel Allen, Kris Kristensen, Marc Siry, Ray Woods, Thuy Tran, Grandpa Zwick, Eric Lee, Darrell Goff, Derek Ellis, John Thomas, Josh Child, and Mark Long: You drive me and inspire me to much greater heights.

And to all the Janda Design Company, Jandaco, Riser Media, and Riser employees past, present, and future: Thank you for enduring the rough times when we had yet to solve all the challenges that faced our growing company. Sorry for the times we weren't perfect…I was always striving with good intentions.

Nick Jarvis, thank you for the wicked illustrations and collaboration on the design of the book. You are a rare talent.

Jennah Mitchell, thank you for the first round of edits. You drove this book in a better direction.

Jan Seymour, the development and copy editor on this book, you are amazing. You epitomize the "OCD Is an Attribute" principle.

Finally, to the rest of the team at Peachpit Press and Nikki McDonald, thank you for believing in this book and convincing me not to name it "Polishing Turds." :-)

HUMAN
ENGINEERING

BEHAVIOR, WORK ETHIC, AND SOCIAL PROWESS
HAVE AS MUCH TO DO WITH YOUR SUCCESS
AS YOUR ABILITY TO BEAT PHOTOSHOP
SENSELESSLY INTO SUBMISSION.

1 THE BIG FAT SECRET

Ask anyone who I've worked with over the course of my career and they'll all probably say the same thing: "Michael Janda is absolutely, without question, one of the most talented creators of mediocre graphic design work the world has ever seen." To which I would wholeheartedly agree.

When it comes to design, I'm all right. I am definitely above average, but I know many designers who can design circles around me (fortunately, I employ some of them). However, I don't know many designers who have had the good fortune of finding the level of "success" in their career that I have been blessed to achieve. Why do some amazing designers struggle to accomplish great things and other mediocre designers find great success? Hard work? Being in the right place at the right time? Sheer blind luck?

The truth is that in the graphic design industry (and nearly every other occupation out there), your creative design and technical skills account for only a fraction of your value to a client or to an employer. I have no doubt that it is your interpersonal skills that get you that success. One of my favorite books of all time is Dale Carnegie's 1936 masterpiece, *How to Win Friends & Influence People*, and it is my heartfelt belief that this book should be required reading for everyone in the world. Many of you have likely read this gem; I have myself purchased, read, and gifted this book countless times.

The book's introductory material explains the purpose for which it was written based on research conducted by the Carnegie Foundation for the Advancement of Teaching as well as the Carnegie Institute of Technology. Following Mr. Carnegie's quote in which he believes that only 15 percent of financial success is due to technical knowledge, while 85 percent is due to personal skills and an ability to lead people, he continues a few paragraphs later with the following principles: The person headed for higher earning potential is the one who not only

has the technical knowledge but who can express ideas, lead people, and develop enthusiasm in those people.

He continues by noting John D. Rockefeller's famous quote that states that the ability to deal with people is a purchasable commodity equal to sugar or coffee, and that he himself would pay more for that ability than all others. With this, Mr. Carnegie would imagine this to be a critical topic to be taught in college. But as he points out, he has never seen a college course such as this in all the land.

I've already admitted that my design skills are far from otherworldly. And I would not be so arrogant as to say that I am a master people manager (plenty of my ex-coworkers would quickly agree on this point). But I do openly posit that my success as a graphic designer has more to do with my ability to get along with others—bosses, clients, employees, and teammates—than it has to do with my design and technical abilities.

This can also be seen in the way I've put together the team at my agency, comprised of hand-picked, quality individuals that I know contribute to our success. As I think about the current team, based on Mr. Carnegie's research it is no surprise to me that the person with the largest salary is not a designer, not a programmer, and not even a project manager. Rather, the person linked to the highest monetary value is my right-hand man who currently serves as "president" of the company. Perhaps, though, a more apt title for him would be that of "Head Schmoozer."

He is the one who walks the tightrope of communication between our clients and our employees. He is absolutely indispensable; our clients love him and our team respects him. He doesn't own one share of stock in our company but I openly share company profits with him. Even though he couldn't design his way out of his own garage, he is a great people person—and that translates to great company interaction with our clients and to the resulting great end products. So it follows from Mr. Carnegie's research, these interpersonal skills are critical to success not only for myself as agency owner but for those coworkers surrounding me.

This book is not the platform for sharing all the secrets to managing and relating to people. There is plenty of information out there on the

subject that comes from people much more qualified than I. The format of this book is, however, the appropriate place for me to say that I believe your finely tuned graphic design skills will get you only 15 percent of the way to success in your career, rather than the 90 percent of the way that the design schools lead you to believe. Begin working on your people skills today to ensure that you achieve your full measure of success.

Ultimately, I believe that if you want to succeed in your career as a graphic designer, you need to focus time and energy into developing your interpersonal skills. The more you can get in tune with the needs of your clients, bosses, and team members, the better off you will be. People will rave about your stellar service, and you will begin to enjoy the fruits that come from the tree of hard work and jobs well done.

IF YOU WANT TO SUCCEED
IN YOUR CAREER AS A
GRAPHIC DESIGNER,
YOU NEED TO FOCUS
TIME AND ENERGY INTO
DEVELOPING YOUR
INTERPERSONAL SKILLS.

2 · THE EXTRA MILE

When my career was still in its infancy—a mere two years old—I was privileged to experience firsthand how the act of exceeding the expectations of your employers can greatly advance your career. The year was 1998, and a children's toy, game, and book publishing company located in Phoenix hired me to create a new corporate website.

The dot-com era was heating up and our nation had never seen excitement around an opportunity like the Internet since the California Gold Rush 150 years earlier. The ambitious CEO who employed me had a grand vision of what his maiden online voyage could become. He envisioned users coming to his site and finding a bookshelf loaded with books. The user would click a book, turn the pages to sample it, and then be able to buy it right off of the virtual shelf.

Fortunately for me, I had invested considerable personal time learning an early version of Flash and had experience with some 3D modeling software. I suppose the competition for the job was light due to the newness of the technologies, but I was certainly grateful to land the opportunity.

Going the extra mile was second nature to me, as I seemed to have been born with a deep-rooted desire to please others. From day one I began to build more than the CEO had asked. He wanted a book-shelf—I 3D-modeled the inside of a virtual store with a bookshelf in it. Then I imported the 3D assets into Flash and "programmed" some interactivity (at the time, Flash allowed only some basic functionality by using drop-down menus).

After the room loaded, the user could click the bookshelf, which would load a zoomed-in view. In the zoomed-in view, the user could click a book spine; the book would then fall from the shelf and open to display the sample pages. The 3D store also contained some little interactive elements that engaged the user. When the user clicked a sign, a ball bounced across the screen. When the user moved their

mouse over certain items, a tiger from one of the books popped out of the side of the screen with a word bubble prompting the user with what to do next.

I also signed up for a rudimentary shopping cart system and loaded it into an HTML frame so that when the user clicked something, they could buy from the site. All in all, it was pretty rough by today's standards, but at the time nobody else was doing anything like this.

Needless to say, the CEO was blown away at the expected bookshelf becoming a virtual store. After promptly giving me a raise, he talked about adding another feature to the store: a room where the user could go to learn about the company. I got to work. At first I added a door to the virtual store. The user would mouse over the door and it would open. When they clicked the door, it would load the new room where they could learn about the company. But I knew if I wanted to continue impressing my new boss, I needed to exceed his expectations. I 3D-modeled the outside of the virtual store, so that when the site loaded, the user was presented with the front of the virtual store—it was a quirky, brick building that was sure to capture the interest of their target audience.

When I unveiled this to the CEO, he was again amazed at what I was building. He expected an additional room—I gave him an entire building. This time he asked me to hire someone else and to add more rooms to the virtual store. I found a very talented person and our little team began working on a town (of course, the CEO was expecting only more rooms). When he told us to add more buildings to the town, we created a world with different climate zones (arctic, jungle, tropics, and so forth). He asked for more climate zones—we began adding to the galaxy.

Over the course of the next year and a half of exceeding the CEO's expectations, I had amassed a team of approximately a dozen employees dedicated to the creation of oKID.com, The Online Kid Site. It was one of the first virtual worlds on the Internet. oKID World now contained online games, cartoons, educational content, sponsorship opportunities, an online club, and of course, an e-commerce section (the original intent for building this world). The oKID cast of characters was a unique group

of kids whose names all started with the letter "O". Owen, Olivia, Oscar, Orchid, and O-dude were just a few of the colorful characters we created.

Every morning around 7:30 A.M., I would get a call from the CEO to walk him through the new things on the site. Our team had self-imposed daily launches, all with the goal of exceeding his expectations. The CEO was parading the site around to interested parties and bringing millions of dollars of investor capital into his company. I had nearly doubled my salary in less than two years, and was gaining the experience and a portfolio piece that would shape my professional future.

With every client and every project, the best graphic designers regularly and purposefully exceed their clients' expectations. If the client expects two comps, send three. If your boss needs something at 3:00 P.M., have it ready at 2:00 P.M. Always try to be one step ahead of their needs and work to exceed expectations every chance you get.

3 SOAK UP ADVICE

The graphic design industry is filled with critiques and advice. I realize that I may be in the minority of people who actually thrives in this type of environment. I can barely design for fifteen minutes without asking for someone's opinion, and I can't remember a time in my career when I didn't have my nose in a self-help book searching for advice from people who have walked life's paths before me. Perhaps the fact that you are reading this book puts you in the minority of those who are actively searching for ways to improve. Or, maybe you are reading this book because your boss or teacher put a copy of it in your hands. Either way, I am glad you picked it up and started reading.

I often tell people that in college I learned how to learn. But I didn't really learn the skills and attributes I needed to succeed until I had graduated and started my career. I never had a mentor, and I have spent more of my career managing than I have spent having people manage me. Most of what I know has come from independent study, as well as times of trial and error. My hope is that by soaking up the advice in this book you can avoid some of the pitfalls I have endured, and find increased success in your career.

Over the years, as I have scoured books on design and business strategy, I have found that most books contain as many gems of advice as they do unreasonable duds. As you read this book, I invite you to apply what reasonably works for you and disregard what doesn't. These are merely the strategies, philosophies, and experiences that have led me to find success in my career as a graphic designer.

4 YOU ARE NOT YOUR WORK

Graphic designers can be a sensitive lot. Or perhaps it is artists in general who have thin skin. Either way, there is something about right-brained people that reads like a prescription drug bottle: "Caution: Do not mix with sleeplessness, constructive criticism, subpar coffee, or well-meaning advice." In order to succeed in the design industry, however, it is imperative that you remember that you are not merely the sum of your work. If you interpret design critique as a character critique, you are setting yourself up in a defensive position that will impede your ability to improve your design skills and adapt to different creative environments.

Some time ago I walked past one of our designer's desks and glanced at the design she was working on. It was pretty rough and headed down the wrong path. I knew this designer was a little sensitive, so I tried to choose my words carefully. "So, you're getting started on X project? Be sure to review the example designs the client sent over that illustrate what they are hoping to achieve." That was all I said. I walked away, confident that I had handled the exchange tastefully. Later that day, a few of my employees who sat near her told me that after I left she went into the restroom and sobbed. She didn't just "cry," she "sobbed."

I wish that she had taken what I meant as a gentle nudge in a better direction as a good thing rather than a bad thing. If I did not know without a doubt that she was a skilled and capable designer, I would not have hired her in the first place!

In order to grow in your design skills, you have to hunger for critique and advice from wherever you can get it. Feedback is critical when it comes to being able to push your design to higher levels. If a colleague were to say to you, "Why don't you try reducing the size of the logo a little bit," you shouldn't interpret it as them saying to you, "You call yourself a designer? You suck, you're ugly, you smell like the back of a 747, and your momma wears combat boots!" You have to

realize that your work does not define you as a person and find it inside yourself to say, "Thank you. That is a great suggestion. I'll give it a try and see how it looks." Then you must work to truly feel grateful that your design is being pushed and that your colleague felt comfortable enough with you to be able to offer caring, professional advice to help you look better in the long run.

Give the feedback you receive a try; if the new work looks better, keep it. If it doesn't, then go back to what you had. One of the keys to growing in your skills is to learn not only to welcome feedback but to desire it from anyone who will give it to you. The greatest designers surround themselves with people whom they trust both as individuals and as creative advisors.

5 BE NICE TO EVERYONE

We've all heard the Golden Rule, which essentially states: "Treat others how you want to be treated." Throughout generations and across the globe, numerous religions and philosophers have echoed this universally acclaimed sentiment.

Christianity
"Therefore all things whatsoever ye would that men should do to you, do ye even so to them: for this is the law and the prophets."
— *Matthew 7:12*

Confucianism
"Never impose on others what you would not choose for yourself."
— *Confucius Analects XV.24, tr. David Hinton*

Hinduism
"That man who regards all creatures as his own self, and behaves towards them as towards his own self, laying aside the rod of chastisement and completely subjugating his wrath, succeeds in attaining to happiness."
— *The Mahabharata, Book 13: Anusasana Parva: Section CXIII*

Islam
"Hurt no one so that no one may hurt you."
— *Muhammad*

Greek Philosophers
"Do not do to others what would anger you if done to you by others."
— *Isocrates*

"What you wish your neighbors to be to you, such be also to them."
— *Sextus the Pythagorean*

"Do not to your neighbor what you would take ill from him."
— *Pittacus*

I was taught the Golden Rule in my youth and have always strived to act accordingly, but it was not until the past few years that I realized how critical this principle is to a company's practices.

I have worked with a lot of amazing people throughout my career. Being nice to everyone has always seemed a simple task. Los Angeles is notorious for abrupt exchanges. People seem always to be in a rush… no time for chit-chat. My wife and I decided that the fast-paced lifestyle, cost of living, and horrendous traffic has caused this cultural issue in L.A., but I am proud to say that I never gave in to it. Years ago while serving as creative director at FoxKids.com, I received a knock at my door. In poked the head of Thuy, an intern in our marketing department who was finishing up her schooling at UCLA. She had been sent to my office by her boss to pick up some style guides.

Just being myself, I decided to chat with her for a few minutes. During my brief interrogation, I asked how school was going, how she was enjoying her internship, and other friendly but light conversation. After this experience, I assume that we passed in the hall a few times but I have no recollection of any other conversations.

I didn't think much of this experience until many years later after Thuy had become one of my first "big-time" clients. You see, after Thuy finished her internship, she landed a job at ABC Family. This was right around the same time that I started my own business. While at ABC Family, she sent project after project to our company. I eventually had to hire several people just to support the load. I added it up once and realized that in a four-year stretch of time, Thuy had been responsible for sending over $1 million dollars of business to my company. One day we were having lunch together and she said, "Hey MJ, you know why I'm such an advocate for you, don't you?" I responded, "No, but I sure appreciate it." She said, "Do you remember that day at Fox that I came to your office to get some style guides?" I replied, "Yeah." She finished by simply saying, "You were nice to me and talked to me."

To this day I still have close ties with Thuy, and I have had the privilege of returning a fraction of those favors by providing

recommendations for her for employment opportunities. That day that she came to my office and I was "nice to her" planted the seed for a business relationship that would far exceed my wildest dreams or expectations.

I belong to a business organization called Corporate Alliance. The intention of their organization is to help business leaders build relationships through luncheons, retreats, and other events. They do a great job. One of their mottos is "Avoid relationship arrogance." Relationship arrogance is when you make an assumption that a relationship with someone has no value to you. This is an easy mistake to make, and is one that I could easily have made with Thuy. (Think, "I am MIGHTY CREATIVE DIRECTOR and you are peon intern.") Fortunately, this thought never crossed my mind. If it had, I know now that the cost of that backwards thinking would literally be counted in millions of dollars.

You never know when the junior designer sitting next to you may hold the keys to your next huge freelance project. You never know when the receptionist at your least favorite client's office may refer you to your next job opportunity. You never know. The only safety measure you can take is, "Be nice to everyone." And not only is it important for the sake of your professional career...in my opinion, it is just a better and happier way to go about your day.

Here are some simple strategies to help you be nice to everyone:

- Smile at people
- Express gratitude
- Call people by name
- Have a daily conversation with a stranger
- Practice random acts of kindness
- Be yourself

One thing that is absolutely critical in this process is to be "real." Most people can tell if you are being nice or if you are being fake. You have to be genuine and sincere in your kindness toward others in order for your actions to truly have a great impact. Begin practicing this today so that tomorrow it becomes a natural behavior.

YOU NEVER KNOW
WHEN THE RECEPTIONIST AT
YOUR LEAST FAVORITE
CLIENT'S OFFICE MAY
REFER YOU TO YOUR NEXT
JOB OPPORTUNITY.

6 DRAMA IS FOR SOAP OPERAS

I admit it. During the summer of my fourteenth year, my older brother and I watched "Days of Our Lives." The dramatic story of Bo and Hope, the conniving Viktor Kiriakis—it was all too much to deny. There were gang wars, love stories, and everything in between. The soap opera drama provided an entertaining release from real life. Unfortunately, too many people take that level of dramatics into the work place. This can be a relationship killer.

Some time ago, we met a client for lunch who began talking about another agency he uses. He compared our agency to this other group and said that he appreciated that we were a "No Drama" firm while the other group, on the other hand, was the "Drama" firm. As an example he gave, if there happened to be a text change needed on one of his websites, he would call the other firm and they would immediately have a disproportionate response to the situation, such as, "You need a text change? Let me get a conference call set up so we can talk about it. We'll need myself, three programmers, the company president, and our office manager on the call to discuss the logistics of changing that text. How does 3:00 P.M. work for you?"

While soap-star–worthy reactions may be fun at home and with friends, they are neither respected nor tolerated in the real world. Here are some ways to keep drama at bay in your dealings with others in the workplace:

- Take a break when you feel like being dramatic. Oftentimes things fall into perspective after you've stepped away and looked at them later with a refreshed set of eyes.

- Have someone read your dramatic email before you send it. I rewrite and rewrite and rewrite emails to make sure the tone is just right. The last thing you want is to have your client read between the lines and get the wrong message.

- Have only the appropriate people on the call or in the meeting. You don't need to fill a room with people to discuss a simple tweak to the copy.

- Use a coworker to get things off your chest instead of venting in a lengthy email dissertation. When a client is getting dramatic, it is frequently helpful to complain, blow up, or freak out to your coworker first. This will help you calm down and then prepare a proportionate response.

When you feel yourself slipping into drama-queen mode, take a deep breath, count to ten, drink a pot of coffee—whatever it takes to get your mind back into focus and to stop reacting in a dramatized and often inappropriate fashion.

7 NO MORE FLYING SOLO

I recently had lunch with a networking group I belong to. There are roughly 30 people who participate in this group, and we meet once per month. This monthly powwow is mostly just a chance to get to know other businesses in the area; many of the people who attend are people whom I know from other business circles as well. In this particular event, I had an epiphany as I looked around the table during lunch: I was surrounded by friends. This group had moved past being a networking group for me; it was now a luncheon with 30 close friends. I have individual relationships with each one of these people. Many of them actively refer business to my company, and I actively refer business to many of their companies. This is like an army of free salespeople out there promoting my business. It was at this moment that I realized that your friends will willingly and freely market your business, so it would serve you well to make a lot of friends.

My business was founded on relationships. In the early days of my company, a few ex-coworkers who had landed at new companies began sending work to me because I was a friend.

One of our company missions is to "turn our clients into friends." Over the years I've had clients

- Use me as a reference on their resumes

- Ask me for letters of recommendation

- Ask me to help them find new jobs

- Ask for advice on how to handle difficult situations inside their business

- Close the door to their office during a meeting and then unload all the drama going on at their business

- Say to me, "You're like a brother to me."

If telling me "You're like a brother to me" isn't evidence of a friendship, then I don't know what is. Here are a few strategies to help you build up your pool of friends and begin harnessing the power of positive and lasting relationships within your company:

- Get involved in industry groups (AIGA, technology groups)
- Seek out networking groups in your area (many are free)
- Join your local Chamber of Commerce and other business organizations
- Get involved in online networking using LinkedIn, Facebook, and other social media tools
- Ask people to lunch
- Invite a contact to a sporting event
- Get a few acquaintances together and hit the links

Also, get involved in as many business circles as is reasonable for your time and location (the more the better). Work at forging relationships with business contacts in nonbusiness settings, as this is where people generally put their guard down and true friendships can begin to flourish. Remember, though, that sincerity is critical. People can tell the difference between sincerity in your desire to build a friendship and you just trying to milk them for business.

YOUR FRIENDS WILL
WILLINGLY AND FREELY
MARKET YOUR BUSINESS,
SO IT WOULD SERVE YOU
WELL TO MAKE
A LOT OF FRIENDS.

8 GRIPES GO UP

My mother-in-law is one of the most positive people I know. When the sun is shining she says things like, "Isn't this the most beautiful day you have ever seen?" When it is pouring rain she shares comments like, "Have you ever seen a more beautiful rainstorm?" I teased her about this once, and she said simply, "That's just how I feel." Indeed, everyone who knows my mother-in-law would agree that her positivity is infectious and contagious.

As easily as positivity breeds positivity, negativity also breeds negativity. I'm not sure why, but the graphic design industry seems to have more than its fair share of grumpy workers. Perhaps the constant stress of pending deadlines encourages frustration. Or maybe it is due to the never-ending stream of critiques that causes designers to become negative in their view of life. Then again, maybe people just like to have pity parties. Whatever the case, one thing I know for certain is that the negativity of one person can spawn negativity in another, which can virally transfer to another until an entire production team is infected. We have seen this happen a few times in our company's history. One team member goes sour, and before we know it we're replacing the whole regime.

Perhaps the biggest cause of the spread of negativity is complaining. Complaining inspires complaining. Don't get me wrong, there may be valid things for you to complain about: Your client makes ugly changes to your best design. A surprise deadline keeps you at the office late. Your chair is uncomfortable. Your computer is too slow. Your boss is an idiot. The power to the building just went out. These and many other challenges surround a designer every day. But complaining about them becomes as addictive a habit as smoking, and serves only to highlight issues and does nothing to correct them.

I'll give you three suggestions here for making the most of the situation. First, instead of being a contributor to office negativity, it is imperative to your success to try to stay positive amidst the frustrations

of the design world. Negative attitudes that stem from complaining will be felt by your clients, coworkers, and bosses. Body language and tone of voice are dead giveaways to negative attitudes—it would be foolish to assume otherwise. Also, it would behoove you to realize how quickly a negative comment or persona can spread. Much like a rampant wildfire or two extremely enthusiastic bunnies, a poor attitude and a heart filled with contention can douse the flame of creativity and joy in an instant, causing grumbling and complaining to multiply at an alarming rate.

Second, realize that oftentimes the solution to someone's negative mindset could be found and acted upon in less time than it takes to give voice to the complaint. If you have a tight deadline, for example, hunker down and get to work. The time you waste complaining to your coworker about your client and their unrealistic deadline could be better used in actually working toward achieving the milestone and making your client happy in the process.

And as a third suggestion to benefit both the company and yourself, take proactive steps toward improving the situation that is creating the problem. If your computer is too slow, let your boss know and help research a solution. If a client is consistently demanding rush changes or unreasonable deadlines, work to implement a better set of project expectations the next time you begin a project. Rather than complain about your frustrations to your coworkers, proactively present solutions up the chain of command in your business. Your goal should be to leave your place of work better than you found it; be a beacon of positivity in a stormy sea of negative attitudes.

The blockbuster movie *Saving Private Ryan* seems to be on television every other weekend, much to my delight. I find myself watching it with devout interest nearly every time it is on. Several of the scenes are imprinted on my mind, and one brief verbal exchange between Tom Hanks' character, Captain Miller, and a private under his command had a significant impact on me. In it, Private Reiben questions his captain about the fact that he never gripes. Captain Miller responds by saying that "Gripes go up, not down." In other words, a captain gripes to his superiors, not the other way around, and never gripes in front of those below him in rank.

This movie may have told a fictional story, but the advice is true. Griping to your coworkers serves only to breed negativity. Griping up the chain of command can help bring about positive change.

In my company, we've become highly intolerant of negative attitudes within our team. As soon as an employee exhibits a negative attitude, we call them in for a chat. We dig in to discover what is frustrating them and work together to help solve the problem. We didn't do this in the past, and we watched our negative cultures spin out of control. I've seen a "bad apple ruin the whole bunch" several times in my career. Don't be a bad apple.

9 THE STRESS BUCKET

I am sitting in Starbucks on Madison Avenue in New York City. The "Stress Bucket" chapter has been on my list of things to write for over a year. Ultimately, it took some experiences here in New York to inject the final inspiration into this task. There are cars everywhere and people swarming the streets like ants. Many of the New Yorkers handle the stress of living in the big city with apparent ease. But a few times per day I'll pass people who have just "lost it." One guy in particular was shouting expletives at his wife that he'd "had it." He was "done." I was not sure what led up to his explosion, but it was obvious that his stress bucket was full.

You see, everyone has a stress bucket. As you go through your day, your bucket fills and empties depending on your activities. On days when you have lots of meetings and demands weighing on you, the bucket fills quickly. On other days, like weekends, there may be little stress in your bucket, allowing the time to pass with relative ease. If you don't empty your bucket and it keeps filling with stress, it will eventually overflow and an explosion of stress will occur, like the gentleman in New York. Sometimes, when your bucket is filled nearly to the top, all it takes is "one more drop" to make it overflow.

You've undoubtedly heard the phrase, "That's the last straw!" This phrase originated as a mid-17th-century proverb (according to the Oxford Dictionary of Quotations) referring to the idea that one final piece of straw added to the back of a camel would make the load unbearable and cause the animal's back to break.

Everyone has seen (and likely experienced) this breaking point at some point in their lives—that time when a simple thing makes even the calmest of people freak out. Where do you think the expression "Don't cry over spilled milk" came from? Obviously, babies' stress buckets don't hold much and all it takes for them to "lose it" is something as simple as a spilled cup of milk.

A graphic designer's life can be a deadline-driven, emotionally stressful world. As my company was growing in the early years, we were doubling our billing and staff every year. I was a stressed-out wreck! Just ask my family or any of my employees at the time. Most of them can share with you stories about my bloodshot eyes, which I refer to as "Cylon Raider mode" (this phrase is derived from red-eyed cylons in the popular 1970s version of *Battlestar Gallactica*); I was strung out on stress.

In the workplace, keeping your stress bucket in check is important. If you don't, you will inevitably cause those near you to walk on egg shells, and worry about everything they say and do around you. You really have two choices when it comes to managing your stress. You can either have a really big stress bucket, or you can empty a smaller bucket regularly. Here are some techniques that I've learned in the trenches to keep my stress bucket in check. Keep in mind these are in no way backed by scientific research or focus-group testing; they are just a few things I do in an effort to keep my stress bucket from gushing over:

- Take a break. Get up from your desk and go for a short walk. Take a few deep breaths and get that oxygen flowing.

- Clean up your desk and your work area, since clutter contributes to stress. Keeping your workspace organized and clean lightens your load.

- File emails. My Inbox is my lifeblood. If it gets loaded with hundreds of messages, I start worrying that I've forgotten something. Keep your Inbox clean, and make sure that you respond quickly to your emails to keep them from building up and adding drops of stress to your bucket.

- Get a task started. Sometimes the mounting pressure of an upcoming task can be lessened by simply getting it started. If you have some comps to design, take a few minutes to create a new Photoshop file with the correct dimensions. Place some of your design assets into the document on separate layers, and then save the file. This simple task takes only a couple of minutes and can lighten your load just enough so your stress bucket doesn't overflow.

- Take out a piece of paper and write down every task you have to complete. This activity often reveals that you have less to do than you think. And even if you have more to do than you think, the organization of information helps to relieve some of the burden.

- Keep your finances in check. It comes as no surprise that, unfortunately, the bulk of the stress that people face often relates to money. As a business owner, I regularly watch hundreds of thousands of dollars come into the company's bank account and then go right back out. It stresses me out! I've found that much of this stress can be alleviated by simply counting the money. Add it all up and then figure out how long it will last you. (See the chapter titled "Next Worry Date" in Section 5 for additional information.)

- Email your clients. Sometimes stress can mount from not knowing where you stand with your clients. Take a few minutes and email a message of appreciation. A quick email like, "Just wanted to let you know that we enjoy working with you and appreciate the projects you send our way. Thanks for being a great client," can entice a response from a client like, "Thanks for the message. We enjoy working with you, too." This type of positive affirmation response can take stress out of your bucket.

- During one fast-growing year in my business, I drank an awful lot of diet cola drinks. I now refer to that year as "The Anxiety Disorder of 2006." I am speaking only from personal, not scientific, experience when I say that caffeine contributes to stress; I know it contributed to mine. You can dig up plenty of research out there that discusses the effects that caffeine has on the body.

- Get regular exercise. Not only am I a workaholic, I'm a workout-aholic. I hit the gym at least five days a week in the mornings before I go into the office. I know that regular exercise helps to lessen stress.

- Sleep seven to eight hours per night. Giving your body the rest it needs helps keep your stress bucket from overflowing.

- Eat healthy. Again, no scientific research here—just a simple truth that is grounded in my own life experience. Consuming healthy foods keeps your body functioning properly and can have a positive impact on your stress level.

- Mend a bridge. Many of us carry long-term burdens by having damaged relationships in our past. Walking around with this baggage can make the minimum level in your stress bucket be at least halfway full (or more). Figure out some ways to mend the bridge and humble yourself enough to act on them.

The stress bucket is real, and keeping it from overflowing can be a challenge in the stressful, deadline-driven world of graphic design. The best way to fight against this is to have an arsenal of stress-fighting techniques at the ready for whenever the need arises.

THE STRESS BUCKET IS REAL,
AND KEEPING IT
FROM OVERFLOWING
CAN BE A CHALLENGE
IN THE STRESSFUL,
DEADLINE-DRIVEN WORLD
OF GRAPHIC DESIGN.

10 TWO TYPES OF GRANDPAS

Bad things happen to good people. It's a fact. No matter how talented and filled with integrity you are, you will have some pretty miserable professional moments:

- You might find yourself laid off and have trouble finding a new job.

- You might have to deal regularly with an overbearing, idiotic, know-it-all boss.

- Perhaps you'll lose money, maybe even a lot of it.

- Clients will abuse you and pull projects from you.

- Some clients may even drop you as a vendor through no apparent fault of your own.

- You'll probably get stiffed on an invoice or two…or three…

- Late nights will happen.

- There will be bugs in your code or computer crashes that make you go prematurely gray.

- Clients will change scope on a project over and over again, and still expect you to execute for the same amount of money.

- The best comps you have ever created may be thrown in the trash with instructions to go back to the drawing board.

- The proverbial bus will probably roll over you again and again.

You can't avoid it. These things happen in nearly everyone's career. (Everything in the above list has happened in mine.) There is virtually nothing you can do to prevent the inevitable, but the one thing you have control over is how you react. You have control over yourself. Through it all, how you use that control will mean one of two things will happen: You will either become Grandpa #1 or Grandpa #2.

Grandpa #1 is the guy who everybody knows and secretly fears. Perhaps he lived down the street when you were a kid. He was the old, crotchety character sitting on the front porch. Every time you came near his yard you were nervous that he'd start yelling at you to stay off his grass. Maybe he falsely accused you of stepping on his flowers. Most likely he has a BB gun on his lap waiting for the neighbor's dog to set "just one foot" on his lawn. Grandpa #1 is a grumpy old man who seems to be against everything in the world. Everything he sees is negative. "The world is circling the drain on the way to perdition," he thinks.

Grandpa #2 is quite different. Most people know a Grandpa #2. He is the guy who has all the answers. His gentle, patient soul calms the whole family—all the way down to the great, great grandkids. He is admired and revered by all who know him. He has seen it all in his life and therefore can help guide you through the challenges that come your way. He is a sage, a captain, a tried and true leader. When the world is in chaos all around, Grandpa #2 calmly says, "All this will pass and we'll be just fine."

Grandpa #1 and Grandpa #2 probably had very similar lives. Both, like everyone else in the world, had their fair share of challenges and trials. The big difference between the two, however, was how they chose to deal with adversity. And these choices had a lot to do with the things they said to themselves in their toughest times.

Throughout his life as the world raged around him, Grandpa #1 likely said things like this:

"Who is to blame for this problem? Cuz it certainly isn't me!"

"This sucks. One more thing like this and I'm quitting."

"The Man is keeping me down."

"My boss is such a jerk."

On the other hand, Grandpa #2 probably viewed things differently and asked himself this:

"What can I learn from this experience?"

"What do I need to change in my life so I don't have this same challenge again?"

"How can I help others avoid this problem?"

"What steps do I need to take to remedy this situation?"

This simple difference in point of view meant Grandpa #1 grew to become an unapproachable grump, while Grandpa #2 grew to become patient and wise. How we turn out in life has everything to do with how we respond to the challenges we inevitably will face.

Pay attention to the things you say to yourself the next time your boss shoots down your comps or a client chews you out. Who are you becoming, Grandpa #1 or Grandpa #2?

11 BE A WALL PAINTER

In the early days of my business, after hiring a new employee we would all go out to lunch together to celebrate the new addition to our team. This tradition included the "telling of our worst jobs ever." The new employee would tell us their worst job and then the current reigning champion of the "worst job ever stories" would tell their story.

Nate, one of our first hires, is still the reigning champion. Nobody has knocked him off the worst job pedestal. What is his claim to "worst job" fame? It was his time making dog jerky. He would put on a rubber suit and spend all day in a freezer room pouring frozen meat by-products into a giant blender. At the start of the day, the meat by-products would be frozen. But as the day progressed, things would begin to thaw, and the freezer and his rubber suit would quickly fill with the blood and guts of the once-frozen meat. Inevitably, the rotten smell would seep through the rubber suit, mix with his sweat, and embed itself deep into Nate's skin. Even a long, hot shower after his hard day of work would not expunge the putrid smell from his pores.

This job (and I'm sure many others) that Nate has held in his life have molded him into one of the most hardworking, dedicated, and humble people I have ever worked with. Although he is a designer and production artist at our company, he is nearly always the first person to volunteer for any odd job that comes up. It is not uncommon to see Nate move a desk, paint a wall, take out trash, clean out a storage room, or change a light bulb. He does these things without complaint and I often imagine that he is comparing his cushy job sitting in an office chair designing things on his computer to his grueling

days making dog jerky. Nate was our company's first Employee of the Year, and his service-minded attitude continues to make him invaluable to our business.

I was recently watching a biography about Ray Kroc, the founder of McDonald's. I was astonished to learn that one out of eight Americans has worked at McDonald's. If you happen to be one of the fortunate 12.5 percent of the nation who has worked there, I say, "Congratulations." You are probably a better worker for it.

Sometimes I joke to our team, "We'll fly out and plunge our client's toilets if they ask us to." It comes out as a joke, but truthfully, I would do it. It is not beneath me.

I am grateful for the work ethic and lessons I learned in each of my humble jobs. Here is a list of my colorful job history:

- Detassled corn (entailed walking through corn fields pulling the leaves off the top of each stalk)
- Babysitter
- YMCA youth day-camp counselor
- Lawn mower for neighbors' yards
- YMCA lifeguard
- YMCA swimming and diving instructor
- YMCA fitness center consultant
- Wagon Wheel Playhouse usher
- Walmart (stocked shelves in third shift)*
- Temp employee (fed a binder)
- Ponderosa restaurant waiter*
- Lawn mower for the school system
- Arby's restaurant (I made the sandwiches)*
- Roofer
- Head Start preschool (teacher for Spanish-speaking migrant worker children)
- Indiana University football (ushered for football games)

- Indiana University graduate dorm library (yep, I was a librarian)
- Telemarketer
- AlphaGraphics (prepress coordinator—my first job out of college)
- Reynolds Graphics (junior designer)
- Market Direct (graphic designer at a direct marketing agency)
- Futech/oKID (creative director)
- Fox (senior creative director, Fox Studio; managed the design, development, and editorial of the Fox Kids and the Fox Family websites)
- Riser (founder, CEO, toilet cleaner, wall painter)*

I put an asterisk next to each job in which I cleaned a public restroom at one time or another. I'm not presuming that my eclectic job history makes me better than other people. However, I know that I am a better person than I would have been had I not gone through these diverse job experiences. I appreciate what I do for a living and know that many (if not most) people don't have the luxury of making their hobby into a living.

Proudly, I don't hold any prejudices…except for one. I believe you are a better person if you've ever had a job that required you to clean a public restroom. This humbling task teaches so many lessons, among which is the willingness to do whatever the job requires. I have seen over and over again in my career that the people who are willing to go the extra mile and do whatever task is required of them by their boss or client are among the most valued in the company.

We have won many awards throughout our company's history, one of which is the "Best of State" award for Utah, and which we have proudly won many times. Each year businesses are selected to win this award in several different categories, our category being "Graphic Design," not surprisingly. What may come as a surprise to some graphic designers is that the "Graphic Design" category is a subcategory of "Business Services." Dictionary.com defines the word "service" as the act of being helpful, aiding in something, or doing someone a service.

In order to fully succeed in their career, "service" must be at the heart of a graphic designer's goals. Your job is to make a client's life easier. They are coming to you in need of help. They can't design these things themselves. They have external pressures mounting on them that only you can alleviate. Ultimately, cleaning public toilets early in life is not the only way to learn gratitude and humble service to others. Many people are fortunate to learn these lessons in their homes. Others are born with service built deep inside of them. Regardless of how you learn to serve, learn it and learn it well. Graphic design is a service-based industry, and thus requires humility and a strong work ethic.

12 EVERY POSITION CAN BE ELECTRIFYING

There are three things that I really love in this world: my family, the Chicago Bears, and my Jeep. Which order these fall in, I'll let you decide. Devin Hester is a kick returner on the Chicago Bears. In 2006 and 2007, he broke the NFL single-season record for kick returns two years in a row. In his first two NFL seasons, he had 11 total kick or punt returns; that is only two returns shy of the all-time NFL record of 13 held by Brian Mitchell (which took Brian Mitchell an entire NFL career to set.) Devin Hester is a game changer.

Now let's run down the list of other electrifying players in NFL history (Peyton Manning, Barry Sanders, Randy Moss, Walter Payton, and Joe Montana may come to mind). For those of you not up-to-date on football stats, that list contains quarterbacks, running backs, and wide receivers...typically the position played by the "electrifying" and "difference making" players. In the 2006 season, Devin Hester of the Chicago Bears was arguably the most electrifying, game changing player in the entire NFL and he is a KICK RETURNER! Now take a minute and name other kick returners in the NFL...maybe you came up with one or two... maybe (out of 31 other teams). The kick returner position has never been what Devin Hester made it to be in his first two seasons.

So what is my point?

In football team terms: In the NFL, you don't have to be the quarterback to make an impact. Devin Hester proves that a kick returner can have as big an impact on the success of a team as the superstar quarterback, running back, or wide receiver. In the case of Devin Hester, he made it so that opposing teams had to alter their game strategies; by the end of the 2007 season, many teams even began

kicking the ball away from him to keep him from having a chance to make a game-changing play.

In graphic design team terms: You don't have to be the art director, creative director, CTO, or VP of blah-de-blah agency to be a key member of a company. Any role, any position, in any organization can have a huge impact on the success of the organization. Throughout my career, I have seen junior programmers and junior designers make HUGE impacts on company success. By striving to maximize your contribution, regardless of the position you fill on the org chart, you can make an impact.

Here are a few questions you can ask yourself to help you become electrifying in your current role:

- What could I do to be better at my job?
- What are some areas in this company that need improvement and what can I do to help improve them?
- What should I be learning to help me improve my skills?
- How can I help my coworkers with their job responsibilities?
- Is there something I can do to help improve our office culture?
- How are our production processes working and what suggestions can I make to improve them?
- What are my unique qualities and characteristics that I can utilize outside of my current role?
- Am I dedicating some time each day to thinking outside of the box? Or am I doing only the jobs assigned to me?

Ask yourself these questions and get serious about answering them, and you will be well on your way to becoming a dominant player on your company's team.

YOU DON'T HAVE TO BE
THE ART DIRECTOR,
CREATIVE DIRECTOR, CTO, OR
VP OF BLAH-DE-BLAH AGENCY
TO BE A KEY MEMBER
OF A COMPANY.

13 LEAD OR BE LED

I was recently attending a meeting where the speaker was talking about the Boy Scout program. I was struck by something he said while relating a story about a new scoutmaster he was going to be working with. The speaker gave the scoutmaster a set of Scout manuals to which the scoutmaster responded, "Now which of these do I really have to read?" The speaker then promptly replied, "Well, that depends on whether you want to LEAD or be LED."

This statement had a huge impact on me. Among many other attributes that the leaders around us possess, this statement emphasizes that leaders are frequently the most educated about the subject matter, and the most prepared to guide others and make decisions based on their understanding of the appropriate materials.

If we want to lead, we must educate ourselves and prepare to make decisions and guide others. Over the course of my career, I have been on an unceasing quest to educate myself on numerous things that I felt were inhibiting growth in my career. After graduating from college, I taught myself HTML and consequently became a key employee in one of my first jobs. While there, I taught myself Flash 2.0 and 3D modeling, which helped me land my next two jobs and be promoted several times, during which time I taught myself

Flash 3.0 and 4.0. This in turn enabled me to start creating games online, and with this knowledge was able to land my next job at Fox where I managed a large development team of programmers, designers, and editorial staff.

There I began the process of educating myself in people and project management skills, which have been invaluable as a business owner. Subsequently, during my time as a business owner I have read countless books on business management. This thirst for knowledge has made all the difference in helping me progress and succeed in my chosen career.

If you want to be a leader, it is imperative that you figure out what you don't know and take the necessary steps to learn it, no matter what it is and what it requires of you.

14 HALF THE VICTORY

One of the biggest failings and sure signs of a junior designer is to sit in a meeting like a wallflower at a high school dance with nothing to say or contribute to the party. It is OK to be a little shy and even better to be a little humble. But even the meek look strong when they have something of value to contribute.

Some people are born with the gift of gab. Others naturally and organically develop it over the course of their lives. Still others need to work at it like they would to develop any other talent. If it doesn't come naturally, it is worth your effort to improve your public speaking and presentation skills. These abilities will help you land jobs and clients as you venture through your life as a graphic designer.

My oldest son is a Boy Scout working his way toward earning his Eagle Scout Award. I have come to know the Boy Scout Motto, "Be prepared," as I have participated in activities with him. What a simple and great piece of advice! We should all apply this nugget of wisdom in many aspects of our lives.

Not only does this counsel help an eager Boy Scout survive in the wilderness, it can help a designer thrive in the workplace. Next time you are called to a meeting, don't be like the junior designer wallflower; instead, be sure to prepare some things in advance:

- Be sure to have something to write on. A note pad, your Moleskine®, a laptop computer—the tool or device doesn't matter as much as the image that you will present when you are prepared to take notes and look interested.

- Do some research and review before the meeting to ensure that the topic is fresh in your mind. If you are meeting with a new client, be sure to learn all you can about them by searching the Web and exploring their website.

- Jot down a few intelligent questions and muster the courage to ask them. It is much easier to come up with intelligent questions beforehand than in the heat of the moment.

- Bring some advice. Plan on sharing a recent lesson learned to help educate someone else. When done tactfully, this can help you look experienced and knowledgeable.

- Plan to share a compliment about another attendee. Do you like a client's brand or product? Tell them and be specific. Did a coworker help you execute on a sticky deadline? Share the experience in your next staff meeting so everyone knows how great this person is.

- Share an opinion. In your next design critique, be sure to have some intelligent opinions to share. Don't just receive opinions; share some of your own.

Some action is better than no action. With a little preparation before a meeting, you can transform your image from that of an inexperienced mouse to that of a seasoned and competent design professional.

15 THE VALUE OF DOWNTIME

The day I graduated from college with my fancy bachelor's degree in Studio Art was a happy one. Indiana University was wonderful…but I remember thinking with a smile on my face, "I will never be in school again." Unhappily, it took about a month of job searching for me to realize that my degree didn't guarantee me a job. I also realized my college portfolio and zero experience weren't exactly "wowing" any potential employers. Finally, the day came when I landed my first "real" job: prepress coordinator at the local AlphaGraphics, making just a tad above minimum wage.

Now, AlphaGraphics is a fine organization, but it isn't exactly the Madison Avenue dream career of an ambitious new graphic design grad. I was grateful to have "a job" and realized that my college degree helped me "learn how to learn," but it did not give me all the skills I would need to succeed as a graphic designer.

So, in true Michael Janda OCD form, I took it upon myself to learn everything I could about the design industry. At every company I have ever worked at, I have engaged in the ambitious goal of learning new skills. In the mid-1990s, I taught myself skills that proved to open doors for me at new companies where I served in creative director roles (including Fox Studios). I am also constantly scouring design galleries and magazines to stay current on design trends. As my role has shifted to that of business owner, I have devoured business books to earn my "MBA" in the trenches of real life. The point is that I have used idle time to build my own skill set, which has led to countless professional opportunities and significant growth in my career.

Too often I have seen team members and employees at companies I've worked at (and my own company) piddle away their idle but company time playing games, watching videos, and poking around social media sites. Shame on them for wasting employer dollars. And even bigger shame heaped upon them for wasting valuable time that could have gone toward benefiting their professional future.

My questions to you are: What are you doing with your downtime? Where do you want your career to go? What are you teaching yourself to help get you there? I implore you to teach yourself new skills and do all you can to stay current with industry standard technologies and design trends. Most employers are happy to see employees take initiative to learn new things, as these new skills will contribute to the success of their business.

Look around your workplace. What areas need improvement? What can you do to help? In my experience, even the worst bosses typically reward ambition and problem-solving steps that contribute to improvement of their company. Can you help with company marketing efforts online? Can you make suggestions to improve processes and systems in the company and then champion their implementation? Heck, take out the trash if you have to. Idle time that you are being paid for should be used to benefit the company that pays your bills and puts the Hot Pockets® on your table.

WHAT ARE YOU DOING
WITH YOUR DOWN TIME?
WHERE DO YOU WANT
YOUR CAREER TO GO?
WHAT ARE YOU
TEACHING YOURSELF
TO HELP GET YOU THERE?

16 I'M NOT A WRITER

I was recently interviewing a candidate for a design position at our company. In response to one of the interview questions, he naively said, "I'm not a writer." I immediately thought (but did not say), "You want to be a graphic designer? That means you're a designer, a writer, a programmer, a photographer, and sometimes an illustrator."

As a graphic designer, you often have to fill in the holes left by your client's inability to deliver necessary assets. Also, if you want to be in a position where you can consistently over-deliver and go the extra mile for your clients, you need to be able to tap into a rich reservoir of talents and skills that go beyond those you graduated art school with. So be prepared to polish your skills in every trade associated with graphic design, because you're going to need them.

Not only that, a graphic designer that is part of a small company should assume they will also have to be a computer fixer, a phone answerer, a sales representative, a furniture mover, a wall painter, a picture hanger, a desk assembler, a trash taker-outer…you get the idea. The more hats you are willing to wear, the better team player you will be. Your coworkers and supervisors will appreciate you more as you contribute to the success of the business in more ways than just amazing them with your killer design skills.

We as human beings were made to go through life continuing to assimilate information and grow; our ability to digest new things and add to our natural skill sets is what separates us from the zoo animals we gape at on the weekends. We would be foolish to think otherwise. It is therefore imperative that we strive for excellence everywhere—not just in our proclaimed field of specialty.

17 TOOT YOUR OWN HORN

Growing up on a lake in northern Indiana taught me many lessons. Among them is the universal truth that "crap naturally floats to the surface." Inevitably, the top layer of the channels in the lake would contain many treasures such as dead fish, trash, and seaweed. Sure, the lake was filled with good stuff as well: beautiful bass and other fish swam beneath the surface. But the only time you saw them rise to the surface was when they were dead and rotting.

As a boss and graphic design business owner, I've learned that this same thing holds true in business settings. "Crap naturally floats to the surface." When a project goes awry, people hear about it up the chain of command. When a client is upset, your boss will inevitably find out. If a deadline is missed, word spreads. The "crap" in a design agency naturally floats to the surface for all to see. It is rare that a client will call your boss to tell them what a great job you are doing, but they certainly will call when you do a crappy job.

The "good stuff," unfortunately, requires effort to circulate. Unlike the "crappy stuff," you will have to make an effort to share the good things that happen during the course of your projects with your coworkers and boss.

For example, it is not uncommon that a client will email you a compliment on your good work. This is the type of "good stuff" that you have to make an effort to circulate inside your company. A simple email forwarding the message from the client with a message of your own saying, "Just received this from the client. Kudos to everyone on this project!" is usually sufficient to get the compliment passed around.

Another thing we've done at our agency is the occasional "Expose Yourself Friday" meeting. As need arises, we set aside an hour or so on a Friday and give everyone on our team a few minutes to show off projects they've been working on. This not only lets the "good stuff" come to the surface, it also provides an opportunity for everyone on

the team to see the cool work that their teammates are producing. It serves as a great way to circulate positivity, helping employees feel more appreciated.

Your boss is probably very busy and, if you're lucky, won't often meddle in your projects. If you want to make sure they know the great job you're doing, chances are you have to make an effort to show them. My father-in-law has always said, "You have to toot your own horn, because nobody is going to toot it for you." If you don't have a reporting structure to show off your stuff…all your boss will likely hear will be the negative things that happened. Take the time to prove your worth and let your good works speak for themselves.

18 DON'T WORK IN A VACUUM

"Don't work in a vacuum." Of course I didn't coin the phrase, but when I first started spreading this statement around the office, I honestly had some people think that I was talking about a vacuum cleaner. Don't be fooled, though—what I want you to be thinking about is space: the final frontier. Most of us have seen a movie where some guy gets sucked out of his spaceship into outer space. His love interest is inside the ship with no way to save him. The soft, sad music is playing while they touch hands against the glass. She is crying. He is dying. He has no way to move, no way to speak, no way to breathe. He is completely alone in the vacuum of outer space.

I spent three years of my life working in that vacuum. I was a basement-based, one-man show. No critiques, no internal feedback, no fresh outside ideas—just me cranking out some of the best mediocre work in America. Sure, my mediocre work was good enough to make my clients happy and even keep them coming back for more. It was even good enough for those relatively happy clients to spread my name around. But I know for a fact that my work is even better when I collaborate with others.

Once I began hiring people, I was quickly reminded how influential collaborating with others can be on the quality and reach of any given design. Time after time, I saw good design turned into great design through collaboration.

The simplest way to get out of the vacuum you work in is to simply spin your chair around and say, "Hey, what do you think of this?" If you are working in an office environment, there is likely someone nearby who can provide some type of feedback. Don't be arrogant and make the mistake of thinking that your feedback needs to come from another designer; this type of pride and blindness can lead you down the path that leads to design worthy only of the yellow pages. Anyone can provide insights that can improve your work. Some of the most

helpful feedback I have received has come from nondesigners who tend to see things through a consumer's point of view.

Feedback frequency is also important when it comes to your productivity. You don't want to get too far down the path of your project before you ask for someone's opinion, since there is nothing worse than having a comp almost completed only to realize that you missed out on integrating a key element, or that you failed to utilize a groundbreaking concept that could have changed the direction of the entire project for the better. I regularly ask of anyone available, "Hey, do you have a second to take a look at this? What would make it better?"

Not working in a vacuum applies to everything, not just design projects. We have rules in our office that require everyone to get feedback on everything. If someone is sending an important email to a client, they have someone else read it to check for tone and typos before it is sent. Every proposal is reviewed by someone other than the writer before they are sent. Pricing and project schedules are also bounced around a few people for feedback before they are sent out.

Inevitably, you will receive lousy feedback from time to time. When this happens, simply smile and say, "Thanks." Remind yourself that 90 percent of brainstorms are typically comprised of bad ideas. It is better to get poor-quality feedback and not react to it than to get no feedback at all—especially since that last 10 percent is often where true greatness in unveiled.

In the end, the best designers swallow their pride and recognize that their ideas aren't always the best, and they are willing to collaborate with others to create great design work, leaving bad design lost in space where it belongs.

19 THE GRAPHIC DESIGN MEGAZORD

My time at Fox Kids had a huge impact on me: I made great friends, had tons of fun, and gained the opportunity to work on awesome projects for amazing brands. My own children were very young at the time, and Power Rangers was one of Fox Kids' hit shows. I was literally drowning in Power Rangers paraphernalia—Power Rangers shirts, videos, toys, pencils, notebooks, books, and costumes were all over our office and my home. My son was three years old and he inevitably became a huge fan of the show.

The genius formula used in each Power Rangers episode goes something like this: the Power Rangers are on the brink of being wiped out by this week's bad guy. The bad guy turns into a giant monster (think Godzilla) and the Rangers realize they cannot possibly beat the giant monster alone. Wisely, the Rangers jump into their individual vehicles and combine them to form the giant Megazord robot. The Red Ranger ship becomes the body. The Blue and Yellow Ranger ships become the legs. The Pink and Green Ranger ships become the arms. A giant sword magically shows up and the Megazord is now powerful enough to take on the evil giant monster and save the world yet again.

Similarly, the graphic design world is like a giant Power Rangers set. On the base level it may seem like your individual talents and skills are enough to tame even the gnarliest of villainous design problems. But even the world's best superstar designer is stronger in a team. Several people working harmoniously together can conquer tasks too great for just one person.

The "Graphic Design Megazord" concept follows this pattern: Each project is assigned to a team of people for execution. The team may consist of a project manager, a senior-level designer, a junior-level designer, a programmer, and a quality assurance specialist. The roles of the Graphic Design Megazord will vary from project to project and

business to business. The point is that a team can accomplish greater tasks than an individual alone can—after all, there are only so many hours in a day, and one person cannot possible serve as designer, project manager, and creative director without dropping the ball somewhere at some point in the project.

So fire up the old Red Ranger and transform your abilities and skills into the collaborative masterpieces they were always meant to become.

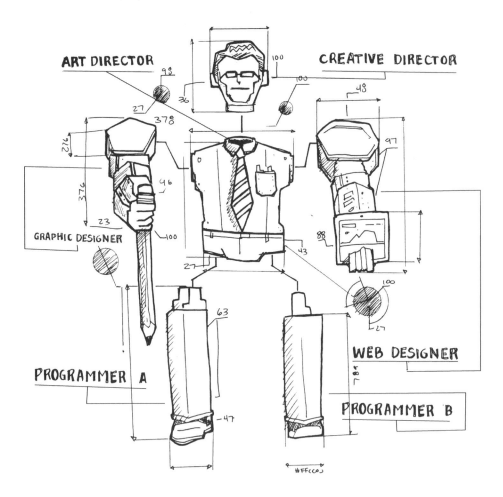

20 LIVE AS A TEAM, DIE AS A TEAM

About five years after starting my design agency, I became acutely aware of the codependent nature of a business. Perhaps these feelings began to swell when we held our first annual company party at the local amusement park, Lagoon. Each employee, with his or her family in tow, met at our rented pavilion for lunch. This was the first time we had all been together in such a manner. I began to count heads and was humbled as I felt the weight of running my business in a way that could continue to provide for all 52 people who were dependent on it for their financial support (my dozen employees plus their spouses and children).

It didn't take long for me to realize that I was also dependent on each of our team members to successfully perform their duties at our company in order for my family to be provided for. And not only that, each employee was dependent upon every other employee. The financial repercussions of a project going awry could force me to make hard business decisions about whom we could afford to keep and who might have to be let go.

The reality is that everyone must feel the responsibility for every project to succeed whether they are assigned to the project or not, because if Jane blows a project resulting in the loss of a client, John might lose his job.

When money becomes tight in an organization, tough business decisions have to be made. In regard to your and other employees' worth, an employer will closely examine the following items.

Cost

How much do you cost versus how much money the company can bring in due to your efforts? The more profitable you are to the business, the better chance you have of being retained through all but the most grievous circumstances.

Redundancies

If your company has three designers and one programmer, and the programmer is involved in a botched project, there is a likelihood that one of the designers may be let go when finances require it—even if the project failure was the fault of the lone programmer.

Attitude and Fit

When the economic recession finally hit us early in 2009, we had to make some tough decisions. We had plenty of redundancies, and cost versus contribution was pretty much equal across many of our team members. That left us to judge each employee's attitude and cultural fit within our organization; your company will view the circumstances in the same way we did.

The truth is that none of us ever want to be on either end of these tough business decisions. In order to achieve that goal, we all must feel the weight and responsibility of each and every project to succeed. If a designer on Sally's team fails to do their job, the result could be that a designer on Ralph's team has to dust off their résumé and find new employment.

21 EVERYONE DOES SOMETHING BETTER THAN YOU

In my early twenties, I spent some time living in the northern coastal cities of Colombia. Part of my soul longs to be there still, as I made some amazing friends and fell in love with the culture. My experience there was also filled with unique and deeply meaningful life lessons. One of those lessons was taught to me by a dear friend from Bogotá.

My friend and I were chatting one day, and I was discussing some of the challenges I had with the personality quirks of a mutual acquaintance. Human nature makes it easy for us to notice the flaws in others. This practice breeds negativity and inhibits teamwork, two things that can critically influence success in the field of graphic design.

My Colombian friend gave me some advice that has stuck with me throughout my life. He said, "Everyone does something better than you." He then proceeded to instruct me that with everyone he meets, he tries to figure out what that "something" is, and then emulates it. This strategy changed my outlook on life and my perception of others, and I immediately began practicing this point of view.

When I find myself negatively noticing the flaws in others, I humbly attempt to figure out what that person does better than me. There is always something. Admittedly, with some people you have to look harder than with others, but with everyone I've met, I've managed to find one thing that they can do better than me.

Take a minute to look around your office. Examine the people there. If you could incorporate one attribute into your life from each person, what would it be? With a humble outlook, I often don't have to search very hard:

If I knew all the keystrokes that our production artist Nate knows, I would be a faster production artist.

If I had the organizational skills that our office manager Rachel has, my life would be less stressful.

If I knew ActionScript like our programmer Brent does, I would be irreplaceable.

If I had the client-relation skills that my right-hand person Jeff has, I would be a better project manager.

If I could draw like our illustrator Christian, I would be a more well-rounded graphic designer.

If I could work as fast as our creative director Josh does, I would get home early every day.

If I was as fun and kind hearted as our art director Andrew, nobody would ever want to leave my company, and every client in the world would want to work with me.

This exercise produces three results. First, it keeps you humble. Second, it helps you appreciate those around you, which leads to less infighting and other behaviors that are culturally counterproductive. Third, it should give you a list of things that you can work to improve in your life to make you a better graphic designer and an all-around better human being.

22 YOU ARE RESPONSIBLE FOR YOUR OWN TIME

Every designer or agency that has achieved any measure of success has endured the experience of late nights and weekend work. They happen. They are inevitable. This is an unfortunate part of the graphic design industry. If you are lucky, you will work at a place that fights against the late-night current and strives to schedule things in a way that gets you out of the office at a reasonable hour.

At our agency, there were a few years in a row where we were doubling our billings. This type of growth proved very difficult to manage. The unfortunate thing is that I often felt alone in my efforts to manage the growth: I would hire more people, use freelancers, create production systems, give motivational messages, buy everyone lunch, give out bonuses—but none of it seemed to get the workload under control. As a result, our team ended up putting in a lot of late nights and I became sincerely disheartened by it. I truly valued my employees and respected their family and personal time. This was not the type of work environment I wanted for my company.

In the space of one week, by chance I had two separate, closed-door meetings with two different employees, both of which helped me to recognize the key to our excessive-hours problem. The discussion I had with each employee contrasted greatly.

Employee #1 came into my office, closed the door, and sat down. He had stayed late the night before and started the conversation by saying, "Morale is at an all-time low. People are sick of staying late. What are you going to do about it?" He was looking for someone to solve the problem for him. He didn't bring any solutions to the table. I immediately started thinking of all the things I had already done (hiring, bonuses, raises, modifying processes). None of it was enough and I needed help. I needed his help, but he didn't offer any solutions

to the problem. His speech only served to make me hyperaware of the problem we had with morale. In essence, he was blaming me for his late nights.

A couple days later, Employee #2 approached me requesting a similar closed-door meeting. He had stayed all night the night before to hit an important deadline for a major Hollywood studio. I braced myself for another complaint-fest. Instead, Employee #2 began his conversation by saying, "I just want you to know that I love my job. I really like working here. I'm doing the best I can to get things done." Instead of looking for someone else to blame for his late night, he was blaming himself. He was worried about getting fired for not getting the work done faster. He saw ample areas where he could improve and listed them for me with advisement that he was working to get better. A huge moment of relief swept over me. I appreciated this employee and his extra efforts, and he recognized that. And his willingness to personally find ways to improve his workload helped me discover that each employee could work towards finding the balance in their own workload.

Employee #1 didn't last much longer at our company. He and several others—not surprisingly—sought new employment. On the other hand, Employee #2 continues to be an important cog in our machine.

I learned a lot about people and management during this challenging experience. One of those lessons is that "You are responsible for your own time." Before you go blaming others for your overtime

schedule, look at yourself. Are you using all your time effectively? Have you presented solutions to the frustrations you are experiencing in the workplace? Have you asked for help from your teammates? Have you delegated pieces of the project to others who are not as busy? Take responsibility for your own time and focus on trying to be part of the solution, not part of the problem.

ART SMARTS

THE BEST DESIGNERS TAKE "LUCK"
OUT OF THE EQUATION.
SMART PROCESSES, STRATEGIES, AND TECHNIQUES
WILL HELP YOU CREATE A MASTERPIECE
EVERY TIME.

23 OCD IS AN ATTRIBUTE

I will never forget my first press check. I had designed a brochure for a client of the direct marketing agency I was working for in Phoenix. Admittedly, I felt cool that I was able to go to the press check. The hour and a half drive to Tucson went quickly due to my enthusiasm; I was like a kid leaving for a family vacation on the coast, knowing that ahead of me lay all the wonders and excitement of the unknown. The printer greeted me warmly and took me back to see the brochures. They had decided to go ahead and run all of the copies while they were on press; the paper was nice and the fold job was spot on. The printer's work was stupendous!

Unfortunately, as I would quickly realize, my work was the problem. I began skimming down the text on the front page and then I learned a valuable lesson: FAX is not spelled FZX! Now that I noticed the typo (after everything was printed) I could not believe I had missed it before. How could I have let such a grievous error slip by me? The cover consisted of a photo, the client's logo, and about ten words (FZX being one of them). Last time I checked, a ten percent typo rate isn't going to win you any design awards. In the end, they reran the job and I ran out of their shop, tail between legs and all.

Since this experience, I have become obsessed with proofing my work and the work of others. In fact, one of my personal mantras is "OCD Is an Attribute." I understand that OCD (Obsessive Compulsive Disorder) is a real challenge that many people struggle with every day, and it is certainly not my goal to make light of it. I am merely trying to point out that in graphic

design you must obsess about the details. The placement of every pixel must be considered. No detail must be left uncritiqued. No typo can be left unfixed. If something is off-center by the slightest degree, it can quickly become a visual abomination.

We live in a world where computer software enables designs to be perfect—down to the smallest pixel and up to the largest print format imaginable. Error-free design is not only possible but imperative to your profession and to the quality of your finished products.

Great graphic designers are typically great proofers. The core elements that should be considered in a proofreading exercise include layout, typography, and color usage. Here are just a few questions you should ask yourself when reviewing any graphic design project:

- Is there anything about the layout that can be improved?
- How does the eye flow through the composition? Can you read the elements in the proper order?
- Examine the typography. Are there any typos (spelling and punctuation)? Have kerning, tracking, and leading been attended to with every possible detail? Is the text ragged? Are there rivers? Widows? Orphans?
- Are the elements that should be consistent, consistent? What about headers? Buttons? Font usage?
- Is anything out of alignment with the grid of the design?
- Are there any tangents? Are there elements butting up against each other (or a margin) that are visually awkward?
- Does the color palette work? Could any of the colors be improved?
- Have photos been appropriately treated to improve their visual quality? Has any cropping been cleaned up and utilized as best as is possible?
- Do any photos or images appear to be grainy or low quality?

THE
DIFFERENCE BETWEEN
GOOD DESIGN
AND
GREAT DESIGN
IS PAYING ATTENTION
TO THE
DETAILS.

These inquiries, along with other related questions that you may come up with, must become second nature to you. You must be able to look at a design and consider these things almost without even knowing that you are doing so. As with anything you want to get better at, you must practice, practice, practice.

I've turned graphic design critiquing into a life game. Nearly every magazine, billboard, menu, newspaper, and advertisement I look at I view as a critiquing opportunity. This may seem like an exhausting way to live, and perhaps it is. However, there is nothing more thrilling (albeit sometimes annoying and frustrating) than when you find a typo in your dinner menu or when you notice a low-resolution image in a newspaper ad. It is fun to find errors in the work created by an unknown designer. You can bash them up and down, guilt free! Embrace every opportunity you get to release your inner OCD, and remember that the difference between good design and great design is paying attention to the details.

24 POLISHING TURDS

Creating a quality product is at the forefront of the long list of responsibilities that designers face each time they step into the office. You have to keep pushing yourself to get better and to take your designs to new levels. Every project is a new opportunity to design an award-winning masterpiece and an anchor portfolio piece.

While most projects may start out with this grandiose mindset, the unfortunate thing about graphic design is that it can sometimes become more about polishing turds than creating the next *Mona Lisa*. Let me illustrate this with a hypothetical example.

Client X needs a logo designed for his landscaping company. You scour your favorite design books for ideas. You click hundreds of landscaping websites trying to get into the mind of the client and his customer. You even go so far as to buy a handful of landscaping magazines to really try to understand the industry. You know in your very core that this is going to be the best logo ever!

Your sketches look great and it is time to make some mock-ups. You parade them proudly around the office and everyone is in awe of your design abilities. You're starting to think that you just might be the best designer to ever walk the face of the earth.

You send the logos to Client X for review. Of course you know that Logo Option 4 is the obvious choice and that the client will definitely choose that one. You anxiously await the client's reply—they will certainly recognize and rejoice in your awesomeness. The phone rings; Client X is on the line.

"We showed these around to the team and we weren't really feeling any of them. One of our guys showed me a font they have on their computer. It's called Comic Sans. It was really cool; kind of light-hearted, like our business. Can you try that font on some logos in the next round?"

Your heart sinks a little, but your competitive spirit kicks in and you decide that you'll really show them how good you are in the next

round. You make a whole new batch of amazing logos and you throw one in there with Comic Sans as the font in an effort to appease your client. The other designers in the office hail your greatness until they see the Comic Sans logo version, at which point they laugh and point. You try to explain yourself, but their laughter continues. You send the logos to Client X, confident that this time you have hit it out of the park. Client X calls:

"This round was much better. I think we are getting somewhere. We like the direction of Logo Option 8—can you push that one a little harder in the next round?"

You try to remember which one is Logo Option 8. You open the delivery document and scroll to that page and feel completely deflated when you realize they like the Comic Sans logo! Client X continues:

"Also, in our meeting we were thinking you could make the grass icon purple instead of green. My wife loves the color purple and thought that would make the logo stand out more. Oh, and my brother was telling me about this Photoshop filter that can make things look beveled…kind of 3D. We think that would be cool, too."

This is the defining moment when your responsibility shifts from creating unique and high-concept designs to merely polishing turds. Obviously, in the case of my hypothetical scenario, the client is asking for a turd. Your job is to turn it into the best looking turd it can be and then get that turd out of your production pipeline as quickly as possible. At this point you must check your pride at the door. Don't spend countless hours trying to convince the client why your logo ideas are better. Simply accept that the design is not going to be the masterpiece you were hoping for and polish it as best you can.

Do what they ask. Polish that turd. Deliver it. And then thank your lucky stars that the project is over and you are free to move on to the next (and hopefully more harmonious with your design sensibilities) project in your queue.

Remember, though. Polishing turds does not mean that you abandon your design principles. If the client wants purple grass in their land-scape logo, then use your color theory expertise to choose the absolute best purple color possible. If Comic Sans is their font of choice, then make sure that the kerning and leading are set to total perfection. If

the client wants a little bevel and emboss on their logo, then use all the design finesse you can muster to make it just right. Make that turd the best and prettiest turd the world has ever seen, and remember that not every project is meant to be a masterpiece.

Ultimately, in spite of your goal to create the best designs in the world, the reality of the graphic design industry is that oftentimes you must create the best design that your client will allow and work within the parameters they have set—even if that goes against everything you know to be good and aesthetically pleasing.

25 HAIRY MOLES

Moles, freckles, birthmarks—they are all part of life. Nearly everyone has some sort of skin abnormality somewhere on his or her body; it is simply the way we're built. In some cases, a small mole right on the face is even considered a beauty mark, bringing to mind Marilyn Monroe and Cindy Crawford, to name a few. On the flip side, however, there is something visually disturbing about a hairy mole. I doubt that Cindy Crawford would have had the same success in her modeling career if she had a pile of hair pouring out of her mole. Sure, in her prime she was arguably the most beautiful woman in the world. But a big hairy mole on her face would have drawn so much attention that even the most lustful men in the world would probably not have been able to look past it.

Is this a superficial perspective? Perhaps. However, if you conducted your own independent survey, I'm sure you'd find it to be true.

"Hairy moles" exist not only in dermatologist offices but in graphic design as well. When they appear, it makes no difference how amazingly beautiful your design is; your client won't be able to look past the "hairy mole." Let's take a look at a few of these hairy creatures:

- The client requests a change that you don't make. This is a great way to frustrate your client. You have to make sure you review and satisfy all of your client's requested changes before submitting the next round of comps for their review.

- You leave a broken link or image on a website. Your client will lose confidence in you if they find even just one thing broken. They will likely think to themselves, "Wow, what else could be broken?"

- The design contains an ugly logo. If so, chances are that it will drag down the visual success of the rest of the piece. Imagine the *Mona Lisa* with an errant brush stroke in the bottom-right corner.

- The project contains bad typography. Widows. Orphans. Rivers. Typos. You may have an awesome layout, but if you don't have stellar text to go along with it, the design can never be fully appreciated.

- You've missed a deadline without communicating with the client. Even if you are just a few minutes late, you will have left your client waiting, and this is a huge issue. It may appear to be a little mole, but it is a hairy one and it detracts from the overall beauty of your client's experience with you.

Watch out for hairy moles. Proof everything carefully. Graphic design is about the details. The smallest detail left to chance can scar the success of any project.

26 THIS IS NOT VERBATIMVILLE

Verbatimville is a land of thoughtless zombie drones who wander around like robots doing exactly what they are told. Far too many graphic design professionals live their lives wandering in Verbatimville. When their client asks for a change, they do it exactly as they are told without utilizing their own knowledge of design principles or tapping into their design instincts. You will never progress in your design abilities if you live your life stuck in Verbatimville. Your projects will never achieve their full potential if you simply follow the mandates of your boss or client; you must instead move out of Verbatimville and into the land of Creative Genius.

One of the most embarrassing things ever produced at my company was due to a Verbatimville mindset. Our team was working on some banners for Warner Bros. It was a great project and we were the preferred vendor for this group. The client had delivered key art for the banners and we were instructed to use that art in the banners. To this day I am not sure how our team could think it was acceptable to send the banners they sent for client review. Due to the file size requirements of the banners, the JPEG quality of the key art had to be set to 10% or 15%. The results were banners with huge pixels and artifacts; you couldn't even tell what the images were supposed to be. These hideous banners were sent to Warner Bros. with no explanation or comment. I can only imagine that our client was thinking, "What in the world are these? They look terrible!" And of course, some of our team members who live in Verbatimville were thinking, "Well, you asked for the banners to be a certain file size. You also asked us to use the key art you sent. As a result, the JPEG quality had to be set really low. Hope you like 'em!"

Alternatively, here is a safe approach to injecting your own creativity into a project without offending your boss or client: Create one version that is exactly what they ask for, and prepare another version that is

your better idea. Here is how the conversation goes when you reveal the comps:

"Here is Comp A. We followed your suggestions and made the adjustments exactly as you requested."

(The client is satisfied that you followed their explicit instructions and is not offended. This is the Verbatimville comp.)

"And here is Comp B. As we were working on your requested modifications we had some other design ideas come to mind. In this comp we implemented those ideas and feel that it is a strong option to consider because of… (fill in the blank here with whatever stellar and grandiose reasons you may have)."

(The client is still satisfied with Comp A and is now also excited that you are going the extra mile and using your head. You win brownie points whether they like your extra solution or not.)

Inevitably, there will be times that your client or boss will prefer Comp A. When that happens, please refer to the chapter "Polishing Turds" in this section of the book and move forward with the knowledge that you offered up your best creative effort.

There are two other habits that the zombies of Verbatimville can't seem to kick.

Not reading copy: They will just copy and paste text as it is handed to them. Next time, try reading the copy and make suggestions for improvement. Reading the text will also help the designer to create copy areas that appropriately highlight key phrases.

Not treating photos: This happens when designers settle for using photos exactly as they are provided. Next time, try opening up Photoshop and making necessary adjustments to color, contrast, levels, curves, and so on. Usually a minute or two of enhancing a photo can make a dramatic improvement.

In order to progress in your design and production capabilities, you must continually ask yourself, what would make this better? Keep pushing yourself and refuse to assume that the idea you are provided with is always the best and only one. Inject your creativity into every project and remember, "This is not Verbatimville."

YOU WILL NEVER PROGRESS
IN YOUR DESIGN ABILITIES
IF YOU LIVE YOUR LIFE
STUCK IN VERBATIMVILLE.

27 SHOCK AND AWE

All working designers know there are clients in any person's Rolodex that seem to fight against great design no matter how much you try to convince them otherwise. It only makes sense, then, that in the war against subpar design, the Shock and Awe principle would apply just as it would on an international battlefield. While we don't advocate dropping massive bombs on your clients (in spite of the frustrations they cause you), we do advocate overwhelming them with spectacular displays of design prowess that "destroy their will to fight" against you. If Shock and Awe is used properly, your clients will become putty in your hands, humbly submitting to your will and deferring to your expertise.

Harlan K. Ullman and James P. Wade are credited with coining the term "Shock and Awe." In their 1996 document "Shock and Awe: Achieving Rapid Dominance" (National Defense University and later authored by the U.S. Department of Defense), Ullman and Wade define four characteristics of rapid dominance:

- *Near total or absolute knowledge and understanding of self, adversary, and environment*
- *Rapidity and timeliness in application*
- *Operational brilliance in execution*
- *Near total control and signature management of the entire operational environment*

Let's take a look at each of these items and their application to the creative industry.

Near total or absolute knowledge and understanding of self, adversary, and environment. You must amaze your clients with your technical knowledge and your understanding of their industry. They must have total confidence that you understand what they are looking to achieve and that you were the right choice to execute on their needs.

Rapidity and timeliness in application. Clients should be dazzled by how rapidly you respond to their inquiries and how quickly the project takes flight. Your timeliness on all matters ensures that your clients are never waiting on you and allows you to stay in control of the project from inception to final product.

Operational brilliance in execution. Every time you send something to a client, an effort should be made to blow them away, to exceed their expectations. You must go above and beyond the call of duty in both design and technical execution.

Near total control and signature management of the entire operational environment. You must have defined and methodical processes. Your organizational skills will put your clients at ease, as they will know that you are in complete control of the project, deliverables, and all milestones.

Shock and Awe should be the goal of every interaction with your client in every phase of the project. Here is a list of Shock and Awe recommendations to use at various points in the project that can help you to begin dazzling your clients.

While working to secure a client or obtain a green light on a potential project

- Send the client a basket of goodies or an unexpected gift.
- Deliver a proposal sooner than expected.
- Take a client to lunch or golfing.
- Hand-deliver a printed and bound proposal (as opposed to an emailed PDF).
- Include some exploratory comps in your proposal.
- Provide a line-item discount reflecting charitable organization, friend, or volume pricing.
- If you work at a larger company, have someone from your upper management send a personal note or email to the prospective client.

- Since a project green light should initiate a rapid succession of events, a quick kickoff meeting or introduction to applicable team members is a great way to get the ball rolling fast.

During the creative phase of a project

- Provide more comps than the client expects. This could include variations on a theme as well as completely new directions. For example, if the client is expecting five logo ideas, send ten.

- If the project is a logo design, put the best logos in an environment (like on the side of a truck or building). Also, with a logo design you could include business card ideas that correspond with the logo to demonstrate how the brand could extend to marketing materials.

- On a print project, include a printed mock-up that is folded to help demonstrate what the finished product will look like.

- When you have a face-to-face meeting, print the comps and mount them on gator board to leave them with the client. You could also bring a simple gift or goodie basket.

- For a website project, where the client has only minor design feedback after the first or second round of comps, you could consider building out some clickable pages to show them when you send the final comps.

At the build-out phase of website projects

- If you have all necessary client assets, build out the entire site to be completely full of their desired content when sending the client the first clickable version.

- Create functioning interactive or video elements prior to the client's expected launch date for those items. Many clients are easily impressed by content that moves; creating interactive and moving elements can help bring the project to life for the client.

- You could add unexpected programming enhancements and features to the site.

When a project is wrapping

- Send in the final invoice under budget. Everyone loves it when something costs less than expected.

- Don't charge the client for extra items they requested and anticipated having to pay for.

- Send the client a gift basket or make another gesture to express your gratitude.

And of course, in every phase of every project you should try to deliver ahead of schedule and exceed expectations through Shock and Awe techniques.

28 ART IS MEANT TO BE FRAMED

Here are a few things I've learned over the years: Whipped cream topping on almost every dessert will make it better. Melted cheese on top of almost any entree will make it better. Putting almost any piece of art in a frame will make it better.

I was waiting in line at a restaurant recently and I examined the photos hanging on the wall. Truthfully, the photos were not very good. I have taken better photos using my iPhone than the ones featured here. However, these photos were showcased in a fancy wooden frame with a large white matte around them. They were behind a shiny piece of clean glass, and the photographer had signed the matte with an elegant script handwriting.

Most people have wandered around an art museum at some point in their lives. I myself have a minor in art history and have certainly been to my fair share of galleries. Truth be told, there is a lot of supposed "art" out there that couldn't even be sold at a garage sale. But if you wrap the same piece of "art" in an ornate frame, place it in a museum with a fancy plaque under it along with some spotlighting above, it could end up selling for millions of dollars.

This begs the question, why does this happen? You've likely heard the phrase "presentation is everything." In graphic design, presentation is critical. You could have designed the most amazing comp of your life, but if you just attach a JPEG version of it to an email and click Send, you are missing an opportunity to have that design fully appreciated by your client. Many, many good designers make this mistake. Steer clear of this error by taking every measure possible to control the display environment when showing your designs for critique.

Face-to-face meetings to present your comps are the easiest. Print your designs. Mount them on black foam core. Design a little sticker plaque with your logo on it and the project name. Attach the sticker to the back of the foam core. Put it in a fancy case and off you go!

Design comps sent via the Internet are a little trickier to fancy up. The first secret is to never, ever email a comp. You have no control over the display when you email a design to a client. Some clients won't even get an emailed attachment due to their server settings. You have to put the comps in an environment you can control. For every project, we create a web page that serves as a means of delivery for our comps (such as clickable proofs for website projects). The menu page is nicely designed with our color scheme, logo, and contact information. Every time we send something to a client for review, we upload it to the server and update a link on the menu page. We then email the client the menu page link and notify them that there are new things for them to review. This is the first step to controlling the environment.

Here are a few other pointers for consideration when presenting your clients with a new look:

- Website comps should be placed in an HTML page with a background. Center them if it is appropriate to the design. Make the background stretch to large monitor widths if that is what the final design intention is. Make the website comp look as "real" as you can; don't just upload a JPEG and send the client a link to the file.

- Because print projects are tougher to send in digital format than their Web counterparts, I recommend sending a PDF and JPEG file whenever possible. As an example, the PDF version of a trifold brochure would be a multipage document of the flat brochure. The PDF version allows the client to zoom in, read the text, and see even the most minute of details up close and personal.

- For the JPEG version of a print project, take the front panel of the brochure as well as an inside panel. Place them juxtaposed on the JPEG with a little shadow under the top one so that it looks like a photograph of the actual brochure. Make sure you design a simple little footer for the bottom of the JPEG that includes your logo, name of the project, and date. The JPEG

version is there to help your client get a feel for what the fin-
ished product will look like. You can't rely on your client to be
able to visualize the finished piece when looking at a flat PDF.
This same principle applies to other print design elements:
business cards, letterhead, annual reports, and much more.

- Be sure to send individual PDFs of your logo comps, with
 each logo on an individual page. This allows the logos to be
 reviewed without competing with one another as they would
 if they were all on the same page.

- Logo projects are fun to "frame." I recommend utilizing your
 fancy Photoshop skills to put the logos in a realistic environ-
 ment. We've taken logo comps and placed them on the side of
 a truck, on a celebrity's t-shirt, on hats, on buildings, and even
 on the sides of buses. I interviewed one designer who had
 created a logo for a hockey team; he superimposed the logo
 onto a photo of the client's ice rink. It looked sweet! The client
 can then truly visualize how the logo will appear in a real
 world situation.

Great companies "get" this. Pay attention the next time you buy an
Apple product. You've likely already noticed that their packaging alone
is a classy and timeless work of art! It makes an already great product
more exciting than the packages waiting under the tree on Christmas
 morning. This serves to illustrate the simple truth that presenta-
tion has everything to do with the end-user experience—if
you want that experience to set your design apart and reel
in your clients with that elusive "wow" factor, then take the
time to get your presentation right the first time.

29 IT IS NEVER TOO LATE FOR A BETTER IDEA

During our first six years, Warner Bros. was one of our most valued repeating clients. We're proud to have them as a client and regularly bend over backwards to satisfy their requests. On one occasion, a few of our designers had some comps ready to send to them for a Web-related project. Toward the end of the day, we gathered in the conference room to review the comps. Tweety Bird was the star of the critique and the overall design was spot on. However, as we reviewed the design in an attempt to assess usability, it was clear that there was an issue with the navigation. I pointed out the issue and presented a solution to the lead designer on the project. I suspect the design change would have taken about 45 minutes to execute. His response:

"Well, I agree that it is a better idea, but it is getting a little late in the day so I think we should just send it."

I couldn't believe my ears. You can't retain Warner Bros. (or any other client for that matter) by giving them second-rate design solutions. If there is a better idea, it absolutely needs to be executed. Time is rarely a viable excuse for bad design. I intervened and mandated that the change be made.

Of course, this type of thinking needs to be balanced against deadlines. Deadlines can't be missed, and there are times when a design compromise has to be made. If that had been the case in this example, the appropriate way to handle the situation would have been a simple message in the delivery email to the client, such as:

"In our final team critique of the design, just before sending it per our predetermined deadline agreement, we came up with an additional navigation solution. We wanted to make sure we hit our deadline, so we sent you what we had at the time of our internal critique. We should have the alternate comp ready for you tomorrow morning. On the new comp the design will largely stay the same, but the navigation

will change. We look forward to your feedback on this and on the extra version that will arrive tomorrow."

This message satisfies the client as well as the deadline. It also satisfies the designer by giving them the extra time necessary to execute the change. Your clients are paying you to provide the best solutions possible; in order to fulfill your full measure of graphic design success, your creativity and expertise must be infused into your projects regardless of the time of day.

Of course, there does come a point in a project when you can't go completely back to the drawing board. For example, when the comp phase of the project is complete and production begins, you should stick with the approved design and work toward the execution of that particular plan.

The point I'm trying to make is that agreed-upon improvements generated in critique meetings should be a priority for execution. You must always strive to produce the best work possible, and welcome suggestions for improvement wherever and whenever they come your way. It is never too late for a better idea. And as with the case of the Tweety Bird issue, that short 45 minutes was all it took to correct something that made all the difference in the world.

30 FILLER FAILURES

As designers, many times we find ourselves having to create designs prior to obtaining all necessary assets from the client. This requires that you use some elements For Placement Only (FPO). Unfortunately, without question, sometime, somewhere in your career some FPO elements will end up in the final product. In a printed design they may actually go to press. In a website, they inevitably will be pushed to the live server. It happens; you are, after all, only human.

I learned this lesson the hard way. About a year into my career, I was waiting on copy for a website I was creating. I was young and frustrated. I need some filler text for the design, so I thought I'd vent a little. I began writing, "Why am I writing this copy? The client hasn't provided me with the assets I need to complete their project. This project is taking forever. I hope that the client will give me assets soon…" Then I copied and pasted it over and over again to fill the space in the design. "Whew," I thought, "that will show them—of course I'll be sure I put in the real copy before uploading the content to the live website."

The next day the phone rang. It was the client. She said, "The design is looking good, but what is this text in there? 'Why am I writing this…'" She began reading the text I was sure she would never see. Then she began to chew me out and tell me how unprofessional this was. All I could do was hang my red face low and agree like a scorned dog. Since that day, I have never made the mistake of using inappropriate FPO content.

I'll spare you the story of when one of my employees pushed some FPO copy that included a swear word live onto one of the high-traffic kid sites we created at Fox. Fortunately, our internal team caught the error immediately and made the correction. I suspect that employee has never made that mistake again, either.

The point is you can never be too cautious when using FPO elements. At some unexpected time, the client will see your placeholder text, guaranteed. Here are some thoughts on how to best avoid an uncomfortable mistake with FPO elements.

Use actual copy. Whenever possible, use actual copy and images. If the client has not provided you with content, take a look at their current materials (either in print or online) and see if you can find some assets to use as FPO elements there. We also recommend taking a stab at creating headline text if the client hasn't provided any. Numerous times our team has come up with headlines and taglines that the client falls in love with and actually uses in the final design.

Use Lorem Ipsum. If you absolutely have no assets from the client, you must use Lorem Ipsum text, the placeholder text used in publishing and graphic design. My favorite place to grab Lorem Ipsum text is www.lipsum.com. Please keep in mind that just because you are pasting in filler text doesn't mean you don't have to design the text. You must check for rivers, widows, orphans, and such, just like you would do with any other typographic design you create. Also, so that it doesn't look exactly the same in every part of the design, be sure to copy and paste different portions of the filler text into your design.

Use appropriate material. When using placeholder images, be sure to choose things that are appropriate for the brand. Recently, I saw an employee at our agency reusing FPO screenshots of cartoon design work we'd previously created for a major university and placing them in a new project. This was a huge no-no because the FPO images, though appropriate for the university, were not appropriate to the new brand they were representing. In other words, FPO images should also be "designed" for each project. Be sure they are cropped properly and adjusted for levels and contrast. Bad FPO image usage can scar a great design and keep a client from recognizing the greatness behind a comp—even if the design is the greatest thing since the invention of the iPhone.

Use a gray box. If you have absolutely no idea what images to use, then use a gray box with a little watermark in it that says "FPO: For Placement Only."

Additionally, be sure to explain to the client that you are using FPO elements. We've actually had clients ask us, "What is all that text in the design? I can't read any of it!" You can never assume that the client knows that they are looking at placeholder elements. A simple explanation in your delivery email usually will suffice. (It may seem like overkill, but I recommend that you even explain what "FPO" means if you have the acronym pasted all over your design.)

Finally, always assume that whatever elements you are designing with will somehow make it to your client's eyes…or even worse, make it into the final "live" design. Choose placeholder elements carefully so that you don't have your own "scorned dog" experience.

CHOOSE PLACEHOLDER ELEMENTS CAREFULLY SO THAT YOU DON'T HAVE YOUR OWN 'SCORNED DOG' EXPERIENCE.

31 A RIVER RUNS THROUGH IT

If I added up the hours spent removing one of the two spaces that people put after periods in their text, I'd find that I have probably frittered away more than a few days of my life. Honestly, I'd like to have that time back, so I'm writing an official complaint to the world.

Period - Space - Space - New Sentence
Perhaps you were taught this way in grade school typing class. It is time for you to abandon this practice. Stop immediately. You are wasting my time.

Period - Space - New Sentence
This is how you do it, regardless of what your typing teacher taught you. You are a graphic designer. Your job is to make the text look nice. Two spaces after a period will cause visual grief almost every time.

As Wikipedia explains, the two letter spaces came from 19th-century typewriter use where the typewriter's monotype spacing was not sufficient to separate words for readability and legibility purposes. To get

around this issue, typists simply added the extra space. It then become commonplace to type those two spaces between all sentences. Generations of 20th-century typists were taught this technique during typing class, a lesson that would prove hard to unlearn as times would change.

Today, where proportional fonts assign proper spacing, that second space in two-letter spacing creates too much space. The issue persists because traditional typists continue the practice of adding two spaces, whether out of habit, of not knowing any better, or from a stubbornness to change.

To complicate matters further, there is even an ongoing debate as to which is correct, double or single spacing, with each side claiming readability and legibility of their supported convention is best. Studies have even produced what are claimed to be inconclusive results as far as each side is concerned.

Truthfully, I am not overly interested in the historical reason that people do Period - Space - Space - New Sentence. In graphic design, visual decisions trump nearly all other decisions. This should be reason enough for a graphic designer. Two spaces after a period makes your text prone to rivers. Two spaces after a period will leave awkward gaps in body copy. Two spaces after a period will create visual issues with ragged copy. Text is a visual element and must be designed along with all the other visual elements in your design. Please discontinue the practice of Period - Space - Space - New Sentence immediately. (See how annoying all those weird gaps are?)

32 COMPS OR COMPREHENSIVE?

There is a rampant misunderstanding in the graphic design industry about what the word *comp* stands for; however, it is likely that every graphic designer understands a *comp* to be essentially a draft version or mock-up of a design.

My own disorganized and random survey results clearly show that most of you who are reading this are under the mistaken assumption

that the word *comp* is a derivative of the word *composition*. While it is easy to see where this confusion comes from, the word *comp* is actually a short version of *comprehensive* or *composite*. Although the word *composition* stems from the same Latin root word as the words *composite* or *comprehensive*, there are small differences in their definitions that can make big differences in your design. And the difference in definition between *composition* and *comprehensive* may explain why there are so many bad *comps* submitted by graphic designers throughout the world.

The word *composition* is defined by dictionaries as an act of arranging parts or elements to form a whole in artistic form.

The word *comprehensive* is defined by dictionaries as a detailed preliminary layout of an advertisement that shows placement of photographs, illustrations, and copy.

When it comes to synonyms, Thesaurus.com reveals that the word *composition* includes synonyms such as structure, layout, design, form, symmetry, and balance, all of which are important words when considering your design.

Synonyms of the word *comprehensive* include all-inclusive, exhaustive, extensive, full, lock stock and barrel, the big picture, the whole shebang, and widespread, words that more closely match the true meaning of *comp*.

Consider for a moment what comes to mind when you hear the *composition* synonym—layout—versus the *comprehensive* synonymous word—extensive. Or consider the *composition* synonym—design—against the *comprehensive* synonymous phrase—the whole shebang. Is it no wonder why so many designers produce unrefined and sloppy *comps*?

Every *comp* that a designer sends to a client should be as polished and finished as humanly possible. Every detail should be considered in an effort to help the client easily envision the finished product.

33 DESIGN LIKE THE WIND

A client of ours called the other day and needed us to make a change to the website we had created for them several years before. Our business development director called the appropriate production team member and asked how long the requested task would take. "Should take about an hour, but I'm slammed for the next six weeks with this other project," was the reply. We were floored. Over the course of six weeks, this team member could not find one spare hour of production time to execute the small change? There are 14,400 minutes in a six-week time period. All that our business development director needed was 60 of them. This response showed that this team member didn't realize that we all waste time throughout the day. The five seconds here and there that are wasted in each of our days really add up over time.

If you save five seconds per minute, then you'll save 300 seconds (or 5 minutes) per hour. That's 200 minutes (or 3.33 hours) per 40-hour workweek, or 173.16 hours (or 7.215 days) per 52-week year, or basically a week-long vacation to the destination of your choice! (Or better yet, if everyone on a twelve-person design team saves those precious seconds and we multiply those seconds by a billable rate of $100 per hour, we just found an extra $207,792 of annual revenue!)

One of the former art directors at our company is ambidextrous. He uses a Wacom Tablet with his left hand, a mouse with his right hand, and places a keyboard in the middle. And boy can he can crank out fast work! Unfortunately, not all of us have the luxury of being ambidextrous, but there are several places where we all can save five seconds (or more) per minute. Here are a few ideas.

Learn keyboard shortcuts. One of our fastest production team members seems to know every keyboard shortcut. He isn't the best designer. He isn't the best programmer. But his speed in executing production tasks makes him one of our most critical team members.

THE FASTER YOU WORK,
THE MORE MONEY YOU MAKE.

Batch tasks. Organize your day to clump related tasks together. For example, you could check your voicemail three times per day instead of every time you receive a call. Depending on your role in the company, perhaps you could check your email in batches as well. Do all your Photoshop work at once and then focus on the programming tasks. Work on only one project at a time. By focusing on one task at a time, you save valuable seconds that are lost in switching tasks.

Reduce clutter. If you have piles of junk on your actual desktop and hundreds of files on your virtual desktop, you are wasting valuable seconds each time you go to locate a file or a piece of artwork. By being organized with tangible as well as digital items, you find things faster, keep your head clearer, and save time.

Take regimented breaks. Get up and take a break. If you are anything like me, the longer I sit and work, the more frazzled my head gets. By getting up and taking a quick break, you can clear your head and be more productive when you sit back down.

If you are really in crunch-time mode, make sure your breaks are regimented. Keep an eye on the clock and instead of taking a 15-minute break, take a 14-minute break…60 seconds found!

Put on headphones. If you are in an open-area work environment, wearing headphones can drown out ambient noise and help you focus on the tasks at hand. Additionally, your team members are less likely to bother you if you have headphones on, whether you are actually listening to music or not.

Skip the water cooler. It is easy to waste time by engaging in everyday office banter. Honestly, every production environment I've worked in (including at my own agency) has idle time of probably 20 percent or more of the day, with team members sharing stories, opinions, viral videos, jokes, and other unproductive wastes of time. I usually don't frown on it, and—in my mind—I typically chalk it up to team building, which is important for creativity. But, if the workload is heavy and deadlines need to be met, it is time to focus; skipping these types of office activities can save much more than five seconds per minute.

Tell people you're slammed. If you're rushing to hit a deadline, make sure everyone knows it. Sending out a friendly message to the team such as, "Just wanted to let you know that I am super busy today trying to hit a deadline. Your assistance in helping me stay focused is appreciated," can help deter your teammates from engaging you in the usual interoffice distractions.

Ask for help. If you're really scrambling to find time to hit your deadlines, ask for help. There is a good chance that some of your teammates aren't as busy as you are, and can find some time and ways to help.

Get an egg timer. I'm not opposed to busting out an egg timer to keep meetings and tasks on schedule. It's amazing how much faster we work when we race against a literal clock.

There are countless books written about time management and productivity. If you are really interested in optimizing your day, head to the local bookstore and grab a few. Some of my favorites are written by author David Allen, including the very popular book *Getting Things Done.*

The graphic design industry is a deadline-oriented business. We all have moments where every second counts, whether it is trying to find 60 minutes in a six-week period, or five minutes at the end of the day in order to hit a deadline. Effective usage of time is the key to success, and if you are a freelancer, time is money. The faster you work, the more money you make.

Finally, it doesn't matter if you are the best designer in the whole world; if it takes you ten times too long to get your work done, it will be difficult for you to succeed in the deadline-driven and fast-paced graphic design industry. Optimizing your production speed is critical to becoming the best all-around designer you can be.

TYPE FAST

I have interviewed hundreds of people throughout my career. One of the questions I like to ask a potential production employee (designer or programmer) is, "How fast a typist are you?" Typing speed is typically an accurate gauge of production speed. The faster someone types, the faster they work. This is true of almost every production artist I have seen throughout my career.

If someone cares about becoming a fast typist and has obviously worked toward that goal, they likely have worked to become fast at other things. They likely use a lot of keyboard shortcuts. They likely have strategies that optimize their time. They likely will produce quality work at a higher rate than the guy sitting next to them. Time is money in graphic design; finding people who work quickly and accurately is critical to running a profitable organization.

35 HOW TO EAT AN ELEPHANT

While there may be many ways to skin a cat, there is really only one way to eat an elephant: one bite at a time.

When our agency green lit a kid's project to create an interactive world with games and activities for one of Pepsi's highly recognized brands, we were excited. The only challenge we foresaw was the timeline. This was a giant project with a six-figure budget, and they wanted it to be completed in eight short weeks.

The task ahead of us was to create an interactive universe and three distinct worlds (one for each flavor of the product line). Each of the three worlds was to include custom animations, a unique game, a trivia quiz, and four custom-illustrated coloring book pages. To top it off, we would need to create an interactive section for parents that provided information about the product and nutritional facts.

With a universe, three worlds, three unique games, three interactive trivia quizzes, and twelve custom-illustrated coloring book pages, plus a full-blown product section to create in just two months, we knew that a wishy-washy approach to execution was not going to enable us to eat this elephant. We had to get detailed and organized on this project or else we knew it would blow up in our face on day 55.

Select the team. The first thing we did was determine the people we would need on the project. We chose a team of seven people to dedicate from our company: myself as project manager, an art director, a designer, a programmer, an illustrator/animator, a production artist, plus someone to manage the client throughout the process. We also utilized our office manager for odds and ends support, writing some of the copy, research, and quality assurance.

Break down the elephant into bite-sized pieces. We gathered the chosen team, cleaned off the conference room's dry erase board, and began to brainstorm the creation of a comprehensive list of what

exactly needed to be completed for the project. We were not content with broad stroke ideas like "Design World 1." We broke down tasks such as that into minute detail.

World 1

❏ Create wireframes of World 1 for client approval

❏ Modify client assets to be usable for comps

❏ Design the landing screen

❏ Create storyboard animations

❏ Design icons to direct the user to the three activities

❏ Create rough animations for client approval

❏ Create final animations

❏ Create gray box programming of World 1 screen

❏ Integrate approved design assets into gray box version of the game

❏ Create sound effects library for World 1

❏ Integrate sound effects and final animations

❏ Link activity icons to the finished activities and games

❏ Perform testing and quality assurance

To further illustrate the point, each game carried its own set of tasks to be completed. It is not sufficient to simply task someone to "Design Game 1."

Game 1

❏ Create wireframes of Game 1 for client approval

❏ Design title screen

❏ Design game play screen

❏ Design win/lose screens

❏ Create illustration and animation of characters and elements for the game

❏ Write copy for each of the game screens

❏ Create gray box programming of game play

WHILE THERE MAY BE MANY WAYS TO SKIN A CAT, THERE IS REALLY ONLY ONE WAY TO EAT AN ELEPHANT: ONE BITE AT A TIME.

❏ Integrate approved design assets into a gray box version of the game

❏ Create sound effects library for Game 1

❏ Integrate sound effects and final animations

❏ Perform testing and quality assurance

After we created similar lists for all remaining project elements, we began asking for volunteers and assigning people to the tasks.

Share the burden. As volunteers came forward and assignments were made, we wrote their names down beside each of the line items. Each person clearly understood that if their name was listed beside an item, they were the person who held full responsibility for executing that task. In order to succeed on the project as a whole, each person would need to successfully complete their specific tasks.

❏ Create storyboard animations (Alan)

❏ Design title screen (Janet)

❏ Write copy for each of the game screens (Rachel)

By breaking down the tasks into small pieces, we were able to share the burden of the project across our seven dedicated people, and we were able to get several people involved who were not specifically on the project. As I said, our office manager did much of the research and copy preparation. And, although there was no PHP programming on this project, one of our PHP programmers volunteered and oversaw the testing and quality assurance aspects of the project. The more you break down the project into bite-sized pieces, the easier it is to identify ways for people to help.

Feel the pressure now. The amount of pressure you feel on any project should be directly proportional to the size of the project: the bigger the project, the bigger the pressure. (And surprisingly, the size of the broken-down tasks should be inversely proportional to the size of the project: the bigger the project, the smaller the tasks.)

It is imperative for large projects to fight against human nature's procrastination tendencies. To create adequate pressure, it is advised that each of the broken-down tasks be assigned a specific milestone.

❑ Design title screen (Due February 3)

❑ Design game play screen (Due February 4)

These milestones should be clearly understood and reviewed regularly by the assigned production team. The further you can get ahead of schedule, the better.

It takes a long time to eat an elephant, and there is a lot of digestion involved. You can't just eat the whole thing on the last day and expect to fit it all into your stomach. You have to create a plan, eat some of the elephant, digest it, and eat some more.

36 THE VENUS INITIATIVE

When our agency was relatively new and growing, we felt it necessary to assess potential areas of improvement and further growth; we did this by analyzing the core components that we felt determined our success as a design company. These areas were profitability, client satisfaction, and quality of work. During these early years of our company, we were operating at over 50 percent profitability, and we had a constant stream of praise and unsolicited referrals coming from our clients. But we had never been published in a national magazine such as *Communication Arts*, and we had not felt ready to submit many designs for award consideration, either. While our work was certainly "good," we wanted it to be "great," and we determined that the area of "quality of work" was the element that most needed our attention moving forward.

Our best designers got together to figure out some systems to better enable us to achieve high-quality design and maximize collaboration. We created a process that we endearingly titled "The Venus Initiative," appropriately named after the Roman goddess of beauty and love.

Over time, this process has become more organic in our organization, and these elements happen without the formality of structured meetings. However, the principles we put in place years ago are still key to effectively arriving at high-quality work and can be implemented in your process as well, in whatever manner works the best for your organization. Here is our quality of work improvement process from start of a project to near delivery to the client.

1. Art Director Kickoff

Who Attends: Assigned design team and art director (sometimes business development team members who brought in the project are involved, as well)

Summary: After a project is kicked off within the organization, the art director will meet with the assigned design team to discuss the general details of the project.

Objective: Ensure that the design team has all of the information for the project. This includes:

- Client objectives
- Client's design style (direction)
- Details about what the project entails
- Target audience
- Understanding of what assets are available for use
- Understanding of what content should be included on each element of the project
- Understanding of the timeline
- Understanding of the budget (how much production hours can be spent)

Deliverable: An assigned attendee should take notes and distribute the information to the other attendees for reference throughout the course of the project.

2. Define the Barometers

Who Attends: Assigned design team

Summary: Prior to the meeting, the assigned design team will perform research to find projects similar to the assigned project. The research should include websites, design magazines, design books, and any other appropriate source. Each team member brings their proposed example designs to the meeting for discussion with the group.

Objective: Establish a set of example designs to serve as inspiration to push our designs to match in quality. The example designs are referred to as barometers, and these designs are used as reference points throughout the development process. Please note that the barometers are not copied, but merely used as a benchmark for quality to determine a level of polish in the finished design piece.

Deliverable: The barometers should include at least one but as many as five comparable projects/designs from the researched sources. These designs are added to a project folder or digital production tool depending on the agency's internal production management systems.

3. Thumbs Up Meeting

Who Attends: Assigned design team and art director

Summary: This is the meeting where a lot of conversation and brainstorming should occur. The assigned design team will brainstorm design concepts and create thumbnail sketches for internal review. The thumbnails will include concept ideas and layout/grid ideas. The thumbnails will be discussed in a Thumbs Up meeting that includes the art director and assigned design team. The pros and cons for each thumbnail are then analyzed for each sketch that is presented.

Objective: Determine the concepts and layout or grid to be implemented into the first comps.

Deliverable: The assigned design team should have at least twice as many thumbnails as expected at first comps (that is, if three first comps are expected to be submitted to the client, the assigned design team should present at least six thumbnail sketch ideas). As a group, the assigned team will collaborate with the art director to decide on which thumbnails are to be developed into the first round of comps.

4. Battle of the Bands

Who Attends: Assigned design team and other individuals not assigned to the project

Summary: Designers and nondesigners meet to review and discuss the comps prior to submission for internal approval. This should be a full-blown school-style critique where questions are asked and answers are given (think back to your college days, minus the frat parties, cute coeds, and ping-pong wars as distractions). The designs should be heavily scrutinized and pushed so as to achieve maximum quality. The phrase, "that looks good to me," should rarely be used in this phase of critiquing; the focus should be on "what if" questions. What if we did this for this piece of the design? What if you did something like this site…? The tone from all participants should be, how can we make this better? And it shouldn't matter how good the original submissions may be; think like there should always be room for improvement.

Objective: Scrutinize the designs and develop a detailed list of improvements to be made.

Deliverable: Assigned design team takes critique feedback and revises comps accordingly in preparation for the "Wow Meeting."

5. Wow Meeting

Who Attends: Assigned design team, art director, and other company management team members depending on the structure of the organization

Summary: The assigned design team presents their first comps for internal approval. This meeting should occur at least one day prior to the scheduled delivery to the client so that any final internal changes can be implemented.

Objective: Gain internal approval/feedback prior to the submission to the client. Based on the processes implemented prior to this meeting, the assigned design team should have a level of polish to the work that makes the approval team members say, "Wow," rather than this meeting becoming another all-out critique of the comps.

Deliverable: Internal approval with occasional final changes requested from management.

It is surprising how unstructured many design organizations are. In graphic design and art schools, the classrooms are often filled with gray walls and designs are regularly posted for classroom-sized critiques. But in most of the companies I've worked at (including my own), this step is omitted in an effort to race through production and hit the deadlines. In these cases, the quality of work suffers. Parts (or all) of The Venus Initiative can be assimilated easily into a design organization in a streamlined fashion, enabling considerable improvement in work quality to be achieved practically overnight.

37 PROCESS-A-PALOOZA

The transition from freelancer to agency owner was filled with adjustments. It seemed like we were scaling a mountain and had to continually change our tactics to keep progressing. When I first started hiring employees at my agency, we changed the production process every couple of weeks (much to the lament of my team). We were growing so fast that it seemed with every new employee we needed to tweak the process to allow things to keep working and to find the system that offered the most benefit to the particular team and project; what worked for a team of three with ten projects didn't necessarily work for a team of five with twenty projects.

To implement an optimal system, one of the things we found to be important is to have a defined process of tracking and executing on projects. Here are a few project management process ideas to track and execute that I've used at various phases of my career.

Process 1: To-Do Lists

Nothing revolutionary here, and it worked well as an independent freelancer, too. Get out a piece of paper. List the things you need to do and cross them off when they are complete. (There is no shortage of digital "To-Do List" applications if you choose to go that route.)

When to Use: This system is easy to implement and works well if you are a one-person show managing just a few projects.

Process 2: Inbox

Once I started working out of my email Inbox years ago, I haven't stopped. Simply email yourself tasks that you need to complete. Once a task is finished, file or delete the email. It is an easy way to track your tasks. Most of us keep regular tabs on our email, which inevitably helps you track the things you need to do.

When to Use: This system is best for an independent freelancer with a small quantity of projects, but, as I have demonstrated in my own life, it is an excellent tool for large businesses and executives as well.

Process 3: Dry Erase Board

During the dot-com era of the late nineties, I was creative director over a small team creating one of the first interactive kid worlds on the Web. The CEO of the company would call me every morning at about 7:30 A.M. and I'd walk him through the site and the things we launched the day before. The Internet industry was going crazy at the time and we were in a race to get to market fast. We had lofty goals of launching large amounts of new content each day. Our process was simple: We listed all of the things we had to create and complete on a dry erase board; when a team member completed one item on the list, they would go to the board, cross it off, and write their name beside the next item they were going to tackle. Everyone loved the system because it was simple and allowed for some freedom inside the design team to decide which items they wanted to take on.

When to Use: This is a simple and scalable process that works best when there are many team members of a similar skill set working on one large project together.

Process 4: Job Folders

The first little design shop I worked at used this system, and I replicated it during a few brief stints of my career at other companies. Each project gets a folder (anything from manila envelopes to clear plastic job jackets can work). Each folder contains a piece of paper detailing the project scope. The job folders represent responsibility. The team member who holds the folder bears the responsibility to oversee and execute on the project. As the project progresses through a development team, the job folder passes from team member to team member to execute on their respective pieces.

When to Use: A process like this works well in a print-heavy design environment. The job folders allow for easy archiving of proofs of the printed work and it is easy to document the project scope on paper, since scope changes are not as prevalent in print as they are in interactive projects. However, this type of process can work successfully in production environments that have interactive media projects as well.

Process 5: The Furnace

I love this process because my mind naturally works this way. I've used it in several phases of my career to manage a production team and large quantities of projects. You need a large dry erase board (or something similar). Divide the board into columns (most office supply stores carry thin black tape for this type of thing). You'll need one column for each of the phases your projects pass through. The following phases are pretty consistent with the majority of production environments I have seen throughout my career:

- Estimate
- Awaiting the Green Light
- Concepting
- 1st Comps
- Awaiting Feedback
- 2nd Comps
- Awaiting Feedback
- Final Comps

- Awaiting Approval
- 1st Build
- Awaiting Feedback
- 2nd Build
- Awaiting Feedback
- Final Build
- Awaiting Approval
- Launch/Deliver

Now create a "project card" equal to the width of each column for each of your projects (perhaps it is a 3" x 5", or you could use Post-it notes or something similar). Then simply put each project into the column that corresponds with the phase it is in. Your goal is to move each project card through each phase until the project is completed.

When to Use: The Furnace process is a great way to get a global view of working projects. It also provides an easy way to run a production meeting as you discuss each project with the team, asking, "What needs to happen to move this project to the next column?"

Process 6: Digital Systems

Digital project management tools are commonly used and work miracles in helping creative teams collaborate on projects. We successfully execute on projects in collaboration with people all over the world by utilizing digital project management tools.

Our agency uses Basecamp® (www.basecamphq.com), but there are many other options available, each with its pros and cons. If you are interested in utilizing a digital tool to manage your projects, do your research and pick the one that seems right for you.

When to Use: Digital project management tools are best for companies with larger teams managing numerous projects. Digital systems often scale easily to handle 10 to 100 simultaneously running projects. Most of them come with a monthly fee, so they are best used if you are with a company or working full-time as a freelancer where the consistency of your workflow makes it worth spending the money each month.

38 HIKING YOUR WAY TO SUCCESSFUL PROJECTS

My oldest son is in Boy Scouts. It seems there is never a shortage of campouts scheduled for these young men. Each campout is organized with some sort of hike involved, and in an effort to be a good father I attend all of them with him. He loves it. I, on the other hand, love being with him…and therefore suffer through the hard ground and sleepless nights that sleeping outdoors has to offer. When it comes to camping, I feel like I have served my sentence. You see, I grew up camping and hiking with four brothers and no sisters. It wasn't until I was an adult that I realized the reasons my parents took us hiking and camping on EVERY vacation. First, it didn't matter too much when their rambunctious boys broke things in a forest. And second, if they hiked us around all day we might actually fall asleep at night.

In hiking there are a few formulas to help you successfully reach your destination. I have some experience with many of them. It wasn't until recently that I realized the correlation between hiking strategies and production environments. Let's analyze the correlation between three types of hikes and their corresponding production environment. The goal of each is to arrive successfully at the destination. In hiking, the destination is obviously a location. In a graphic design production environment, the destination is a successful project (one that is completed on time and that delivers above and beyond the client's expectations in all aspects of the job).

Category #1: It's over there…
Many of the hikes I've been on fall into this category. A park ranger or someone "knowledgeable" points into the forest and says, "The destination is that way." The hiking party ventures off into the forest in the general direction they signaled in hopes of finding the location. Oftentimes, they will arrive at the destination, likely after a few wrong

turns and backtracks. Sometimes, they will get totally lost and find their way back to where they started. And, unfortunately, other times the hikers end up lost in the forest for good.

Most production environments operate this way—kind of "willy-nilly." In an effort to arrive at the destination of a successful project, the business owner or salesperson will turn over the project to a production team and say, "It's over there…good luck!" The production team will then scramble through the project, hoping to blindly feel their way to success. A designer may head in the wrong direction for a time…perhaps their boss or client will get them back on track. There may even be some missed deadlines. Frequently this type of production style leads to frustration for both the production team and the client, and far too many design teams operate like this on a daily basis.

Category #2: The guided tour…

Hikes with an experienced guide can be great fun. You pack your stuff and then mindlessly follow behind the guide as they make all your decisions for you. The guide knows exactly where the destination is, and all you have to worry about is turning, climbing, and descending when and where they say. Many times they even hook up ropes for you and tell you exactly where to place your foot.

These types of production environments can operate very success-
fully. All you need is one superstar who knows how to arrive at a
successful project every time, with every client. Usually that person
is in an art director or creative director role. They wander around the
office calling the shots for every project. I've been this person in several
production environments. It may sound like bliss for the designers in
the world who don't want to have to make tough decisions, but the
reality is that it is frustrating to everyone. The design team gets sick
of being told what to do all the time. The superstar creative director
starts wondering why nobody can think for themselves. And watch
out if that superstar ever gets sick or takes a vacation. The whole
company could fall to pieces! To top it all off, this is not a scalable
strategy. If your company begins to grow, eventually there will be a
limit to the number of projects and people your superstar employee
can manage effectively.

Category #3: The detailed map…
The best chance for a successful hike is having a detailed map, created
by someone who knows the area and that is used by people who know
how to read it. Imagine a map for a blazed trail with documented mile
markers and signs pointing the right direction at every split in the
path. These types of maps often contain invaluable advice about pitfalls
to watch for, how much water to carry, and how long it takes to traverse
each part of the trail. It doesn't take a rocket scientist to find the way
to a destination with these tools. In fact, millions of direction-challenged
people find their way to amazing destinations every year using these
detailed maps.

Documented processes, created by someone who knows what they
are doing, are the safest way to operate a successful production envi-
ronment. I'm not talking about a simple process—green light the
project, make website, bill client, repeat. Many companies operate
with things like this in place and "think" they have a production
process. I'm talking about a very detailed and organized flow for each
type of project you do. Only by digging into the nitty-gritty details of
what exactly needs to be done can you be assured that you, or other
people in your production environment, will not forget to act on
important pieces of the project. At our agency we have a set list of

To-Do items that correspond with each project. When a client green lights a project, we attach the appropriate To-Do list to the project and then turn it over to the production team. The detailed To-Do list style production process thus becomes our roadmap to success.

Here is our agency's standard To-Do list for our projects, our "detailed map" to reach our destination. This task list is always changing based on the lessons we learn from each project. It begins with the start of the project and continues until it's complete and archived.

Project Start

❏ {Client} Agency receives lead on a project (via website form, phone call, referral, networking event, etc.).

❏ {Agency} Qualifies the lead by talking with the client to verify the legitimacy of the request.

❏ {Agency} If the request is legitimate, the project is added to Basecamp with Agency as the client (in a Message add name, email, phone numbers, and brief project info). This way the project will be fed into the production management tool for tracking.

Proposal

❏ {Agency, Client} Discovery call, meeting, or email.

❏ {Agency} Internal concept brainstorm and scope. (Request hours, format, strategy from production team, and compare hours and pricing against Profitability Matrix spreadsheet. Also, compare estimated pricing against *The Graphic Artists Guild Handbook* for fair market value.)

❏ {Agency} Prepare formal proposal using the proposal template and drawing upon proposal project pieces archive. (Confirm hours with production team and project price with senior management.)

❏ {Agency} Internal proposal proof.

❏ {Agency} Send formal proposal to client. (Be sure to Cc appropriate senior management and office manager with a fresh email and the approved subject line—Proposal, Project Name.)

Awaiting Green Light

❏ {Agency} Acquire confirmation of receipt of proposal from the client.

❏ {Client} Green lights, requests modifications, or rejects the proposal.

❏ {Agency} If modifications to the proposal are requested, the project is sent back to the Proposal phase and follows appropriate tasks.

❏ {Agency} If the proposal is rejected, the project is archived and Agency asks the client, in person or otherwise, why the project was not awarded to Agency.

❏ {Agency} If the project is green lit by the client, Agency follows up with appropriate formal documentation. (Could be: SOW, PO, Proposal Acceptance Fax, Email Confirmation, Credit Processing, and so on, depending on the client relationship.)

Kickoff

❏ {Agency} Project green light announcement. (Notification sent to the entire Agency team celebrating the green-light news. Can be via email, company announcement, or party depending on the scale of the green light.)

❏ {Agency} Project lead assigned.

❏ {Agency} Sales or management sends Green Light Email to the client and Cc's project lead, office manager, and appropriate management. (Green Light Email serves as the official transfer of the project responsibility from sales to production.)

❏ {Agency} Project lead replies to Green Light Email with a Kickoff Meeting Request Email.

❏ {Agency} Office manager replies to Green Light Email with an Accounting Information Email.

❏ {Agency} Office manager adds project to accounting docs (QuickBooks, What Are We Going to Bill spreadsheet, Proposals Sent spreadsheet, Commission Tracking spreadsheet, updates Numbers Board.)

❑ {Agency} Create project in Basecamp. (Be sure to attach company and client to the project under People and Permissions tab as well as indication of the project lead in title.)

❑ {Agency} Add hours from the Profitability Matrix Spreadsheet (PMS) to Basecamp. (Be sure that you add the hours as a negative number.)

❑ {Agency} Add Milestones to Basecamp. (Milestone format is Client Name: Project Name | Milestone.)

❑ {Agency} Attach standard To-Do template to each milestone.

❑ {Agency} Customize To-Do template for the specific project. (Add and subtract To-Do items, attach dates to To-Do items, assign specific tasks to specific people as applicable.)

❑ {Agency} Create an account in Basecamp for the client. (Include Basecamp Instructions Message in the personal note section.)

❑ {Agency} Create Project Kickoff Message in production management tool.

❑ {Agency} Send initial invoice to client.

❑ {Client} Payment received for initial invoice.

Concepting

❑ {Agency} Prefill Kickoff Meeting Agenda with all known information and send to client for preparation for upcoming Kickoff Meeting.

❑ {Agency, Client} Kickoff Meeting.

❑ {Agency} Send Kickoff Meeting Agenda with completed information from the Kickoff Meeting within four business hours.

❑ {Agency} Receive client confirmation on Kickoff Meeting Agenda Notes.

❑ {Agency} Create Concept Document. (Includes Kickoff Meeting Agenda Notes, Site Map, Wireframes, Technical Strategy.)

❑ {Agency} Concept Document internal review and critique.

❑ {Agency} Send Concept Document to client.

❑ {Agency} Receive client confirmation on Concept Document.

1st Comps Design

❏ {Agency} 1st Comps design. (Quantity of comp designs should correspond with the scope of the project—typically, two to three comp designs for websites are provided at this stage. An effort to provide variety should be the focus—grids, navigational styles, etc. Logos typically include six to ten initial design ideas. Print projects typically include two to three comp designs.)

❏ {Agency} 1st Comps internal review and critique.

❏ {Agency} 1st Comps Delivery Email sent to client. (Website comps should be delivered as JPEGs that are embedded in an HTML page with a tiling background. Logo comps should be delivered as a PDF document with the first page displaying a grid of all the logo options along with the subsequent pages including each logo option on its own page. Print projects should be shown as PDF and a mock-up that makes the printed elements appear as if they are on a solid surface—juxtaposed and shadowed.)

❏ {Client} Provides 1st Comps feedback.

2nd Comps Design

❏ {Agency} 2nd Comps design. (These are revisions to one home page comp direction based on client feedback and creation of one to two subpage comps.)

❏ {Agency} 2nd Comps internal review and critique. (The critique should include a review of the client-requested revisions so that internal confirmation that the requests have been satisfied can be made.)

❏ {Agency} 2nd Comps Delivery Email sent to client. (Only the new designs are delivered at this time. Website comps should be delivered as JPEGs that are embedded in an HTML page with a tiling background. Logo comps should be delivered as a PDF document with the first page displaying a grid of all the logo options along with the subsequent pages including each logo option on its own page. Print projects should be shown as PDF and a mock-up that makes the printed elements appear as if they are on a solid surface—juxtaposed and shadowed.)

❏ {Client} Provides 2nd Comps feedback.

Final Comps Design

❏ {Agency} Final Comps design. (Visual revisions to the 2nd Comps. Creation of one final home page comp design and one to two subpage comps based on client feedback.)

❏ {Agency} Final Comps internal review and critique. (Critique should include a review of the client-requested revisions so internal confirmation that the requests have been satisfied can be made.)

❏ {Agency} Final Comps Delivery Email sent to client. (Only new designs are sent at this time. Website comps should be delivered as JPEGs that are embedded in an HTML page with a tiling background. Logo comps should be delivered as a PDF document with the first page displaying a grid of all the logo options along with the subsequent pages including each logo option on its own page. Print projects should be shown as PDF and a mock-up that makes the printed elements appear as if they are on a solid surface—juxtaposed and shadowed.)

❏ {Client} Provide Final Comps approval. (Minor design requests may be made by the client. Minor requests should be addressed in the First Build phase. Any major design changes requested should be escalated to management for awareness and an additional round of comps should be sent to the client using the 2nd Comps Task List.)

1st Build

❏ {Agency} Secure credit card information for hosting.

❏ {Agency} Provision and prepare server software.

❏ {Agency} Register or transfer domain names to server.

❏ {Agency} Send Email Address Request Email and create email accounts for client.

❏ {Agency} Send Asset Request Email (copy, images, etc.).

❏ {Client} Deliver assets for site (copy, images, etc.).

❏ {Agency} Send SEO Information Request Email.

❏ {Client} Respond to SEO Information Request Email.

❏ {Agency} Build the 1st Build. (Create all site pages. Some pages may not contain final content depending on assets available and timeline, but all pages will be clickable. This is not a broken website!)

❏ {Agency} 1st Build internal review and critique. (Be sure to compare built pages to the approved comps to ensure that the design has been maintained.)

❏ {Agency} 1st Build Delivery Email sent to client.

❏ {Client} 1st Build feedback.

2nd Build

❏ {Agency} Build the 2nd Build. (Make build-out adjustments based on client feedback, integrate all client content and images, add polish to built pages, Flash elements, etc.)

❏ {Agency} 2nd Build internal review and critique.

❏ {Agency} Incorporate SEO information into site.

❏ {Agency} Install Google Analytics.

❏ {Agency} 2nd Build Delivery Email sent to client.

❏ {Client} 2nd Build feedback.

Final Build

❏ {Agency} Build the Final Build. (Ensure that all aspects of the site are functioning properly and that all client 2nd Build changes are made.)

❏ {Agency} Hackathon. (Must be completed by two people utilizing Hackathon Checklist.)

❏ {Agency} Final Build Delivery Email sent to client.

❏ {Client} Final Build approval.

❏ {Agency} Conduct Client Training Meeting. (Use Client Training Meeting Agenda.)

❏ {Agency} Send Launch Packet to client.

❏ {Agency} Launch site.

❏ {Agency} Final live verification click through. (At least two people must verify.)

❏ {Agency} Send the Launch Notification and the Source File Delivery Email.

Post Mortem

❏ {Agency} Wait two to three days to ensure that all deliveries were accepted by the client, and then send Project Complete Message from Basecamp.

❏ {Agency} Internal discussion regarding the project utilizing the Postmortem Agenda.

Closeout

❏ {Agency} Archive the project in Basecamp.

❏ {Agency} Archive and backup the source files.

❏ {Agency} Send final invoice for the project.

❏ {Agency} Project Wrap Phone Call with client. (Utilize the Project Wrap Phone Call Agenda.)

❏ {Agency} Update financial spreadsheets and so on.

❏ {Agency} Receive final payment.

Not every project is exactly the same. Not every client has the same production style. At our company we sometimes do only the programming tasks of a website and therefore need to remove all of the To-Do items that correspond with design. It is important to trim or expand the To-Do list to be appropriate for each specific project.

By utilizing documented and detailed processes in your business, there is no wandering aimlessly in the forest heading in the general direction of the destination. There is no need for a superstar to run around the office telling everyone what to do every step of the way. The To-Do list process serves as a near-perfect map to help everyone arrive at the destination of a successful project.

Having a detailed production process has the added benefit of allowing new employees to operate like veterans almost from day one. Detailed To-Do list style production processes are a great contributor to success in any graphic design production environment. Determine the types of projects you usually work on and then create your own detailed list of successful tasks for each of those project types.

39 SOLVING END-OF-DAY RUSH

When I started my design agency, the first few people I hired were junior employees. Admittedly, I was afraid of the burden of a higher-paid employee and took financial comfort in a low-cost solution. As we began to grow as a business, our employees grew in their skills as well. They had earned the opportunity for promotion as we began hiring more junior employees. Now we had junior employees managing junior employees. What we quickly realized was that these new managers were staying late and struggling to complete their work on time. The end of the day became a mad scramble. The junior employees would often be twiddling their thumbs while the junior managers were pulling their hair out trying to wrap up the projects for the day.

Ultimately, we found ourselves in the midst of a delegation issue. The junior managers had just barely figured out how to manage their own projects and now were in a position where they had to help others manage their workload, too. We issued a document and gave our junior managers some training to help alleviate this problem.

The document was called "Management Strategies to Alleviate End-of-Day Rush" and it was founded on the principle that a manager should do what only they can do and then delegate the rest. As a manager, you must clearly define your role and delegate nearly all other elements to keep all the cogs turning smoothly. The following are a few tasks that can typically be delegated to a junior member of the team to help alleviate stress at the end of a workday.

Prewrite delivery emails. Have a production team member write your emails and then send you the copy early in the day. We recommend that you have standard formulas for most email types, as it is always easier to adjust existing copy than to write it from scratch. By writing these emails early, it is easier to be detailed and organized. If you wait till the end of day they usually come out rushed. Also, it is a great way to create a "task" list for yourself and feel the accomplishment of completing a task by being able to complete the email later

in the day with the final links. It is very important that you don't fill in the "To" and "Cc" email addresses until just before you send the email (usually toward the end of the day) just in case you accidentally click Send.

Create lightboxes. If you need stock photos for a project, get one of your production team members to create the lightbox for you. They could even email you a link to the lightbox. You can select the photos you want and have the production team member download them and place them on the server for you.

Download client assets or upload files. Have a junior team member download files from the FTP sites or upload project files for delivery. This is a time-consuming process that can be easily performed without manager assistance.

Perform the collection and verification of assets. Delegate these processes that include consolidating things on the server, creating "clean" versions of assets (such as merging key art layers, cloning and extending backgrounds, and so on), and reducing assets to the proper dpi (if projects are Web/interactive based). You could also delegate the task of collecting and organizing client copy.

Start a new project the day before it is slated to begin, if not earlier. Have someone on the team do this step even if this means simply getting the Photoshop document open, piling assets into it, and then closing it until the project launch date; this can have a huge effect on reducing stress levels.

While it may not apply to delegation, setting a personal deadline for yourself to complete your daily tasks earlier than the end of day helps alleviate end-of-day stresses. Push for 4:00 P.M. instead of viewing 6:00 P.M. as your timeline for completion. Then you can spend from 4:00 P.M. to 6:00 P.M. working on projects that are due the next day to help you get ahead of the oncoming train.

The real trick to reducing workday stress is to delegate, delegate, delegate. By spreading the production tasks across a team, everyone can complete their daily work on time and with minimal stress.

40 ■ WHY PROJECTS BLOW UP

Every year we have a project or two that blows up in our faces. The client freaks out. Our team gets fed up. The budget quickly gets way too small and the scope becomes way too big. Sure, the client's obvious lack of understanding and integrity usually has something to do with it, but I'm not a big fan of pointing fingers. I always look at myself first, asking, what could I have done to mitigate this disaster? Without exception the answer comes back: Don't skip the details at the start. Every disaster project for every disaster client in my entire professional career could have been alleviated by doing a better job of breaking down the details at the start of the project. Skip this step, and you will be headed for trouble.

A designer often wants to jump right in and start doing the fun part: the artwork. "Who cares about the exact specifications! We'll figure that out later." This mindset has caused me more grief in my career than any other behavioral disorder I have. "Design" is not the first step to a project. A careful, organized, detail-gathering phase is always step one.

Oftentimes, in an effort to achieve a quick green light, our proposals are too general. For instance, a client approaches you about creating a brochure. You write up your proposal and happily send it to the client with a line and price that clearly states that you will "Create a corporate brochure to promote Client X's company." In order to land the project, sometimes you may have to be a bit vague in your proposal, which is fine. Just don't start designing the brochure until you get a fully detailed scope of work agreed upon with the client.

"Create a corporate brochure to promote Client X's company" must be broken down to include details like these:

- Trifold brochure
- 8.5" x 14"
- Six panels

EVERY DISASTER PROJECT
FOR EVERY DISASTER CLIENT
IN MY ENTIRE
PROFESSIONAL CAREER
COULD HAVE BEEN
ALLEVIATED
BY DOING A BETTER JOB OF
BREAKING DOWN THE DETAILS
AT THE START OF THE PROJECT.

- 4/4 color printing (full color on both sides)
- No stock photo purchases (client will provide photos)
- No copywriting (client will provide copy)
- No printing (client will pay for printing directly to the printer)

This type of simple detail will ensure that you have some ammunition to push back to the client when they tell you things like, "I thought stock photos were included in your price," and "I actually was thinking the brochure would be bigger and have 12 panels." Without detailing out the specifics of the brochure, you are left only with your interpretation versus their interpretation of what the project is—in this situation, the client will always win because they hold your paycheck in their hands.

This same strategy applies to all types of graphic design projects, from logos to brochures and signage to websites. Every project needs to be clearly defined at the start to safely mitigate the chance of an explosion at some point in the future.

Be sure to define these items whenever appropriate:

- Sizes
- Concept
- Features
- Functionality
- Wireframes
- Site maps
- What is included
- What is not included
- How many rounds of changes
- How long the project will take

Skipping these details can spell disaster. It's all about using great detail to get on the same page as the client, and then managing their expectations throughout the course of the project.

41 THE LO-FI PDA

I will preface this chapter by saying I am a HUGE technology fan. I've owned every version of the iPod. I could write "graffiti" on my Palm with the best of them. I overcame an addiction to the Blackberry scroll wheel only to replace it with a finger-swipe addiction to my iPhone. Suffice it to say, if it is made out of aluminum and has an Apple logo on it, I already own it or I am going to own it soon. In my digestion of all this technology over the years I've learned a valuable lesson: There are some things that are just better on paper.

At our company, everyone is issued a "Lo-Fi PDA" to go along with their state-of-the-art, hi-fi smart phone. The Lo-Fi PDA is nothing more than a fancy name for a notebook. We are big fans of the Moleskine® Legendary notebooks (www.moleskine.com). Having a Lo-Fi PDA and a pen handy everywhere you go empowers you in the following ways.

Emptying your psychic RAM. David Allen, a renowned productivity expert, discusses "psychic RAM" in his 2000 book *Ready for Anything*. Your mind, like a computer, has RAM, and as you go about your day your RAM fills up with information. As your brain tries to store and organize all of this information, it can get overloaded—much like opening too many windows and applications can bog down your computer RAM.

"Something will 'bug' you until you've clarified your intention about it, decided how to move on it, and put reminders of the outcome and action in places your mind trusts that you'll see as often as you need to and at the right time.

The solution is simple. Write it down. Look at it. Do it or say to yourself, 'Not now.' And trust that you'll see the option again whenever you need to reassess. Give it to a system superior to your mind, so your mental energy can move on to its bigger and better work."

—Ready for Anything, *2003, 26–27*

For me, the "system" he recommends is my Lo-Fi PDA. I almost always have it with me, usually even by my bed. I can't count the number of times I've woken up in the wee hours of the morning, careful not to wake my wife, and written down things that were stirring in my "psychic RAM." I quickly write down my important thoughts or the task I don't want to forget, and because I know I'll check my Lo-Fi PDA again in the morning, I can relax and fall back to sleep.

Speedy note taking. I will go head to head with nearly anyone when it comes to taking notes in my Lo-Fi PDA versus a smartphone. I'm not talking about a full-size keyboard. I'm talking about me with a pencil versus someone with a thumb-sized keyboard. As great as they are, smartphone keyboards just don't allow you to jot things down as fast as a pencil and paper. Additionally, a creative person's note-taking style is often riddled with sketches and doodles. It is a challenge to take notes like this on a smartphone.

Drawing. While smartphones and other devices are making strides in providing capable drawing functions, they are not yet an adequate substitute for a pencil or pen and a pad of paper. The Lo-Fi PDA is the perfect place to quickly sketch out design ideas, wireframes, thumbnails, storyboards, or even logo concepts. Graphic design is a visual world; having a place to take visual notes is essential.

Looking interested. Take your Lo-Fi PDA to every meeting. By jotting things down in a meeting, you appear interested in what people are saying. Even better, the nature of taking notes in a meeting will help you focus on what someone is saying and will help you actually become interested. This is critical in client meetings or in meetings with people higher up the org chart. You write down things they say. They feel important. You gain trust and appreciation.

The Lo-Fi PDA can benefit you in many ways; I've named just a few. Don't get me wrong: I believe in technology. But technology hasn't yet adequately replaced the good old pen and paper in everything.

42 BRING OUT YOUR DEAD

Some graphic design projects go swimmingly. Some are total disasters. When things go smoothly, we often think, "Check me out! I'm a total rock star!" When a project goes awry, we tend to point fingers at the client and say things like, "They don't know what they are doing" or "This client is a total idiot, and doesn't know anything about design." I've had all those thoughts throughout my career. Heck, I think I had all those thoughts last week alone. None of these thoughts will help you achieve better results in future projects.

The only way to truly grow in your ability to execute projects successfully is to learn something new every time. One of the only ways to guarantee that you will accurately analyze each project is to have a postmortem meeting. Traditionally, a postmortem refers to the examination of a body after death. A doctor will dissect the body and its organs to determine cause of death and make other medical assessments. By performing postmortem reviews, doctors have made significant discoveries that have led to great progress in medicine.

After each project is complete, put on your lab coat and grab your scalpel; a careful dissection of the cadaver is in order. This simple agenda will help ensure that you are learning from your experiences and not making the same mistakes over and over again. Below is a look into our medical examination process.

Postmortem Agenda

- Project Name
- Success Rating (1=disaster, 10=heavenly)
- What we did right
- What we did wrong
- What we will change

Take notes and keep a log of all of your postmortem meetings. Put them in a place where everyone on your team has access to them to make sure that others can learn lessons from your experiences. Dig deep and be brutally honest with yourself when answering these simple questions.

When analyzing the project to discover "what we did right and wrong," be careful not to be vague in your answers. Here are a few examples that present a good usage versus a bad usage of the postmortem experience. For this example let's suppose that the project was a complete disaster. The client hated everything you did, and you ended up giving them all their money back in hopes that you will never see them again.

Bad Usage Example

Postmortem Agenda
Project Name: Bait and Tackle Shop Website
Success Rating (1=disaster, 10=heavenly): 1

What We Did Right/Wrong:
This project blew up because the client didn't understand what it takes to build a website.

What We Will Change:
Don't work with bad clients who know nothing about web design.

The above example highlights the fact that the client was clueless. Great; we all knew that. A better use of the postmortem evaluation would be to create a list of characteristics of a clueless client and then create some changes in your process to ensure that you are not caught off-guard by a clueless client in the future.

Good Usage Example

Postmortem Agenda
Project Name: Bait and Tackle Shop Website
Success Rating (1=disaster, 10=heavenly): 1

What We Did Right/Wrong:
This project blew up because the client didn't understand what it takes
to build a website. Here are some specific things that happened that
identify a potential problem client:

- The client asked a ton of questions.

- The client was condescending in their tone of voice.

- The client cut the price and scope of the project
 three times before giving the green light.

- The client seemed unwilling to put time and
 effort into making the project succeed.

What We Will Change:
During the proposal phase of the project we will
watch out for the attributes above that can identify a problem client.
If we see these attributes, we will have a heart to heart with the client
and make sure they are on board with working toward a successful
finished product. If we feel that the client will be a problem client, we
will cancel the project before it starts.

Here are two examples of bad and good usage for a postmortem
on a successful project that can help you repeat that success.

Bad Usage Example

Postmortem Agenda
Project Name: Car Wash Logo
Success Rating (1=disaster, 10=heavenly): 9

What We Did Right/Wrong:
This project went great because Josh designed an awesome logo.

What We Will Change:
Have Josh do all our logo designs in the future.

It is unrealistic that you can have Josh, your All-Star designer, do every future logo. The goal is to figure out how to replicate Josh's success on the logo.

Good Usage Example

Postmortem Agenda
Project Name: Car Wash Logo
Success Rating (1=disaster, 10=heavenly): 9

What We Did Right/Wrong:
This project was a huge success. Josh designed a great logo and was on the same page with the client. Here are some of the key things that Josh did that helped him get into the client's head and get to know what they wanted for their logo design:

- Developed concept sketches presented to the client prior to doing design work.

- Called the client to discuss the concept sketches in detail.

What We Will Change:
We are implementing a requirement that every logo project includes a phase of concept sketches prior to beginning the design work.

A postmortem review on every project that comes through your doors (whether the project was a massive success or an epic failure) can help to ensure that you don't repeat bad experiences and that you do all you can to duplicate the good ones. These meetings don't have to be long or overly formal; something as small as a few minutes learning from the past can make a world of difference for the future.

43 SHAKE THE BUSHES OR GET BIT

I grew up on a lake by a forest in northern Indiana. My wife once likened my upbringing to that of the Dukes of Hazzard—a comparison that was only slightly off. Catching snakes was a pastime for my four brothers and me. We would spend the day in the forest with a can and a stick hunting for our slithering friends. We were afraid of the rare but poisonous Massasauga rattlesnake that we had convinced ourselves roamed the area looking for little boys to corner and bite. The can we brought with us was used to collect the snakes. The stick was used to shake the bushes and underbrush to scare snakes out of hiding. When the snakes slithered away from the bushes, we could see if it was a scary rattlesnake or the harmless garter snake we were after.

Fortunately, none of us were ever bitten by a rattlesnake. But in business, I have been bitten many times when I forgot to first shake the bushes before moving forward. All too often we will jump into a project too quickly without fleshing out all the details. As a designer, you often want to get right into the fun part—designing. The temptation is too great to skip the extremely important detail-finding phase, and instead of hitting your project with a stick, you decide to reach your hand into the bush, which might get you bitten. In fact, nine times out of ten, when a project blows up, we can route it back to something that would not have happened if we had been diligent in fleshing out all of the details at the start of the project.

At the beginning of each project, our team has a Kickoff Meeting with the client. This meeting can be face-to-face or over the phone; either way can be successful. Prior to the Kickoff Meeting, we send our client the agenda. (IMPORTANT: We prefill *all* the information we know to date about the project prior to sending it to the client. You never want to create more work for your

client, and chances are good that you may have already uncovered a good chunk of this information during your proposal process.)

Our Kickoff Meeting Agenda includes the questions outlined below (again, with as many answers as possible prefilled in). Your agenda may be different; what is important is that you dig deep and ask all of the questions you can think of regarding the upcoming project.

Kickoff Meeting Agenda

Project Overview

- What are the deliverables for this project?
- What is the demographic of your target audience?
- Who are your biggest competitors?
- What are the objectives of this project?
- What are you trying to resolve?
- What factors would make this a successful project?
- What concerns do you have regarding this project?

Creative Overview

- What are some adjectives that describe the "look and feel" you desire for the end result of this project?
- Do you have existing marketing materials that we need to match for brand consistency?
- What colors and fonts work well (or have been used in the past) for your brand?
- Name two or more brands or companies in your industry or a related industry that have a "look and feel" similar to your desired end result for this project. List their website addresses.
- What are some brands you dislike in your industry or related industry? What do you dislike about their brand?
- What types of photos or other imagery should be used to represent your brand?
- What assets will be available from you for this project? When and how will they be delivered?

Technical Overview (Internet-related projects)

- What is the server environment for this project?
- Who is the technical contact on your side?
- If known, what scripting and database languages are available on the server?
- Does this site connect to any other websites or technologies (any important third-party technologies such as Flickr, sales-force.com, RSS Feeds, YouTube, Payments Gateways)? If so, who can provide access to those elements?
- Are there technologies or frameworks that you require to be used in the development of this project (like PHP, ASP, Word-Press, ExpressionEngine, Drupal, CodeIgnitor, MooTools,' jQuery, Zend, Kohana)?

Following the Kickoff Meeting with the client, we send them a fully completed Creative Brief that contains answers to all of the questions regarding the project. The information extracted at Kickoff is invaluable in executing a successful project and ensures that everyone is on the exact same page moving forward, no hidden snakes and no poisonous bites to haunt you down the road.

44 RED FLAGS AND EXTINGUISHERS

The term *red flag* is commonly used in businesses to identify that "there is smoke in the air, and where there is smoke there is fire." Something has happened that indicates a possible impending disaster. In graphic design there are plenty of red flags to watch out for. A few years ago, I got sick of making the same mistakes over and over again, and began to recognize red flags in the design industry. I created some documentation for our company for each phase of production that highlighted these red flags; each one was accompanied by a form of documentation to help put out the subsequent fire. We call those protocols "extinguishers."

Every client is different, and every problem has its own nuances. The extinguishers are not guaranteed to put out the fire, but they are a great place to start. The following are a few red flags that we have identified in our company, as well as the steps we take to deal with them when they rear their ugly heads.

 Red Flag: Client cannot provide clear direction as to what they want you to do. They don't have an RFP (request for proposal).

You meet with the client. They are excited about the "big idea" they have. When you begin to dig into the details, however, they aren't clear on what they want you to create for them. If they cannot paint a clear picture at the start of the project, there is a good chance that they will change scope many times during the project, causing you a nightmarish project management experience.

Extinguisher A: If you get a sense that the client is going to be a flake, don't spend too much energy on helping scope out their project for them. A simple request can flush out this type of client, such as, "Client, this project sounds amazing. We can see your passion behind it. In order for us to be able to accurately attach pricing to your project, we'll need some type of RFP. A simple email detailing out all of the elements that you want us to create will help us immensely. Once we receive that, we'll put together some numbers for you." This approach will either force them to clarify their request or expose them as the flake you don't want to do business with. Either way, it puts the ball back where it belongs: in their court and not in yours.

Extinguisher B: Sometimes your gut will tell you that the project is legit and the client could be on to the next big thing. If you feel strongly that the client's inability to pinpoint the scope of their project is just because they need your help in all aspects (including creating the scope), then by all means, offer your help. You could get the ball rolling by saying something like, "Client, we're excited about your project. In order for us to accurately provide an estimate, we'll need to define the scope of work a bit better. Based on our conversation, we will create a scope document and send it to you for your review. Once we lock down all the details, we'll convert the scope document into a formal estimate."

Red Flag: Client does not respond to emails or phone calls regarding questions about the project.
The client pitches you a project. Everything seems to be great at the start but communication goes cold as soon as you start asking questions.

Extinguisher: Don't be like the needy boyfriend or girlfriend who calls every five seconds until they get in touch with the one they love. If the project is pressing and the client is truly interested in having you do the work, they'll be in touch.

Wait a few days or a week from the time of your last contact and then call all the contact numbers you have for the client and leave messages if necessary. Then send one final email. (You have to be sure that your correspondence gets to them and is not left in an email junk bin.) If they still don't reply, archive the lead and move on to hotter opportunities.

Red Flag: Client requests multiple rounds of revisions to the proposal prior to sign off.
In 2008, our agency was approached with the project to redesign a high-traffic and high-profile entertainment website. The client scrutinized our proposal, and requested additions and changes to many parts of it. After a month had passed and eight rounds of proposal revisions were implemented, we finally received the exciting green light to begin work. Three rounds of comps outlined in the proposal turned into more than 15 rounds of comps during the project's lifecycle. The proposed six-month project ended up taking nearly a year to complete. We learned that additional rounds of proposals usually lead to additional work for everything else.

Extinguisher A: After a few rounds of proposal changes, consider adding extra rounds of comps to the scope of work. This way you will anticipate what is likely coming in the project lifecycle and be prepared for that at the beginning rather than being surprised by it in the heat of the moment.

Extinguisher B: Don't come down on your price. Stick to your guns if the client begins to haggle the proposed cost. If they are asking for extra proposals, they will likely expect additional things during the project as well.

 Red Flag: Client does not confirm receipt of proposal.
You send the proposal and never hear from the client again. Generally speaking, people are notorious for poor email etiquette, so not replying to your proposal submission may not be the end of the road, but it is certainly something to watch out for.

Extinguisher: If a client goes silent after they receive your proposal, there is a good chance they are sticker shocked or have other concerns about the project. First, you have to make sure they received your proposal, so follow up via phone and email until you have that confirmation. Then offer your desire to resolve any concerns they may have. You could say something like, "Client, now that you have our proposal we feel we have some talking points. We can rework the scope of the project to accommodate the budget you have in mind. If you have other concerns that are keeping you from pulling the trigger, let's discuss those as well."

 Red Flag: Client balks at the price outlined in proposal.
Your proposal is sent to the client and they come back to you saying, "Whoa, that seems a bit high!"

Extinguisher A: Now that they have your price, you are justified in asking what their desired budget is. You can then offer to modify the scope of the project to fit within their target price range.

Extinguisher B: Educate the client. Oftentimes the client has no real understanding of what it takes to execute on their request. Something very complex may seem very simple in their eyes. Spend a few minutes to explain the costs to the client; a brief write-up that details the time, tasks, and technical elements involved will help the client gain a better understanding of what it takes to complete their project.

Extinguisher C: Make a decision internally as to whether or not the project is worth doing at a lower cost. Some projects have more than just monetary value at stake. Perhaps the project is for a charitable cause. Or perhaps the finished product will help you enter into an industry you don't currently service but have been looking to break into. Maybe the project will make a great portfolio piece and potentially win some awards. These are just a few things to consider before you agree to do a project at a reduced cost.

 Red Flag: Client green lights a project and then begins talking about new features and other elements they want you to create.
This is a sign of a potential problem client. If the scope is changing all the time, you will be trying to hit a moving target throughout the duration of the project.

Extinguisher A: Be sure you have a detailed scope of work listed in your proposal. If the features the client is requesting are not included in the scope of work, be sure to politely remind them that the agreed-upon scope was in the proposal. If they want to modify that scope of work, you will need to readdress the costs in the original estimate and submit a revised proposal.

Extinguisher B: Clients that change scope are usually better off in a "Retainer" or "Dedicated Resource" payment structure. Explain these options to your client and recommend that they change their agreement with you to reflect that payment scale.

Red Flag: Client wants to delay making the first payment on the project.

Typically you should charge some money up front to get started on a client's project. If a client wants to put off making a first payment and you begin work on their project, brace yourself for getting stiffed down the road.

Extinguisher A: If your gut tells you that you are at risk of being stiffed, trust it. Tell the client that you need to put the project on hold until the first payment is received.

Extinguisher B: We have a number of big clients with deep pockets, and for whatever reason it usually takes a little time to get an invoice through their Accounts Payable system. If you are spending a lot of hours on the project and there seems to be an unreasonable delay, you have every right to check on the status of payment. Be courteous and kind, asking questions like, "Client, I just wanted to follow up on the status of the first payment for our project together that has come due."

Red Flag: Client does not like any of the comps.

They may say something to the effect of, "These are all terrible. I'm just not feeling it on any of the comps."

Extinguisher A: Remind the client that you have multiple rounds of comps factored into the project. The comp rounds are there so that you can get feedback and make changes to eventually land on the best design for their project. The best thing for them to do is help guide you in the direction they envision—even something so small as a font used that they like or an angle that catches their eye can go a long way toward helping you piece together something that matches with their vision for the project.

Extinguisher B: Don't let the client get away with blanket statements like, "I don't like anything." This type of feedback is not helpful. Sit down with the client and discuss specifics. Ask specific questions about what they don't like: layout, colors, fonts, and so forth. The more detailed you are, the better. Oftentimes, you will find that the client doesn't hate everything (and this may be a surprise to them, as well.)

Extinguisher C: Ask the client for examples of what they *do* like. When they show you those examples, ask specific questions about what they like about the designs.

Extinguisher D: As great as you are, you may not be able to please some clients. When this happens, I usually chalk it up to a problem with them, not me. If you have not been able to hit the mark after utilizing these Extinguishers and have gone through a couple rounds of comps with the client, they may be "unpleaseable." Don't be afraid to break ties with the client and part ways; this may include painfully returning monies previously paid, and maybe even taking a loss on the project in order to get it smoothly and successfully off of your books and out of your hair.

Red Flag: Client wants to make changes to previously approved items.

Imagine that you are designing a website. After you receive design approval, you move on to the build-out portion of the project. When you unveil the first clickable version of the site, the client makes a request to change the design. This type of behavior from a client can quickly make a project spin out of control. It is critical to handle it properly to ensure that a profitable one-month project doesn't become an unprofitable six-month headache.

Extinguisher A: Explain to the client that design changes at this phase of the project will require reprogramming certain items. This will require the deadline to be pushed

back, as you will need to add an additional round of comps and reprogram the entire site. Be careful not to become argumentative with the client, however; your tone should continue to be service-minded and your goal should always be a happy client.

Extinguisher B: In every proposal you should include a line that states, "Changes to approved designs during the production phase of the project (prepress or programming) may require an extension of the timeline and an increase in the budget." By including this text in your proposal, you will be more empowered to discuss the ramifications of a design change late in the development cycle of a project.

Extinguisher C: If additional costs are agreed upon with the client, be sure to send an official "Change Order" for formality's sake. Additional costs should always be documented for the client to ensure there are no misunderstandings when it comes time to bill for the work.

Red Flag: Client has personal or family money invested in the project.
A project that is being funded by personal or family money is prone to dramatic overreactions and sensitive client behavior. Beware! These types of projects are often accompanied with a client's efforts to squeeze every tiny bit of work out of you for the lowest possible price.

Extinguisher A: You must define an extremely clear scope of work. If an item isn't clearly spelled out in your proposal, the client may make an assumption that it is included.

Extinguisher B: Every effort should be made to exceed expectations. Once a client with personal money on the line gets frustrated with your performance, it is very difficult to restore a strong, positive relationship.

Red Flag: Client does not provide assets in a timely manner.

Frequently you will need a client's logo, photos, or copy in order to complete their project. If the client is not timely in their delivery of those assets, deadlines may suffer.

Extinguisher A: Set clear deadlines for the client to deliver the assets you need. Make sure the client understands and agrees to those deadlines. If you need copy for their brochure on Wednesday, they need to know that you are depending on their commitment to meeting that deadline.

Extinguisher B: The client must be instructed on the ramifications of missing an asset delivery deadline. Every day they are late will usually mean that all subsequent milestones will be pushed back at least a day as well.

Extinguisher C: A phone call works much better than an email. Don't be afraid to pick up the phone and chat with your client to find out when to expect the assets and to explain the importance of hitting that milestone.

Extinguisher D: Incorporate all of the assets the client has sent and leave "For Placement Only" images in the remaining areas of the design. By sending this partially finished design to the client, they will more clearly see the importance of getting you the remaining assets.

Red Flag: Client doesn't have an office.

We had a client approach us about doing some branding and website work for their company. We visited their office and found that they were sharing space with four other companies. They talked big and acted as if they had money. When we broke down their project, we found that they were in need of redesigning nine brands and nine accompanying websites. We expected that they would have a tight budget,

so we strategically spelled out a way that we could reuse website programming for all nine sites to save them money. Instead of $10,000 per site plus the branding work, we landed on a total price of $36,000 for all nine brands and nine websites. We sent our "great deal" proposal to the client and they responded by saying, "Wow! This is pretty expensive! You'll have to come down on the price." We went back to the drawing board and sent a revised proposal with a decreased scope of work. The new price was $25,000 to which they replied, "Still too much." We couldn't make it any cheaper without losing a lot of money on the job and we decided to part ways. We wasted a lot of hours in meetings and writing proposals because we didn't pay attention to the obvious red flag: "If the client doesn't have an office, they might not have any money, either."

Extinguisher A: Do everything you can to find out the client's budget beforehand (see the chapter "How to Flush Out a Budget" in Section 5).

Extinguisher B: Send a proposal with various scope and pricing options. Come up with a plan that offers a low-cost solution, a mid-range solution, and a high-cost solution.

Red Flag: Client has an unrealistic deadline.
The client wants their project done in a timeframe that is extremely tight, or even impossible.

Extinguisher A: Clearly explain to the client everything that needs to be done in order to hit the timeline. If the project is potentially going to cause other projects to suffer or create weekend or nighttime work for your team in order to accomplish the task on time, you may consider increasing the cost of the project by including rush fees.

Extinguisher B: The client (and you) must understand that the quality of work inevitably suffers to a degree in a rush project situation.

Extinguisher C: Explain to the client that to hit their deadline, they must be fully committed to providing clear feedback and approvals quickly. Any delays on the client's side of things will undoubtedly cause a missed deadline.

Red Flag: Client fired their last designer.
Be aware that often you will hear only one side of the story. The client will share stories about what the designer did poorly. What you won't hear from the client is how miserable they are to work with. Until you build your own relationship, be wary of a client who fired their last designer and ask the question, is it possible that you may be next?

Extinguisher: Discuss with the client what went wrong with their last designer that resulted with them being fired. Take detailed notes and put a plan in place to ensure that you don't make the same mistakes as your predecessor.

Red Flag: The project you are creating for the client is their entire business.
Most graphic design projects relate to marketing in some fashion. The goal is to "sell" a specific product, service, or brand. However, sometimes you will be approached to create something for a client that is their entire business. For example, an e-commerce website that has no brick-and-mortar counterpart is a red flag project. If what you build doesn't work due to the design or programming, then the client's business will not work. These types of projects are red flag projects, not necessarily for problems that will result but instead because they require extra effort and attention on your part to ensure their success.

Extinguisher A: You must have a firm understanding of the client's industry and business model. Several client meetings can ensure your understanding. Do plenty of comprehensive research to make sure that what you design and build will work in the competitive landscape.

Extinguisher B: Don't underbid the project. Make sure you have enough of a budget in place to put in the time necessary to make the project succeed. The last thing you need is to be confined within too tight of a budget on a project such as this.

Pay careful attention to the warning signs in your career as a graphic designer. Recognizing and reacting to red flags can save you an enormous amount of pain and anguish down the line.

The red flags I discuss in this chapter are far from the only ones you will encounter during your career. I encourage you to start a notebook of your own red flags and extinguishers. Reacting to the smoke is the best way to prevent a massive fire.

45 BRAINSTORMS ARE 90 PERCENT BAD IDEAS

Brainstorming with a group is an effective way to generate ideas. John gets an idea from something Sally says. George gets an idea from John. Eventually the team lands on something truly amazing. When our creative team sits down to start brainstorming ideas, you will often hear the reminder that "brainstorms are 90 percent bad ideas." The 90-percent bad-idea rule applies to even the best creative minds I have worked with over the years. In order to get to the 10 percent of good ideas that are generated in a brainstorming session, you often have to muddle through the bad ideas. Imagine Indiana Jones slicing through the thick jungle brush, searching for the one trail that will lead to the rope bridge and—ultimately—the lost treasure.

If you don't understand this point of view, brainstorming can be an emotional downer where you end up feeling like every idea you have gets shot down by your peers. In reality, you should have the mindset that every bad idea you throw out is a stepping stone to the good ideas that are waiting to be discovered. This point of view will keep your ego in check while the chaff that is the bad ideas is separated from the golden wheat that is the next great idea.

46 THE COMMUNAL BRAIN

I've been in more high-octane brainstorm sessions than I can count. One in particular, though, stands out to me. While I was working at Fox, our design team leaders had a meeting with the marketing folks. Among other things discussed was a tagline to be used for one of our properties. The brainstorm melee swirled around us until one of the design team members spouted out the phrase that would end up becoming the tagline for the next several years. The only problem was that one of the marketing team members took credit for it. The reality is that no one would probably have come up with the idea if it weren't for everyone else in the brainstorm meeting helping to direct the thought line toward the ultimate winning tagline.

Brainstorm ideas belong to the group. When people get together to share ideas, a "communal brain" emerges. John gets an idea from something Sally says. Sally gets an idea from something Tracy says in jest. Tracy gets an idea from something Jim doodles on a scratch pad. The "communal brain" is really the owner of all of the brainstorming ideas, allowing everyone in the group to share in the satisfaction that they contributed to the great ideas that were generated.

Without this mindset, potential squabbles can arise in a team about who really came up with a big idea. While the "mine is bigger than yours" mentality may be a perk to some occupations (perhaps professional sports and combat situations), it is better for all involved in a collaborative and creative setting to step off their soap boxes and swallow their pride. In the design realm, every designer, regardless of status or ability, is better off recognizing that the great ideas generated in a brainstorm meeting happen only due to the contribution and collaboration with others when they all tap into the power of the "communal brain."

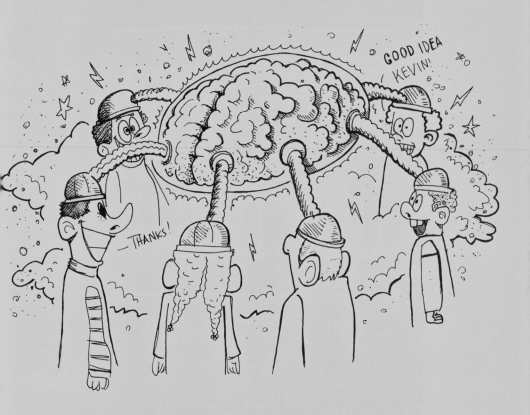

SECTION 3

TWO EARS, ONE MOUTH

SOMETIMES A CREATIVE PROFESSIONAL
WILL ACTUALLY HAVE TO
TAKE OFF THEIR HEADPHONES
AND INTERACT WITH ANOTHER HUMAN BEING.

47 THE ULTIMATE EMAIL FORMULA

The majority of our work comes from clients that are outside of our local area, and the majority of our growth comes via referrals from happy clients. It stands to reason, then, that the majority of our communication goes by way of email, and thus expertly crafted emails are critical to relationship success.

Email writing is a dangerous thing. It can be so easy for the email recipient to misinterpret the tone of your message, unless you make a clear effort to define the tone. The best thing to do is keep things friendly and lighthearted, and get to the point.

The Ultimate Email Formula is simple...

(Message subject)	*This is the "Subject" field in your email application.*
(Recipient name)	*This is "whom" you are sending to.*
(A friendly comment)	*This is a friendly, non-gushy, opening statement.*
(Get to the point)	*This explains the purpose of your correspondence.*
(A friendly comment)	*This is a friendly, non-gushy, closing statement.*
(Sender name)	*This is "whom" it is from.*
(Sig file)	*For crying out loud, put your sig file on your emails! It drives me crazy when I can't readily find someone's contact info. Don't make it hard for your contacts to get in touch with you.*

I received an email from someone looking for a job at our agency. Here is the email dissected into the formula:

(Message subject)	*Traffic Manager Position*
(Recipient name)	*NONE*
(A friendly comment)	*NONE*
(Get to the point)	*Please see attached résumé in response to your advertisement for a Traffic Manager.*
(A friendly comment)	*NONE*
(Sender name)	*John*
(Sig file)	*NONE*

The missing elements made the email get lost in the shuffle…nothing interesting…no personality…no sig file (so if I want to contact this person, I have to dig into the attached résumé).

Here is that same email with the missing elements completed (the original content is left intact):

(Message subject)	*Traffic Manager Position*
(Recipient name)	*Dear Company Name,*
(A friendly comment)	*I hope you are having a great day! I was impressed with your site and I hope to one day join your team!*
(Get to the point)	*Please see attached résumé in response to your advertisement for a Traffic Manager.*
(A friendly comment)	*This sounds like an exciting opportunity with a great company. I'm very interested!*
(Sender name)	*John*
(Sig file)	*(555) 867-5309* *john@username.com*

Following the Ultimate Email Formula makes the exact same message much more interesting. This formula is required at our company, until the principles and procedures it outlines become a natural way of writing email correspondence.

The best part about this formula is that it can be used for any type of email. Here are a few more examples:

Example 1: *Not Using the Formula*

(Message subject)	*1st Comps*
(Recipient name)	*Sally,*
(A friendly comment)	*NONE*
(Get to the point)	*Attached are the comps for your review. We're looking forward to your feedback.*
(A friendly comment)	*NONE*
(Sender name)	*Ralph*
(Sig file)	*NONE*

Example 1: *Using the Formula*

(Message subject)	*1st Comps*
(Recipient name)	*Dear Sally,*
(A friendly comment)	*We have had a great time working on the designs for your new website!*
(Get to the point)	*Attached are the comps for your review. We're looking forward to your feedback.*
(A friendly comment)	*Please let us know if you have any questions. We'd be happy to jump on the phone and chat things through. Hope you have a great day!*
(Sender name)	*Best Wishers, Ralph Johnson*
(Sig file)	*Agency Name (555) 867-5309 ralph@username.com*

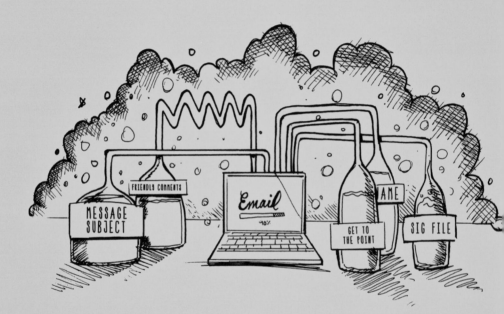

Example 2: *Not Using the Formula*

(Message subject)	*Meeting Notes*
(Recipient name)	*Jane,*
(A friendly comment)	*NONE*
(Get to the point)	*I have attached our notes from our phone call meeting this morning. Please let me know if we missed anything.*
(A friendly comment)	*NONE*
(Sender name)	*George*
(Sig file)	*NONE*

Example 2: *Using the Formula*

(Message subject)	*Meeting Notes*
(Recipient name)	*Jane,*
(A friendly comment)	*It was great chatting with you this morning! We are looking forward to working on this project with you.*
(Get to the point)	*I have attached our notes from our phone call meeting this morning. Please let me know if we missed anything.*
(A friendly comment)	*Have a great weekend! Anything fun planned?*
(Sender name)	*Best,* *George*
(Sig file)	*Company Name* *(555) 867-5309* *george@username.com*

Seems logical, doesn't it? "Nothing revolutionary here," you might say. If that is the case, then why do I get so many lame email messages with no personality and no sig file? Carefully evaluate your personal email processes to make sure that you are providing your employees, colleagues, and clients with the appropriate information, and be sure that any of your employees do the same. Your clients may not thank you in person but they certainly will be grateful, I guarantee it.

48 BEWARE THE RED DOT

"Beware the Red Dot" is a quirky way of saying, "Make sure you reply quickly to email correspondence." I have lived by this mantra for years, and I know that it has had a positive impact on many business relationships.

The red dot is the Mac Mail indicator that appears on the dock icon for your Mail application. The red dot goes away when you have no unread messages. Now obviously, some of you are PC users and may not have a red dot reminding you of unread messages. But the mantra is still the same: Reply quickly to email correspondence. This accomplishes a couple key purposes:

- Clients will feel like you are in the office next door as a part of their team. They will get the message that you are accessible, and that you care about them and their project.

- Requests from people don't stack up on top of each other that would otherwise cause a lot of work and undue stress later.

If you are the "To" recipient of an email, you are the "owner" of the information and it is your responsibility to respond. Some requests can be taken care of immediately and others may take some time. Either way, a prompt reply is advised. If you can take care of the request in a few minutes, do it and notify the client that it is complete. If the request will take some time, reply quickly to the client to let them know that you received the request and then give them an expectation as to when it will be taken care of.

No matter what your go-to response is, the important thing is that you take the time to keep your clients up to date and abreast of all project workings—including any changes to previous work orders or requests for additional information or progress reports.

49 EMAIL BLACK HOLES

I was flying across the country on business. Before I left I made sure to email my business contact the flight information, as they were arranging to pick me up at the airport when I landed. I checked my email before getting on the plane to see if they had responded that my flight itinerary was received. No reply. Throughout my four-hour flight I wasted valuable time wondering and worrying as to whether someone would be at the airport to pick me up or not. A simple "Got your itinerary, Mike" reply back would have saved me a lot of wasted energy. My email had been lost in an "Email Black Hole," and part of my trust in that contact got lost with it. Fortunately, when I landed my business contact was at the airport waiting for me, and things worked out—however, I could have been spared the worry and wonder with just a simple reply.

If someone is talking to you and you don't respond, it comes across as being rude. If someone emails you and you don't respond, it is not much different. Nearly every email you receive should be replied to (aside from spam, of course). We often neglect to reply to an email because we are short on time, because we assume that the client "knows we got it and read it," or because we don't have anything to say… perhaps because we don't currently have the answers to their questions. Regardless of the situation, a prompt response to every email is critical to building strong relationships with your clients and coworkers. The response doesn't have to be (and often shouldn't be) a long-winded discourse; simple replies are often very appropriate in email correspondence. Here are some examples.

General use…

"Got your email. Thanks!" (A simple confirmation like this can put the email sender at ease, knowing that you received the information they sent.)

Someone emails you a question…

"Thanks for the email. I don't have an answer to your questions just yet; I'm checking with John Doe and I'll get back to you by 4:00 P.M." (This is a great way to respond quickly when you don't have an answer to a question sent to you.)

Someone emails you a simple request that merits a simple one-word response…

"Done." (We use this in interoffice communication frequently at our company to let someone know that the request they made in an email was complete. With a client, though, you should probably be a little more expressive than just saying "Done," depending on your relationship level.)

Someone emails you a time-consuming request…

"Thanks for your request. I am looking into how long this will take and I'll get back to you soon." (Then go figure out the strategy and time frame needed to fulfill the request, and get back to the client as fast as you can.)

Someone invites you to lunch and you're too busy…

"Thanks for the invitation. My schedule is too packed with deadlines right now. Could you email me back in a couple weeks and we'll try to schedule something in?" (If you're really too slammed to get lunch, don't be tacky and leave them hanging with no reply to their invitation; most people will understand and appreciate you extending this courtesy either way.)

Someone emails you a compliment…

"Thanks. We always appreciate feedback like that!" (You might even want to throw a compliment back their way.)

These are just a few examples. Use your judgment on how to reply to emails. Personally, I never file an email until I know it has been attended to either by myself or by someone on my team.

50 EVEN THE LONE RANGER HAD TONTO

I remember as a little kid watching old black and white versions of the "Lone Ranger" on TV. My older brother and I would then play Lone Ranger after watching an episode. He was always the Lone Ranger, and I was always Tonto. Thinking back on that now, I wonder why the character was called the "Lone" Ranger when his trusted sidekick, Tonto, was always around to help get him out of trouble. He never really did it "alone." As much as we might think we are "Lone Rangers" in business environments, the reality is that we usually have someone around helping us along the way.

Information is power. When information is shared, it empowers others. There is very little information in my business that is not shared with someone else. My office manager has access to all the information that I do. She opens my mail. She balances my checkbook. She checks my voice mail. And if the redundancy of the information I'm responsible for doesn't lie with her, it lies with one of my two vice presidents who manage all of the inflow and outflow of work in our business.

Keeping information close to the vest is like handcuffing yourself to your business. It makes it so you can truly never take a break, as there is always a place where the knowledge of others stops and you are the only one who can step in and bridge that gap.

We distribute information at our company in many ways. We have an internal blog that is accessible by everyone on our team. Our production management tool is online and is accessible by everyone in our company so they can see where any project stands at any given time. We have biweekly staff meetings where I probably divulge more information than our team wants to know. Though perhaps the best way that we ensure that every piece of information has redundancy is by carbon copying (Cc) someone from the team on an email. There

are very few emails that I send that do not have at least one other person Cc'd on them. An email to my mom is just about the only email that I'll send without copying someone else…and even many of those have my dad copied on them.

Copying others on emails has been a practice at our company for years, and has proven to accomplish several things:

- Somebody else always has the information that you have. That way if you are sick or detained in any way, somebody else on the team can pick up the slack.

- It presents a unified front. It says to your clients that there are more people supporting them than just one, thus instilling more confidence.

- Many, many, many times we have been able to go into another team member's email folders and find a lost email that saved a project or solved a problem.

It is important to note that there is a delicate balance between copying people onto emails for the good of all, and the alternative— seen in the Section 1 chapter "Drama Is for Soap Operas." Certainly it is true that when you Cc several people on an email it can appear that the information is being escalated and overdramatized. To help avoid unnecessary drama, be sure to include only the appropriate people in the Cc area. For example, a designer could Cc the art director on an email to a client regarding design changes, or the sales rep could Cc the company president on an email to a client with the delivery date of a big proposal. Whatever the content of the email may be, there is likely an appropriate person to Cc.

Once you begin utilizing this strategy, you will quickly realize that many people in the business world have not yet learned the importance of copying others on emails. Don't get sucked into the trap of singular correspondence. If a client or contact emails you valuable information, be sure to forward it to the most appropriate person on your team, abiding by the mantra that "Even the Lone Ranger Had Tonto."

KEMO SABE?

51 CANNED COMMUNICATION

"There is no doubt about it: Our agency churns out a ton of projects—more than 1,500 projects in our first ten years of business, to be more specific. Each project averages about eight milestones, and each milestone requires a delivery email of some sort to be sent to the client. That adds up to approximately 12,000 structured delivery emails to our clients in about a decade. If you average that over ten years, it equates to roughly 4.6 email deliveries to a client per day, or an email every half an hour or so.

After looking into this more, we quickly found that we were writing the same things over and over again. The delivery email for first comps of a website design to one client didn't change much from the email that needed to be sent to another client for a similar project. In order to simplify our day a bit and to ensure that our messaging was consistent across all team members, we decided to create what we call "Canned Communication." This is not a revolutionary idea, but I suppose the fact that I didn't have a tool like this until about ten years into my career means that most of you don't have it either.

The easiest way to start using this invaluable time-saving process is to open a blank document in your favorite word processing software, title it "Canned Communication," and start writing the best messages you can for every type of email you send to your clients. These email messages will become your template for all future emails.

For example, you'll probably have canned messages for "Website First Comps Delivery," "Logo First Comps Delivery," "Final Clickable Website," "Project Complete," and so on. If you work with a group, it is a great idea to place the canned messages on a server that everyone has access to.

The trick to this is that you don't want to sound like a copy-and-paste robot in your emails. Even though C-3PO was a keystone figure

in the *Star Wars* saga, I am confident in saying that his ability to draw people in and make them feel special and unique was not on the top of his special skills list. So you'll need to have certain parts of your messages that will always be customized before you send the message out. This is where it becomes even more important that you proofread your messages before sending them out into the Wild West that is Cyberspace—there is nothing more embarrassing than having a client open up an email only to find it is a template and there is nothing of value to them at all.

We have had a few employees send "Canned Communication" to a client without filling out the "Name" areas. This is totally embarrassing and, again, would never happen if the messages were actually read prior to clicking Send.

Not everyone works in the same ways, so you'll want to create messages that match your tone and project types. Here are several examples of our own "Canned Communication" to help illustrate how we utilize this system.

 Proposal Delivery Message

Dear [Client Name],

I hope your day is going well!

Attached please find our proposal for your review. We have made every effort to ensure your project objectives will be met within the budget and scope detailed in this proposal. Please let us know if you have any questions or need any further details as you are reviewing the proposal.

We would love to work with you on this project and are confident that we would do a great job.

Thanks!
[Your Name]
[Sig File]

Green Light Message

Hi [Client Name],

Thank you for sending this project to our team. We are excited to be working with you and look forward to a successful project together!

We would like to get started right away by scheduling a brief kick-off meeting to discuss the many important details of this project. We can either do this via phone or in person. What is a good day and time for you to spend 30 minutes with us discussing the project? We'll make sure all the appropriate people from our team are in the meeting to ensure we are all on the same page going forward.

Best,
[Your Name]
[Sig File]

Accounting Information Message

Hi [Client Name],

I hope you are having a great day!

I am emailing you regarding the accounting details for this project.

As detailed in the proposal sent to you, the initial 50 percent of the total project cost is to be paid at the start of production. I will be sending the invoice shortly. Do you require a PO# on your invoices? Also, are you the best contact for the accounting aspects of this project or should I correspond with someone else in your office?

Thank you for your time; we are looking forward to working with you!

Thanks in advance,
[Your Name]
[Sig File]

Design Kickoff Message

[Client Name],

My name is [Your Name] and I will be taking the lead on our end of the creation of your new website.

We have created an FTP site for you to deliver digital assets to us. Please upload us your logo, photos, and other imagery that we will need to ensure that the website is consistent with your other marketing materials. Here is the access information for the FTP site:

ftp.[TBD].com
Username: [TBD]
Password: [TBD]

Once we receive the assets, we will begin designing the first comps for your site. Comps are conceptual designs that are created to establish the look and feel of the site. According to the schedule, the first comps will be sent to you on [Milestone Date]. After your review, we will integrate your requested modifications and send you an additional round of comps.

If you have any questions during the whole process, please let me know.

We look forward to working with you!

Thanks,
[Your Name]
[Sig File]

First Website Comps Delivery Message

Hi [Client Name],

We have enjoyed working on the initial comps for your project!

There are a few things you should be aware of while you review the comps:

- *The comps are static images only. Nothing is clickable or functioning yet. The goal with these comps is to establish the look and feel that will be incorporated throughout all of the site pages.*

- *Some of the content is FPO (For Placement Only). You may see some "Lorem Ipsum" text and some placeholder photos; as we progress in the design process, these elements will be swapped out with the final content.*

- *As of right now, we have created a few different home page comps. Once we have your feedback on which general direction you'd like to proceed with, we'll incorporate the look of that comp into the designs of some subpages of the site.*

- *In our review of the comps, our team felt like [Comp Number] was the strongest design for the following reasons:*

 [Reason]

 [Reason]

 [Reason]

The comps can be reviewed by clicking the link below.

http://www.[URL].com/preview/

We look forward to your feedback.

Best,

[Your Name]

[Sig File]

First Logo Comp Delivery Message

[Client Name],

We have completed the first comps for your new logo. We are excited about the direction this is headed!

Please consider the following while reviewing the designs:

- *During the first round of comps we made an effort to provide a wide variety of ideas. Some of the ideas you may like a lot, others you may not like at all.*

- We can always mix and match. For example, you might prefer the font used on one logo and the colors and icon from another; in the next round of designs we can play around with mixing these types of elements together.

- After we receive your feedback, we will create a second round of comps that focuses on the one or two logos you'd like to see pushed further.

- In our review of the comps, our team felt like [Comp Number] was the strongest design for the following reasons:

> *[Reason]*
> *[Reason]*
> *[Reason]*

The comps can be reviewed by clicking the link below.
http://www.[URL].com/preview/

We look forward to hearing what you think about these first designs.

Have a great day!
[Your Name]
[Sig File]

Revised Comp Delivery Message

Hi [Client Name],

Hope you are having a great day!

We just completed the revisions to the last round of comps and have uploaded them for your review.

When we discussed the comps together, you provided the following key points in your feedback:

> *[Key Point]*
> *[Key Point]*
> *[Key Point]*

As you will see in the comps, all of these have been addressed. The comps can be reviewed by clicking the link below.
http://www.[URL].com/preview/

We look forward to your feedback on the designs. Per the schedule, we'll expect your feedback by [Milestone Date].

All the best,
[Your Name]
[Sig File]

Clickable Website Delivery Message

Hi [Client Name],

Hope you are doing well!

Our tech team has completed the initial clickable version of your new website. At this phase of development, please keep the following in mind while reviewing the clickable file:

- The site is not fully complete. You may find placeholder images and text in some of the site pages. This will all be filled with final content prior to launch.

- The site has not gone through a full test for quality assurance. Although we test things as we go, there may be elements that are buggy in some web browsers. Prior to launch, we perform an extensive quality-assurance test on all elements.

- The site is still in development. As you are reviewing the preview site, please know that our programmers are still at work. You may even see things change from time to time while you view it.

The clickable site can be reviewed by clicking the link below.
http://www.[URL].com/preview/

Per the schedule, we will be sending you the next version of the clickable site for review on [Milestone Date]. In the meantime, we'd love to hear any feedback you have regarding the functioning elements on the site.

Have a great day!
[Your Name]
[Sig File]

Project Completion Message

[Client Name],

Thank you so much for working with us on your [Project Name]. Everyone on our team enjoyed the project and we are extremely happy with the results.

We will be sending you the final invoice tomorrow and will also be closing out the project in our schedule.

We would love to work with you again. Please consider us for any other projects you may have in the future.

Sincerely,
[Your Name]
[Sig File]

These are just a few examples of the types of messages you probably write on a regular basis. By creating Canned Communication, not only will you save significant time in your production day, you will also be confident that you haven't forgotten to incorporate important items into your messages.

52 | TIN CAN PHONES

Ever play with tin can phones? If you have, you know that what is said on one side isn't always the same as what is received on the other. Similarly, most everyone has played the game Telephone, where you sit in a circle and someone whispers something in the ear of the person next to him or her, and then that person whispers it to the person next to them. And so it goes, until the message travels around the circle; by the time it gets back around, the message is often very different than the original meaning.

With the advances in technology, taking the time to talk to people face to face is a dying art. After all, why have an uncomfortable verbal communication with someone when you could easily hide behind the beauty of an expertly crafted email or text message? All right, I am kidding just a little about this, although there is some truth to it if we were to really examine our society.

As designers, it is critically important that we have successful phone and interpersonal communication with clients. At our agency, presentation skills are at the top of the list of attributes we look for when we interview candidates for our team. As important as verbal communication is, we should never rely on our clients to remember the conversation in the same way that we do.

Every verbal correspondence with a client where a decision is made should be followed up with a form of written correspondence for proper record keeping as well as to ensure that we are on the same page as the client. Here are some examples:

- Account Rep Z receives a phone call from a client asking for a change to a proposal. After he hangs up the phone he shoots off an email message to the tune of, "Client X, nice chatting with you just now! Per our conversation, I'll have the new proposal to you by the end of business hours tomorrow. Have a great evening!"

- Project Manager X and Designers Y and Z have a conference call with Client Y and four of his cronies. After the call, Project Manager X sends an email to the client saying, "Client Y, we enjoyed the conference call. Thanks for your time. Just wanted to shoot you our notes from the meeting for your review. Please let us know if we missed anything!" (followed by the meeting notes).

This correspondence does not need to be lengthy. Just a quick one-line message will often do the trick. Our clients often remark on our communication skills, which are high on the list of what our clients love about us. By following up verbal communication with written communication, you can cut off many misunderstandings at the pass, so to speak, and you can keep clients happy more consistently.

TAKING THE TIME TO
TALK TO PEOPLE
FACE TO FACE
IS A DYING ART.

53 VICIOUS VERNACULAR

Just yesterday our creative director came into my office to discuss a challenge he was having with a major entertainment industry client. We are wrapping up a ten-month long, $400,000 website design and programming project. Over the course of the project we have bent over backwards in an effort to satisfy what has largely become an unsatisfiable client. We are on the final punch list and our creative director had a call with the client to review the status. During the call things got a little heated and the client began to refer to the final punch items in an extreme way. Her vicious vernacular (intentional or not) was doing a good job of shutting down our creative director.

She referred to punch-list items as "massive bugs," making them seem impossible to overcome. My creative director considered them "minor tweaks."

Fortunately for our company, during our production meeting my creative director used less vicious vernacular by referring to the punch-list items as minor. Minor tweaks are manageable, possible to overcome, not painful. The team is heads-down and filled with positivity as they work through the final items. This is the eleventh hour. The project has to get done and emotions are already high. I can only imagine the repercussions inside our production environment if he would have instead passed along the extreme massive bug phrasing. Would we have had a revolt? Would people have been disgruntled? Demoralized? Even quit?

Since graphic design is sometimes like open heart surgery, we need to be careful how we phrase things. Imagine a stressed out and worried family in the waiting room. Their loved one has been in surgery for hours on end with no end in sight. They wait and wait and then finally the heart surgeon comes out to give them an update...

"Well, John is doing *OK*. We're having to rush to *fix a lot* of things."

This Vicious Vernacular does nothing to help put the family at ease.
OK implies that things aren't great.
Rush implies that there is an emergency.
Fix implies that things are broken.
A lot implies that many things are wrong.

A few subtle changes in phrasing can do wonders in helping the family feel more at ease, such as:

"Well, John is doing *fine*. We're having to *be proactive* to *adjust* some things."

Fine implies that things are stable.
Be proactive implies that the doctors are working quickly, but there is no emergency.
Adjust implies that there are subtle modifications to be made.
Some implies that not everything is wrong.

Here are some typical words to avoid, as well as some excellent substitutes:

- Instead of *fix*, use *tweak* or *adjust*.
- Instead of *changes*, use *requests*, *adjustments*, *revisions*, or *modifications*.
- Instead of *rush*, use *work quickly* or *be productive*.
- Instead of *issues*, use *elements*.
- Instead of *problems*, use *items*.
- Instead of *improve*, use *modify*.
- Instead of *tight timeline*, use *aggressive schedule*.

Instead of telling your client…
"We are making your *changes*."

Tell them…
"We are accommodating (or updating) your *requests*."

Instead of telling your client…

"We are *rushing* to hit the deadline."

Tell them…

"We are *being productive* to hit the deadline."

Instead of telling your client…

"We are working on some *issues* that are taking extra time."

Tell them…

"We are working on some *elements* that are taking *a little bit* of extra time."

Instead of telling your client…

"The team is working to *fix* all the *problems* in preparation for delivery."

Tell them…

"The team is working to adjust all the *items* in preparation for delivery."

You get the idea. Be careful when writing and speaking to use nonescalating words and phrases that will keep your client's stress level as low as possible.

54 AN ARMY OF SUPPORT

My first couple years in business were spent slaving away in my basement like Gollum trapped in the dark underworld caves. But even when I worked as an independent freelancer, it took more than just me to satisfy my clients. I had an accountant. I sometimes vended out overflow work out to my graphic designer friends. My wife spent countless hours talking me off the ledge. "Me," even when I was technically flying solo, was really "Us."

Even then, I always made an effort to phrase things in a way that conveyed the message of multiple people supporting the client. I replaced words like "me" and "I" with "we" and "us." I didn't want my client's confidence shaken by thinking that they had the support of only some guy in his basement. I wanted them to feel like they had an army of support. An army can win the wars that one guy with a BB gun can only dream of fighting.

As my company grew, the "we" and "us" team-style phrasing rang more and more true; we really did have an army helping our clients and we took every opportunity to remind them of that important fact. Our team is instructed to make sure they convey that team attitude in all their client correspondence. As a result, our clients take comfort in knowing that their project is being worked on and reviewed by many people, which makes them feel like they are getting a lot of value for their money. They worry less about deadlines and quality knowing that multiple people are watching out for them and for the quality of their project.

Replace...
"*I* received your feedback."

with...
"*We* received your feedback."

Replace...

"I'm *the* designer working on your comps."

with...

"I'm *one* of the designers working on your comps."

Replace...

"*I* should be able to finish the design changes by the end of the day."

with...

"I'm working with *the design team* to finish the changes by the end of the day."

Say things like...

"*We're* getting close to wrapping up the project."

"*Everyone* has enjoyed working on this project."

"*We* conducted an internal review of the comps."

"Thank you for sending those assets to *us*. *We* are starting work on your comps immediately."

You get the idea.

If you really are working by yourself, I'm not encouraging you to lie. I'm merely stating that you have to recognize that there is almost always someone else in your army even when you are an independent freelancer. Talking this way helps the client understand that as well. When the client understands that an army is backing them, they sleep a little easier at night. And in the end, that's all the client really wants from you... the confidence that you are going to execute every small detail of their project successfully and fabulously.

As for actual team environment, this sentiment is imperative to cohesiveness and unity. It is easy for art directors to take credit for the work of others, which inevitably causes frustration and resentment to grow within their team. Napoleon Hill, in his masterpiece *Think and Grow Rich*, cited this behavior as being one of the ten major causes of failure in leadership.

"The leader who claims all the honor for the work of his followers is sure to be met by resentment. The really great leader CLAIMS NONE OF THE HONORS. He is contented to see the honors, when there are any, go to his followers, because he knows that most men will work harder for commendation and recognition than they will for money alone."
—Think and Grow Rich, *1937, 82*

We might all be better off to just remove the words "I," "my," and "mine" from our vocabularies. Clients will feel more secure knowing there are many people supporting them, and the other members of your team will appreciate and respect your humble approach.

55 FRIENDLY UPDATES

Doctors seem to understand something that many graphic designers don't: the need for "friendly updates."

Imagine, if you will, a beautiful happy family: a dad, a mom, and a few kids. This unfortunate family learns that dad has a heart problem and needs to have a major surgery. The whole family heads to the hospital together on the day of the surgery. They meet together with the doctor who reassures them that his team knows what they are doing; they have done this surgery thousands of times. The family sighs in relief, feeling like everything is going to be "OK." Dad is wheeled off into the operating room and the rest of the family gathers closely together in the waiting room. The clock watching begins.

Every hour, on the hour, the doctor sends a nurse from the operating room to the waiting room. "Your husband is doing great. The surgery is progressing as planned, no complications whatsoever," the nurse reassures the family. These friendly updates keep the family from panicking and they continue to wait anxiously, but confidently, throughout the lengthy surgery.

Now imagine the same scenario without the regularly sent, reassuring messages from the doctor.

During the first hour, mom keeps thinking about the doctor's confidence. She believes everything is going to be fine.

During the second hour, she remains confident, but her memory of the doctor's confidence begins to fade. Butterflies start to flutter in her tummy.

During the third hour, mom starts looking up every time a nurse walks in. She is in need of some reassurance.

During the fourth hour, mom can't remember anything the doctor said. Panic sets in. She starts imagining her husband flat lining on the operating table.

During the fifth hour, mom is in a total state of hysteria. She is sure her husband is dead. Her hysteria spreads to her kids. Everyone is freaking out.

"Friendly updates" could have changed everything for the family above.

I often say that graphic design is like open heart surgery. The area of friendly updates is one of those cases. Many clients freak out about their projects like the family did about the dad's surgery in the above example. The less you communicate, the more your clients will begin to get nervous, panic, or even freak out.

It is critical to keep your finger on the pulse of your projects and provide "friendly updates" to your clients to reassure them that everything is going to be OK. This is especially true if the milestones are spread out over long periods of time.

Quick, short, email updates can make all the difference in the success or failure of a project—especially where new clients are concerned. Tell your clients what you are working on and reassure them that you have their project on your mind and in your project queue. A great example of a friendly status update could be as simple as this:

"Just wanted to shoot you a quick email to let you know that we started designing your logos today. We have some great ideas and look forward to sending them on Tuesday."

Alternatively, you could begin with something like this:

"The team began programming your site today…"
"We provisioned your server this afternoon…"
"We've made good progress on your comps and plan to send them to you tomorrow afternoon per the schedule…"

These are just a few examples. Each of these updates will help your clients get back to the level of confidence they had in you at hour one. Use your judgment and try not to overwhelm them with details when you send them a friendly update. Just reassure them that you are in control of their project and that it isn't flat lining on the table.

JUST REASSURE THEM THAT
YOU ARE IN CONTROL
OF THEIR PROJECT
AND THAT IT ISN'T FLAT
LINING ON THE TABLE.

56 DEADLINE BALLET

One of the fastest ways to ruin a client relationship is to miss a deadline. You must make every effort possible to deliver on what you commit to your clients, bosses, and coworkers. At times there are reasonable circumstances that create an inability to deliver on a promise. While these circumstances need to be kept to a minimum, when they do happen there are strategies to help you gracefully dance through an uncomfortable situation.

Get others involved. As soon as you feel a deadline may be in jeopardy, you should run it up the chain of command. If you are a designer, tell your art director or business owner. You have to make people aware as soon as you know a deadline will be missed. The later you notify the appropriate people, the bigger their disappointment will likely be. Nobody likes this type of surprise.

Be deliberate about communication. An increase in the scope of a project is often the biggest culprit behind a missed deadline. You'll be on a call with a client and they will ask for something new; this is the moment to talk about the deadline, not a few days later when the deadline is zooming by you at the speed of light.

It is not uncommon for a client to miss a deadline on their end. They may be late in sending you necessary assets for the project. As soon as they miss their milestone for delivery of assets, you must begin a discussion with your client and your creative director or boss about the deadline in question.

Another reason for missed deadlines is an unanticipated software glitch, or maybe your computer gives out on you. Perhaps you are programming something for a website and there is a bug in the code. These types of problems happen and can cause extreme delays in production. When things like this go down, it is vital that you communicate the problem and take an active role in finding a solution. Be warned, however, that clients aren't too interested in "the dog ate

my homework" stories. Be sure you have version controls on code and backup versions of files to hedge against the chance of software and computer issues.

Put your tail between your legs and fess up. When a deadline is in jeopardy, a message should be sent to the client. The message should be apologetic in tone and should state the reasons for missing the deadline. Even if there is a death in the family, you should muster the strength to apologize for the missed deadline.

If the client is the cause of a missed deadline, be careful not to play the "blame game." State the facts and apologize. If you are at a point in the project where you have something that is appropriate to send as is, then send it so the client can at least see where the project stands.

Realign expectations. Now that the cat is out of the bag, you need to establish a new set of expectations with the client. Make sure that you and the client both understand the new milestones and be sure to put it in writing. If it is a verbal conversation, make sure to send a follow-up email as well.

Hit the next deadline and apologize again. One missed deadline, and you might be able to salvage the client relationship. Two missed deadlines and you are probably doomed. Be sure you hit the realigned milestones, and when you do, be sure to apologize again for missing the previous deadline.

Rebuild the relationship. Once you successfully complete the project, begin your efforts to rebuild trust with the client. Don't be afraid to talk about the missed deadline. Discuss with them what you have changed in you process to ensure it won't happen again. Tell them how important they are to you and your business. Now is a good time for a lunch invite or another "out of the office" experience to help strengthen the relationship.

Missed deadlines will happen. Most of your clients know that and have experienced it. If you take the right tone with the client, your relationship can survive the setback and more projects will likely come your way.

57 BIG BROTHER

About a year into my career, fresh out of school, I was on a conference call with a client. From my direct marketing agency, it was two team members and me speaking with the client. We were building a website and creating various other marketing materials for them, and they were having difficulty grasping our explanation of the project. We became increasingly frustrated due to their ignorance, and when the call ended we hung up the phone and began a rant about this client's apparent idiocy. Then I glanced down at the phone and realized that the light was indicating the line was still active. I broke out into a cold sweat and quickly tapped the disconnect button about a dozen times.

Had they heard all the names we just called them? To this day I still don't know. And it doesn't matter anyway; there is no doubt that I learned my lesson: "You have to assume that someone is always listening." Think about it for a minute. There are so many ways that someone can overhear you trash-talking your clients, your colleagues, or any number of other seemingly unsuspecting people in your life.

Is the phone line really disconnected?

Are you sure that someone isn't in the other room? Down the hall? Up the stairs?

Does the mute button really work on your phone?

Is your teammate on a call with a client who can hear you in the background?

Are the walls really as soundproof as you think?

Perhaps you assume you'll be safe speaking outside or ranting over lunch with your coworkers. Are you sure the people sitting within earshot don't know who you are or who it is you are talking negatively about? You can't be certain.

You have to be especially careful of this issue online. Your personal Twitter and Facebook posts can spell relationship disaster if used to vent about a frustrating client or project. Once that information gets blasted into the black hole of cyberspace, you can never take it back.

I have an acquaintance that seems addicted to complaining about people. Every time I'm with this person, it seems they have a new person to bash on. I reluctantly listen and think to myself, "Hmmm. I wonder what they say about me when I'm not around." If you complain to one client about another client, they could easily assume that you do the same thing about them. This type of behavior quickly erodes hard-earned trust and can tarnish your reputation as a designer as well as a person of character and integrity.

OK, let's be honest. A little venting can be a healthy way to cleanse yourself of life's frustrations. And, admittedly, some clients certainly deserve every ounce of negativity you may telepathically (or even verbally) be sending their direction. But you had better be absolutely certain that your remarks are confidential, or they can destroy a profitable relationship for you or the business you work in.

Maybe the best thing to do is take the old advice, "If you can't say anything nice, don't say anything at all," and apply it to your life at home, at work, and with your friends. The conspiracy theorists might be right: Big Brother just may be listening after all.

58 THE DOMINO EFFECT

My childhood fight against boredom drove me to find creative outlets. In between fort building and forest exploration, my brothers and I spent hours and hours playing with Legos, Lincoln Logs, Erector Sets, and dominos. I have fond memories of setting up domino trails and knocking them down. One tap on the first domino sets off a chain reaction that cannot be stopped until it topples every other domino in the trail.

Few things say to your client "we've got your back" better than creating a chain reaction. Here is an example of a chain reaction in our business:

1. Client X calls or emails to green light a project.

2. Immediately: Business development person sends an email to the client, "Thanks for sending this project to our team. Everyone is excited to work on it. I've Cc'd our production manager, John Doe, to loop him in on the project so that he can get things rolling with his team. I'd also like to introduce you to Jane Doe who handles our accounting. She will be in touch regarding invoicing details."

3. Immediately: Production manager replies to the business development person's email, "Client X, We are really looking forward to working with you on this project. We will be setting up the project in our online production management software. When we do so, you will receive a link with some instructions of how to access the project in that system. We use this software to manage milestones and communication regarding the project. Our goal is to ensure that you always know what is going on with your project while it is in the development phase."

4. Immediately: Office manager replies to the business development person's email, "Client X, The production team is excited to get started. I will be the point person for all accounting procedures. Is there a Purchase Order number that we should include on our invoices? Also, are you the best contact for invoicing or should we get in touch with someone else for those details?"

5. Within one hour: Production manager sets up the project in the online production software and Client X receives an email with instructions regarding how to access that information. Production manager also sets up FTP access for the client to upload assets to the server.

6. Within 24 hours: Production manager sends an email to Client X introducing them to the art director on the project. The art director then requests to set up a Kickoff Meeting with the client to discuss the design details of the project and ensure that the design team and the client are on the same page.

Imagine how Client X will feel as this sequence of events plays out. Within the first 24 hours after giving the project the green light, they have been in correspondence with four key people on the team, accessed your production management software, gained FTP access to your servers, and scheduled a Kickoff Meeting with the art director and design team. All of these things were instigated based on a chain reaction that began with Client X green lighting a project. The only reaction the client can possibly have is, "Wow, these people are on top of this project!"

Every business is unique. Perhaps your business does not have an art director or office manager. Whether your company is large or small, or if you are just a one-person team working out of a dimly lit corner of your basement—it makes no difference; chain reaction systems can be created for any size or type of business. Getting started is easy; simply pull out a piece of paper and start jotting down the sequence of events that follow key moments in your projects.

It may look something like this:

Event: Client green lights a proposal.
 Chain reaction: What happens next?

 •

 •

 •

Event: Client sends feedback on design comps.
 Chain reaction: What happens next?

 •

 •

 •

Event: Project is completed and approved by the client.
 Chain reaction: What happens next?

 •

 •

 •

Each of the events in your chain reactions list should be designed to amaze your client with your organizational skills and attention to the details of the project. Formalize and document your chain reactions so that they can be utilized by all the members of your team, thus ensuring a unified client experience with your company.

In contrast to all of this, few things scream, "we don't really care about your project!" more than a client green lighting a project and then having several days pass before any communication or progress is made on your end. Even if the project isn't scheduled to start for a couple weeks, it is still important to keep regular communication going in the down time. A green-lit project is a fire that needs to be stoked regularly to keep the flames of client satisfaction and confidence burning.

AVOID THE W.W.W.

Avoid the W.W.W.? No, we're not talking about the World Wide Web—we are talking about the fact that you never want your clients to Wait, Worry, or Wonder (the W.W.W.). Every effort should be made to avoid these concepts in your dealings with your customers and clients.

Wait. Clients should never be left "waiting" on you. If you say that you will send them comps at 3:00 P.M., then make sure you send them at 3:00 P.M. If you are not going to make that deadline, then by no later than 3:00 P.M. you must reach out to them via email or phone, letting them know that you are running a little behind and you won't have the comps ready until 4:00 P.M. (or by whatever new time you anticipate having things wrapped up.)

If you have a client meeting scheduled for 10:00 A.M., then you should show up at 9:55 A.M. If you're not there as 10:05 A.M. rolls around, the client's confidence in you begins to take a nosedive.

Worry. Clients should never "worry" about the responsibilities they have given you. Part of your responsibility is to exude confidence in your ability to execute on their project. By clearly communicating expectations and your development strategies, you can keep your clients from "worrying" unnecessarily.

Wonder. "I wonder if anyone is working on my project?" "I wonder what I'm going to see next?" "I wonder if these guys understand what I'm trying to accomplish with my project?" These and more are the types of things your clients should not be "wondering" about you.

Clear communication is the key to avoiding the W.W.W. This includes clearly communicating timelines, development strategies, contact information, conceptual understanding of the project, and any other pertinent information related to succeeding on the project your client has entrusted you with.

CLEAR COMMUNICATION
IS THE KEY.

60 BE AFRAID TO CLICK "SEND"

How many times have you walked out of your room thinking, "Dang, I look good!" only to hear your spouse say, "Are you going to wear that? You really ought to change. Let me pick out something for you." The fact is that getting a second opinion on your handiwork is critical to success in every area of life. When viewing your own work, it is easy to overlook little details and to miss things due to your closeness to the project.

Most graphic design organizations are good at assigning people to complete project tasks. When a project is given the green light, a designer is assigned to create the look and feel of the design, a programmer is assigned to build out the functioning pages (for Web-related projects), and—in bigger organizations—a producer is assigned to pull all the pieces together into a polished, cohesive unit. Obviously, though everyone should be checking his or her own work all along the way, you will not be the best proofreader of your own work. I'm a firm believer that at least one person should be assigned to be the proofer on any given project; to be honest, the more people you have proofing the work, the better.

Not to be boastful, but I must say I have become a talented proofer. Perhaps all those years of sending unintentional typos to my clients have scarred me into a state of perpetual paranoia. To further clarify— proofing goes beyond textual consistency and accuracy; it extends to layout and design elements as well. I don't follow a checklist or specific strategy for proofreading graphic design work, but if you are in need of improving your skills in this area, here is the general flow of what works for me.

Big Picture (Take a first glance at the project; then take a few steps back and look again.)

- Does the design match the client's brand?
- How is the overall composition? What would improve it?

- Compare the design to other projects the client may have mentioned or that you used as inspiration (such as example sites or printed material). Does the design meet or exceed the quality level of those samples?
- What is the point of the design? Is it trying to sell something? Tell a story? Convey a message? Is this accomplished from a big-picture standpoint?
- Are the dimensions of the design appropriate for the project?
- Is any text the same from area to area within the project, and if so is it consistent in all ways?

Broad Strokes (Begin drilling into the main areas in the project.)

- How does the eye flow through the design? Is the eye resting and focusing on the right elements in the right order?
- Does the visual weight of the design elements work? Is there anything that's too heavy? Too light?
- Is the color palette working? Are there colors that do not seem to fit the brand or design?
- How are the font choices? Are there too many being used? Too few? Do they work well in the design?
- Do photos and images match and support the overall design and messaging?
- Is the core messaging clear? Is there a headline or other text that needs to convey a different message? Will people easily know what they are looking at?

Nitty Gritty (Scan through every pixel of the project in detail.)

- Look at every single word and punctuation. Are there typos?
- Are design elements structured on the grid properly? Is there anything that could break the plane on the grid to add more interest to the design?
- Is there anything off-center or out of alignment? Text elements are the biggest culprits of this problem.

- Have photos been treated properly? Have they been adjusted and enhanced properly? Are photos facing the right direction? Have they been cropped properly?

- Is font usage consistent in the design? Is the text spaced properly (leading and kerning)? Is there any missing punctuation? Any widows or orphans? Rivers?

- Are there any weird design tangents? This is a very common design issue. Brush up on your Gestalt Theory to look for these things.

As a side note, spell check is not infallible. Their are many times that words can seam two bee correct, when inn reality, the VERSION or MEANING of the word in question has altered the hole gist of the point ewe are trying two make. This can make four a very embarrassing conversation with a client or you're boss; inn sum cases it could even cost ewe future work.

This is hardly a conclusive list, but these are some of the core elements to look for prior to sending anything in for review. The last thing you want is to be seen as foolish, hasty, or worse yet, inadequate as a designer, simply because you failed to pursue due diligence in the areas of proofing and editing your work.

61 THE TRAGEDY OF TIME ZONES

In the early years of my business, most of our clients were in Los Angeles (Pacific Standard Time). My company was located in Utah (Mountain Standard Time), which carried a one-hour time difference with the bulk of our clients. At the time, most of our team worked a 9:00 A.M. to 6:00 P.M. shift. This meant that our day was ending around 5:00 P.M. in Los Angeles.

Many days included a scramble to meet our deadlines. I remember numerous days where we would click Send on a delivery email at 6:01 P.M. to hit our deadline. The time difference between our location and that of our clients was definitely working in our favor, as 6:01 P.M. was 5:01 P.M. in Hollywood.

Although this strategy was seemingly working, oftentimes our clients would blast back a response for us to make a few minor edits before they could send the designs up the chain of command for approvals. This response often led to us needing to stay later than expected to implement the client's changes.

Our solution to this problem was to move our delivery time back a couple hours. Instead of considering 6:00 P.M. an acceptable delivery hour, we pushed it back to 4:00 P.M. This meant we could hit our deadline and still have a couple of hours left in our day to make last-minute client changes.

The success of this strategy was short-lived, as soon thereafter we began to secure clients on the east coast—mainly in New York City and Washington D.C. These clients had a two-hour time change that was working against us. Our 4:00 P.M. deadline delivery goal became 6:00 P.M. in these clients' locations. If these clients requested some last-second adjustments to their designs, they were often left staying late at their office as they waited on us to make the changes. (Making your client stay late at work is not a good way to make them love you.)

All of this came to a head when we were creating a large interactive website for a major consumer products company. The project had gone famously. The client was ecstatic with our work and with their interaction with our team. We almost got through the project without a single blemish until the day of the soft launch of the project when we received this email from our client:

"We never got a link today for final review of the development site. We're going to push the launch of the site until tomorrow."

It was only 3:30 P.M. our time when this correspondence came through. But with the time change, it was 5:30 P.M. in our client's location. Even though we still had a couple hours left in our day, in their eyes, the business day was over and we missed the deadline.

I felt awful. Our perfect relationship had now been marred by a slipped deadline. I envisioned the client checking their email periodically throughout the day and their disappointment growing with every email check that didn't yield our delivery. Did they badmouth us to a coworker? Was their boss' boss wondering where the delivery was? Would we be able to salvage the relationship?

Fortunately for us, we had built up enough clout with the client to see us through this incident, but a valuable lesson was learned. Graphic design is a deadline-driven industry. Designers, for the most part, are all used to working under the gun of the deadline. However, that deadline is often mistakenly just a "date" and not an "hour."

To remedy our problems with time zones and worrisome clients, we strive to send our day's deliveries in the morning. Unless you are working internationally, your clients will typically receive your morning delivery with applause. For us, a morning delivery typically ensures that our West Coast clients receive their deadline deliverables before they get into the office, and our East Coast clients receive them around lunchtime.

 Even if you are doing work in only one time zone, meeting your deadlines before lunch is a better way of doing business. By doing so, your clients will have a window several hours long that ensures they will know that the deadline was hit.

And you will be able to relax all day knowing that the pressure is off for the time being.

Most of us learned the art of procrastination while working our way through grade school. This art is often perfected in the first few years working as a professional graphic designer. The best way to ensure that deliveries can happen in the morning is to put pressure on yourself to have everything ready the night before.

NEVER FIRE A CLIENT?

cool!

NEVER GIVE your clients HOME WORK!

Stand in manure smell like manure

Let your client leave their MARK

ASSUME PEOPLE ARE IDIOTS!

SECTION 4

HAPPY
HEAD HONCHOS

EVERYONE HAS TO ANSWER TO SOMEONE.
IT MIGHT BE A BOSS. IT MIGHT BE A CLIENT.
IT MIGHT EVEN BE YOUR MOM.
LEARNING HOW TO HANDLE SUPERIORS
TACTFULLY WILL OPEN THE DOORS TO SUCCESS.

TO: YOU FROM: ?

DON'T BE THE DESPERATE GIRLFRIEND!

Let your client be the 800 lb gorilla

RAWR!

FORGIVENESS POINTS

62 DESIGNERS ARE FROM MARS, CLIENTS ARE FROM VENUS

Just about a year after my wife and I were married, we were invited to attend an evening dinner event where a professional marriage counselor planned to talk about how to make a great marriage. Although our marriage was (and is) a great one, we decided to attend the "break from the norm" date night. The counselor gave a great speech—funny and well presented. Like a typical male, I don't recall everything he said…merely a few highlights.

He explained to the young crowd that men and women differ in many ways. For example, when presented with life's trials, women seek to be understood and comforted, whereas men seek solutions. As a result, when helping someone (like a spouse) through life's trials, women give comfort and understanding, and men give solutions. He continued to illustrate the point that men think one way and women think another.

Ironically, his time ran out and he didn't get to the portion of his speech where he presented to the group "the solution" to the dilemma. My beloved new bride and I went home and she cried for an hour as she wondered how we were ever going to make our marriage work while being so naturally incompatible. Of course, I presented her with plenty of solutions.

Graphic designer and client relationships are often like husband and wife. Sometimes love is in the air. Sometimes frustrations arise. And sometimes divorce is inevitable. Most of these divorces are the result of the fact that designers think and act one way and clients think and act another.

This chapter may come across like that marriage counselor's speech. I intend on illustrating the differences in how designers and clients think, but not provide you with any solutions. In some ways this book itself is an effort to be a solution to this dilemma. But the harsh reality may be that there is no cut-and-dried solution. However, the simple knowledge of the differences could be enough to help avoid the potential pitfalls found in the natural incompatibilities between designers and clients.

Let's start with what makes designers tick. You likely became a designer because the insatiable need to create things fuels your soul.

You want to design cool stuff. That is item number one and needs no explanation.

You likely want to make money while you design cool stuff. Otherwise, you probably would have chosen a different form of art.

Pretty simple: Designers want to design cool things and make money. As a result, designers spend all kinds of time trying to sell people on the fact that they can create cool things. They design slick portfolio sites. They create books showing off their work. Heck, at my company we even put portfolio samples on the back of our business cards as we search for every opportunity to show off the cool stuff we can create. We do all this in an attempt to make money doing what we love.

So what do clients want? In my experience, clients are in search of the following types of things.

A return on their investment. They expect to spend money to make money. Clients typically expect that buying graphic design services from you will yield more sales and money for them.

Looking good for their boss. Many of the people you work for have a boss or other stakeholder breathing down their neck. Their goal in hiring you is to help them look good.

Stress relief. Clients are often stressed, worried, or confused about their graphic design project needs. They are looking to you to lighten their load. They just want to be able to sleep at night. They want to trust and have confidence in your ability to execute on their project.

A good deal. Clients are shopping for a good deal. They want you to work for as cheap as possible. No, not every client plans to financially abuse you, but plenty of them do.

Relationships. Most clients are searching for someone who can solve these problems for them on a regular basis. They want to build a relationship with their vendor so they don't have to go through the trauma of searching for a vendor all over again.

Good design. In some rare circumstances, clients may be actually searching for amazing design. But in most cases, clients care about good design only as a means to accomplishing the other objectives previously noted.

Designers try hard to sell graphic design. What they really should be selling are the things the client, boss, or stakeholder really wants. People buy confidence. People buy trust. People buy relationships. People buy stress relief. People buy good deals. If you can solve these client needs and have the privilege of creating cool design, consider yourself lucky and be sure to pinch yourself on your way to the bank.

PEOPLE BUY RELATIONSHIPS.
PEOPLE BUY STRESS RELIEF.
PEOPLE BUY GOOD DEALS.

63 LET YOUR CLIENT LEAVE THEIR MARK

Most of your clients want to feel like they have in some way influenced the work you are creating for them. Not only is it wise to let them think that, but it's good practice to sometimes graciously accept their influence. However, many designers tend to be naturally defensive about their work. During client presentations, these types of designers go in with their armor on and shields up, ready to defend their design to the death if need be. Whether a client's feedback is big or small, a battle will ensue where the designer will argue every point the client makes in order to keep their precious design intact. This attitude causes problems in several areas.

First, this approach to design defense does not recognize that the client is paying for the work. If they want you to try something in red instead of blue, they are entitled to see that comp. They're writing the check. Giving in to client requests does not show weakness, but rather it shows that you respect the client and understand your relationship—they are paying you to work for them.

Second, battling every little design point that a client makes does nothing but create conflict and convey a sense of pride and arrogance on your part. Your job as a designer is to make your client's life easier, not more difficult. If they feel like they need to argue with you over every little detail, their tolerance for working with you will quickly wear thin. This is a surefire way to lose a client.

Third, letting the client make changes to the designs helps them feel ownership and pride in the finished product. There is no better way to help a client fall in love with the design than if they perceive something to be their idea and their masterpiece. When they love the work, they will parade the design around their office telling all their colleagues something like, "See that? That was my idea. Isn't it cool?!"

Also, when the client loves a design, they inevitably love the person who produced the design. This is the way to win the loyalty of long-term clients.

It is important to note, however, that I'm not suggesting that you roll over and agree with every comment a client makes about your work. There are times when requested changes need to be tactfully fought. I'm merely suggesting that letting the client leave their mark on the design can empower them to take ownership of the project and continue coming back to you for more.

The next time a client wants to change something that seems insignificant to you, don't get riled up. It is important for your clients to leave their mark on the work in order to feel a sense of pride in the project. Don't try to talk them out of every idea they have; instead find ways to let them leave their mark while maintaining the integrity and splendor of the design.

64 "FORGIVENESS" POINTS

With every new job, new boss, new client, or new project, you have one goal and one goal only: to build up "forgiveness points." The graphic design industry is filled with craziness. A myriad of variables will inevitably cause a project to blow up at some point in your career. A typo may get printed. Perhaps a server will get hacked and disable a website you created. Maybe you or someone on your team will miss an important deadline. At some point in the lifecycle of your business relationship with a client or company, something will go awry and the project will come to a screaming halt. Whether your relationship with the client or employer will survive the blow depends on how many forgiveness points you've accumulated.

Forgiveness points are what I consider the measure of how much a client will overlook your flaw when it inevitably rears its ugly head. When you start a new job or land a new client, you start with zero forgiveness points. Over time, these points are then built up through your perfect execution of work, such as

- Producing high-quality design work
- Hitting deadlines
- Exceeding expectations and going the extra mile
- Making no mistakes in the work
- Not missing client-requested changes
- Building a strong relationship with the client through extra-curricular activities

Now, knowing that you start with zero forgiveness points, if you miss the very first deadline on the very first project with a new client, the client may have a tendency to say, "Wow, they missed the first deadline. This isn't going well. We need to look for someone else." However, if you have forgiveness points built up after having hit every deadline with that client over the past twelve projects and then you

miss a deadline, the client may be more apt to think, "Wow, that stinks. But they have been so good for so long. They've never missed a deadline before. No doubt this was a fluke and they will be back on top of their game in no time."

Forgiveness points are quickly lost when anything goes haywire at any time in a project, whether it is your fault or not. Examples of things that can whittle away at your points are

- A website server going down
- An associated vendor making a mistake (a bad print job, for example)
- A needless mistake (typo, forgotten request, etc.)
- An argument with a client
- A missed deadline

With most clients, you lose forgiveness points at a much higher rate than you gain them. You may have to do three great things to gain enough points to offset the loss of points from one bad thing. Three great projects with a client might see you through one disaster project. And then you're back at zero, and your client is likely thinking, "We'll see how the next project goes before hiring them again."

As an owner of a design agency, I have seen forgiveness points used in a different light: as they save and lose the individual jobs of my

employees. In 2008, a programmer who had saved the day many times at our company during his two years of employment played a key role in a botched project. I never once considered letting him go. He had been "so good for so long." He had plenty of forgiveness points build up to warrant my immediate and irrevocable forgiveness for his mistake. Alternately, in 2010, a new designer at our company had two errors go to press in his first month working at our company. We had to pay for reprints on both of the jobs. This designer hadn't proven himself yet. He had zero forgiveness points in his arsenal, and thus we made the decision to part ways. We couldn't afford to keep working with him in hopes that he wouldn't continue to make mistakes.

Forgiveness points with new clients or employers take time to accrue. Stay focused and on top of your game at the start of every new relationship. Over-deliver and amaze your client or employer with perfect work for as long as you can sustain it, because inevitably, someday, you will be at the center of a disaster project with nothing to see you through but your forgiveness points.

65 LET YOUR CLIENT BE THE 800-POUND GORILLA

Never underestimate the power of humility or the importance of keeping your foot out of your mouth. While this can be a difficult thing—especially if you are a designer with on-fire ideas and a killer portfolio—it is vital to your continued survival within the tight-knit group that is called the "client pool."

ABC Television has been a client of ours for years. We love working on their projects, and our contacts there are truly fun and wonderful people. On one of our many visits with them we had a chat about the different personality "styles" that design agencies have. We talked with them about how we are service oriented and always made an effort to accommodate the needs of our clients, no matter what.

Our contact at ABC began sharing some frustrations he had with an agency that they had hired recently for a big project. He told us about how they had a meeting to discuss the project and the agency people ended up doing a lion's share of the talking, even though ABC had definite ideas in mind of what they were looking to accomplish. The agency execs told ABC what they needed and what the project should be without taking the time to listen first. I envisioned the stereotypical agency troupe, walking in wearing black turtle-neck sweaters and horn-rimmed glasses, their pointy noses in the air and smartphones gleaming under the fluorescent lights. I also saw in my mind's eye these agency folks walking out of the meeting thinking they were so cool and—after they were gone—the ABC folks talking about "what a cocky bunch of jerks they really were."

The lesson that I ultimately took away from this conversation was the importance of "letting your client be the 800-pound gorilla." Now, I'm not saying you shouldn't offer up recommendations and ideas. You definitely should have an air of confidence and ambition when you present yourself, your company, and your ideas to a client. However, I am saying you should do it with some humility and respect. Your clients are the people who butter your bread. In a band of silverback gorillas, they are the dominant male, the head honcho that directs the day-to-day activities of the group. So be grateful for your clients and, for goodness sake, take the time to listen to their ideas before offering up your own. You have two ears and one mouth for a reason: so that you talk half as much as you listen. Take notes in the meeting to show genuine interest in what they are saying. When you speak, do it without the elitist, arrogant, or demeaning front that designers can be known for (even though your ideas may very well be better than their ideas). After all, the company they are hiring you to design for is their pride and joy; it's their baby. Do yourself a favor and hear them out—you will be glad that you did.

66 DO YOUR GENEALOGY

Previous chapters have gone a long way toward establishing the importance of your relationships to the success or failure of your career; now it is time to figure out who puts food on your table. Your clients and employers are the people who are the Santa to your Christmas, the quarter in your candy dispenser, and the banker in your real-life Monopoly game.

A couple years ago, I got into a deep conversation with one of the vice presidents in our agency. As we started discussing the history of our business and where our valuable referrals had come from, I grabbed a marker—as I often do—and headed to the dry erase board. I began to plot out the initial contacts we had in the early days of our business, and then I proceeded to draw lines connecting them to the people

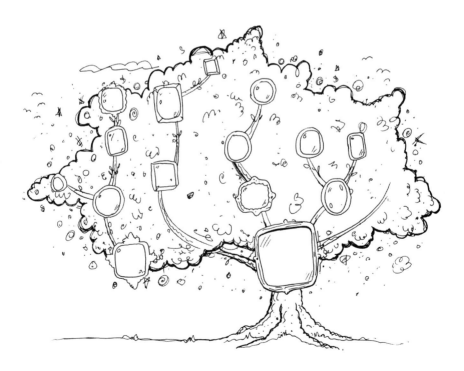

they had referred us to over the years. It began to look something like a company organizational chart.

As I took another look at it, I realized that it was more like a genealogy tree. Who would have thought that family history concepts could be applied to business! In the end, we had five years worth of referred clients and contacts mapped out on the board with lines connecting them together like a kindergarten craft project. What that genealogy revealed to us was nothing short of mind boggling: One initial contact from the early days of our business had been the seed of about 25 percent of all total business we had received moving forward over the years.

As a whole, our company has not spent much money on traditional advertising. What we have done is spend our money investing into our genealogy tree. This is the list of people who have actually given us work and paid us money! We regularly take clients to lunch, treat them to a round of golf, send them gift baskets, recognize their birthdays, and many other things to keep this list of invaluable people aware of us, as well as to let them know that we value and appreciate them. Before you spend hard-earned money trying to market your services in a magazine or billboard, first consider ways to spend money on your client genealogy tree.

In order to best leverage your relationships, you must understand your company's genealogy. Start with the very first client or two that gave you work. Put them on a piece of paper, draw a box around their names, and then draw a line to someone they referred you to. Figure out your client genealogy and then make sure you keep those people happy—after all, chances are high that they are the source of your greatest personal revenue streams.

67 NEVER GIVE YOUR CLIENT HOMEWORK

Over the past several years, we have been on retainer with TV Guide. Our strong relationship has definitely been win-win; they need us, and we need and appreciate them as one of our most active and long-term clients. A few weeks ago, we had a face-to-face meeting with them in which we discussed one of the big projects our team was in the process of executing for them.

During the meeting, I told the execs that we would need to have all of the project details broken down into To-Do items, which we would then add to our production management software. Our team would then be able to work off of those To-Do items to successfully manage all of the project details. For a second, the VP of the group looked at us like a deer in the headlights and I realized that he thought we were asking for his team to come up with all the To-Do items. He was likely thinking, "How in the world are we going to find the time to break down the project to that level of detail? And even though we have access to your production management software, we aren't very good at using it and don't have time in our day to figure it out."

I could almost hear those thoughts coming out of his head, and I quickly said, "You give us the tasks, changes, information but in any format you want. Whether it is a phone call, email, text message, instant message…you could write things on a napkin for all we care. We'll convert every request into a To-Do item, add it to our project management software, and work from that list." He exclaimed without hesitation, "THANK GOODNESS!" I could tell that I had struck the right chord, so I continued by saying, "We are here to make your life easier. We'll take care of all the details. Just feed them to us in whatever way is easiest, fastest, and least stressful for you."

Always remember that graphic design is a service-based business. In most cases, your client hired you because they are stressed out and need your help; giving them "homework" assignments only adds to their stress, and makes you look incompetent and unprepared to handle every aspect of their project.

Of course, there will be times when you need to ask your client to do things. In these cases, you can try to make it as easy on them as possible by gathering or prefilling as much of the required information as you can. Here are a few examples.

Project content: You are building a website for a client. Your client needs to send you the copy for the project. Instead of asking the client to email the copy to you, think about how you can make it easier for them. Perhaps you could prefill a Word document with all of the copy from their current site and email them that copy with a message like, "We are at a point in the project where we need the copy for your new website. To make this as easy as possible for you, we took the copy from your current site and pasted it into the attached Word document. We know you are planning to change a lot of that content on your new site, but hopefully this will help make it easier for you. Please let us know how we can help."

Project images: It is time for photos to be added to the brochure you are designing for your client. You might be tempted to email the client and ask them to send the images they want to include in the brochure. Don't fall for that temptation. Instead, think of a way that could make it easiest for the client. You could say, "We are ready for the final images to be chosen for the brochure. The final design has room for seven photos. Two of the photos are the ones you sent at the start of the project, which means we'll need some stock photos for the other five. We have set up a lightbox on the stock photo site we use and filled it with a dozen or so options. If you don't find five images in there that you would like to use, you can easily add additional photos to the lightbox and we can chat them over. Here is the information needed to access the lightbox…"

Prefilled bad-word filter: Recently my company created an online application for a kid company. The application had several submission forms, and due to the fact that it was a form targeting children, a bad-word filter was required. Instead of saying to the client, "We are ready for you to send us the bad words you want to include in the filter," we said something like, "We are creating the bad-word filter for the application. We have a list of bad words that we have used on past projects. Would you like us to use our list? Or do you have a list that you have used in the past for similar projects? Here is a link to our list…" As with the other examples, this goes to show that you should do everything you can to make the client's assignment easy.

Prefilled Creative Brief: At the start of each project, we prepare a Creative Brief for our clients. The document contains a series of questions that help us get on the same page as our client. We discuss the Creative Brief with the client on the phone or in a face-to-face meeting. Prior to the call we fill the document with all of the information we currently know about the project. Oftentimes, we'll even put in our assumptions about the project and ask the client for confirmation. We never send the empty document to the client asking them to complete it.

These are just a few examples of the types of things we see in our business. The types of clients and projects in your business will likely be different, and there will inevitably be times when your client will need to provide you with parts of the project. But the message is the same for everyone: Do everything you can to keep the things you need your client to do at a minimum. After all, they hired you to do the job. The more you do without their assistance, the easier you'll make their life.

68 ASSUME THAT PEOPLE ARE CLUELESS

One of the best things a designer can do is assume that people are clueless. And for the most part, in this context the clueless people are your clients. Now I am not positing that your clients are literally mindless morons—chances are they are very intelligent and successful business people. However, graphic designers often err by assuming that their clients know way more than they do about what the heck is going on regarding the design process and their role in it. Assumptions are frequently made that your clients understand how to give feedback, what they are looking at, what is coming next in the project, and so forth; these assumptions are usually way off base.

Most of the time, your client does not understand what it takes to execute their project. They probably don't know how to give good feedback. Your client doesn't know what the next steps are. There is frequently no understanding of the graphic design process at all. And unfortunately, the best chance for success in every project stems from a working relationship where the designer and client work together as partners. You must understand their needs and they must understand how you will work to satisfy those needs. In every phase of the project, it is safest to assume that your client is clueless, thus your job is to teach them along the way so that they can successfully play their role in the project.

There are three key areas in which your client may need your help to understand their role as it relates to their project.

Your client may need your help understanding what they are looking at. You must assume that your clients have basic computer knowledge and little understanding of graphic design elements. If you are

meeting with a client face-to-face, teaching them about what they are looking at is easier than having to explain yourself every time you have a conversation with them about comps or revisions. If you are emailing elements to your client, then you must assume they are clueless and explain to them what they are looking at. Here are some examples to help you get the gist of this mindset and how to correctly implement it into your business practices.

(Bad) Assuming too much: "Attached are the logo comps for review."

(Good) Assuming they are clueless: "Attached is a ten-page PDF of your logos. The first page contains all the logos on one page. The other nine pages in the document contain each logo individually placed so it can be reviewed separately from the others. We recommend that you print all ten pages and hang them where you can see them."

(You'd be surprised how many times we have had clients not know to scroll on a multipage PDF. These clueless clients think you sent them only one logo and will therefore assume that you are the clueless one.)

(Bad) Assuming too much: "Here are the website comps for review."

(Good) Assuming they are clueless: "We have completed the website comps for your review. Clicking the link below will open your browser window to view the comps. Please keep in mind that these comps are nonfunctioning images only. That means that buttons and other elements will not work at this phase of the project."

(You'd be surprised how many clients try clicking on comps because they don't understand the static nature of a comp.)

Your client may need your help understanding what you require of them. Once they have passed the proverbial design baton to you, even seasoned clients may have no real understanding of what their role in their project entails. You have a responsibility to educate them as to the best way for them to provide feedback and assets, and then you must learn how to manage their expectations. Failure to help them with these things can cause projects to blow up and can even result in you losing out on future business from that client.

(Bad) Assuming too much: "We look forward to your feedback on the attached logo comps."

(Good) Assuming they are clueless: "To help us arrive at the best logo design for your company, please consider the following when providing your feedback. Which logos do you like and why? Which logos do you dislike and why? Which color choices and combinations do you feel are closest to what you desire for your logo? Are there elements on different logos that you would like us to mix and match (perhaps the type on one logo and the mark on another)?"

(These types of questions help lead the client to provide the best feedback, and eliminates the blanket, unhelpful feedback designers the world over dread, such as "We just don't like any of these.")

(Bad) Assuming too much: "We are now ready to begin building your website. Please send us assets so we can integrate them into the functioning site pages."

(Good) Assuming they are clueless: "We are now ready to begin building your website. Please send us assets for integration. For copy assets (body text and information for each page of the site), you can just email them or send us a Word document. For photo assets, you could send us a CD, upload them to our FTP site, or email them over (assuming they aren't too large for email), whichever works best for you. Digital photos (JPEG, TIF) are best for us, but if you have things that need to be scanned, we can take care of that, too. We'd be more than happy to talk on the phone to help guide you through any of those processes."

(Don't make the assumption that they know what assets even are, let alone what format to send them in. You must teach the client all these things when making your request.)

Your client may need your help understanding what the design process requires. My team solves this by giving clients a rough overview of the design and production process when we kick off the project, and then teaching them what they should expect next at every phase of the project.

(Bad) Assuming too much: "We are excited that the website comps are approved and we are beginning the next phase of the project."

(Good) Assuming they are clueless: "We are excited that the website comps are approved. Next is the programming phase of the project. We will take the approved design and turn it into functioning website pages. The initial couple pages take the most time, so you may not hear a ton from us over the next couple days. But rest assured that we are heads-down on your project. We look forward to showing you some functioning pages on Friday, per the prearranged schedule. While we are working on the programming, we recommend that you start gathering your copy and images for the site. We will need to integrate that into the site after the initially built pages are completed on Friday."

(Take every opportunity to manage client expectations by explaining to them each phase of the project. The client should always know what you are doing and what they should be doing as well.)

One caveat: Be careful of your tone. The reality is that many (if not most) of your clients are extremely sharp, super talented, and successful individuals (in their respective field). When I say that you should assume they are clueless, it is only referring to their knowledge of your respective field. You never want to be demeaning to your client as you provide instruction and training. You should assume they are clueless, but not treat them like idiots. You have a responsibility to teach and train your naïve clients throughout the graphic design process.

69 LONG-TERM RELATIONSHIP VALUE VS. SINGLE TRANSACTION PROFIT

While serving as creative director for the online divisions of Fox Kids and Fox Family in the early 2000s, we hired an outside agency to do some layout work for our new style guide. The agency was highly recommended by another trusted vendor, so we didn't even get a competitive estimate. They sent in their price at $40,000 for the project and we immediately gave the project the green light. Their initial comps were spot on, and we were excited about the direction they were headed with the design. Over the course of a few weeks, my team sent over the content we wanted in the style guide and they flowed it into the templates we had approved. Everything was proceeding nicely. When we arrived at the end of the project, the style guide layout was beautiful and we were all happy with the results.

Then the agency sent over their invoice, which included a surprise "Change Order" for $20,000 on top of the $40,000 price we had agreed upon! Their justification was that the original estimate was for a certain number of pages and the content we sent them exceeded what they had bid on. Admittedly, their claim was true. The style guide ended up being many pages longer than any of us had anticipated.

My frustration was that they never once mentioned to us that they would need to increase the budget to accommodate the increase in scope of work. They were always more than happy to lay out whatever content we sent over to them without even a whisper to indicate that we were beginning to exceed the initial proposed amount of work; we proceeded under the assumption that the budget was still intact.

A few of us from our team had a conference call with the owner of their agency and the people assigned to our account. I asked about what world they live in where they think they can increase the cost of the project by 50 percent without ever mentioning to their client that they were incurring extra fees. The owner of the agency said that, "Even at $60,000, the project was still a steal of a deal by any stretch of the imagination." However, he failed to understand that my frustration was rooted in the principle of the situation, not in the cost.

We ended up being able to gain approval for the increased budget and we paid the invoice. Guess what? I have never once considered using that agency again. They sold out a chance to receive any future work for a measly $20,000. I spent the next couple years working at Fox—where our department had an annual budget in the millions of dollars—none of which went to that agency. Then I started my own agency, which, over time, grew to be larger than the agency that sent us the ridiculous change order. My agency has sent out millions of dollars worth of invoices and has outsourced hundreds of thousands of dollars throughout our years in business. Not once did I ever consider using that agency, even though their work and the finished product were excellent.

This situation may sound like it's got a bit of vindictiveness on my part, but know that I'm not a spiteful person; it was the lack of business tact in the delivery of the change order that I didn't appreciate. It seems this agency didn't understand that in business, a long-term relationship typically has more value than any profits a single transaction may generate.

Recently, we had a new client approach us to do some work. This client shared with us a few stories about how he had been burned by change orders from his previous agency. His biggest complaint was that they never charged what they committed in their proposal. Every invoice included extra change fees and additional charges. We, of course, promised that this would not be the case with us. However, in order to ensure that our clients know they will never be surprised by our agency, we added the following term to our proposal.

"The Client shall be responsible for making additional payments for changes requested by the Client that are outside the original assignment. An estimate for these additional charges will be approved by the Client before any work is done. No additional payment shall be made for changes required to conform to the original assignment description."

Unfortunately, the graphic design and advertising world is filled with people who charge extra fees that were not agreed upon by the client. This relationship-damaging practice is a detriment to your career growth.

70 ODDITIES AT THE START MEAN ODDITIES AT THE END

A few years after starting my company, we were approached by a client to create an interactive entertainment website. The project was big, and it was right up our alley. After all, we work with clients like Disney, Warner Bros., Fox, Sony, and such. We were a great choice for them, and our whole team was excited about the prospect. We sent our first estimate, just shy of $300,000, to get things rolling. Although they ended up green lighting a much lower price due to scope revisions, there was no sticker shock with the initial proposal. Moreover, the client was an advertising agency, and we were convinced this was going to be a great project. How could they be a bad client when they walk in our shoes every day? We expected nothing but smooth sailing and a successful working relationship.

Then the oddities started. Just before they officially signed off on the proposal, the agency asked us to complete a personality test for everyone on our team. They claimed they wanted to know who they were working with and—in a condescending manner—made us feel like this was commonplace with the big "ad agencies." We humbly agreed to complete their personality test and admittedly felt like we were out of the loop. "I guess all the big ad agencies make their vendors complete personality tests prior to working together," we thought. They sent over the tests in PDF format and our team members began choosing adjectives in a series of rows and columns to define their personality in the workplace. We sent the completed tests back to the client and anxiously awaited the results.

They were pleased that our agency had a good mix of personality types. Each employee had been categorized into four personality buckets. We had fun at our office finding out the results and teasing each other about our respective personalities. The client began asking questions about how the project would be run in our shop and who

ODD BEHAVIOR
AT THE START OF A PROJECT
IS ALMOST ALWAYS
GOING TO YIELD
MORE ODD BEHAVIOR
DURING AND AT THE END
OF THE PROJECT.

would be working on things on our side. We wanted an all-star team on the project and told them we would have our art director run point. He was our best project manager, and all of our clients loved working with him. They replied that they didn't want him to work on the project because he wasn't the right type of personality. (Keep in mind, they had never once met him or spoken with him in person or otherwise.) They wanted someone else from our team to manage the project on our side. This should have been a *huge* red flag that this client relationship was going to be a disaster.

We had seen our art director manage hundreds of projects during his few years with our company. We knew he was the man for the job. But we caved. We let them tell us how to run our company based on a five-minute personality survey. We assigned the person they chose to be the lead on the project. He wasn't an awful choice by any means, but he did not have the same level of project management skills as our art director.

We kicked off the project and got to work. The next eight months were filled with nothing but turmoil. The client revised the scope three times after kickoff. They were not willing to pay us for pieces of the project they cancelled after we began working on them. We had weekly phone calls, mostly asking them for assets that were almost always late. And in the end, they made a request to cut the entire project in half. We jumped through hoop after hoop in an effort to accommodate this client. Finally, we had enough and made the decision to part ways as amicably as possible.

In retrospect, the odd behavior exhibited at the start of the project should have been a crystal ball for us. We should have had some backbone and made sure we ran our business as we knew how. What kind of client thinks they can tell you how to run your business based on a five-minute personality test?

The moral of this bizarre but true story is that too often we as designers are too accommodating for our clients. Odd behavior at the start of a project is almost always going to yield more odd behavior during and at the end of a project. The best thing to do is take charge of the project from the very start and not be afraid to pass on a project if it appears it may be a heartache down the road.

71 DON'T BE THE DESPERATE GIRLFRIEND

Think back to high school. Remember the girl or guy who seemed "unattainable?" You know, the one everyone seemed to have a crush on? I am willing to bet that there was never a time when that person came across as being "desperate." On the contrary, that person probably seemed perfectly happy and confident with or without your adoration. I'm not a psychologist, but perhaps this lack of desperation is one of the attributes that made this person so desirable.

As a freelancer or agency owner, keeping business coming in is an ongoing activity. If you want to be successful, it is imperative that you have at least a few clients who provide regular work to your business. "Selling" to these clients should be first on your list of priorities. The challenge is approaching them with the right message.

If you come right out and ask for work, you could appear desperate. I have stooped to this level only once in my career (so far). It was in the height of the recession in 2009. NBC Universal was our biggest client from the previous year and they hadn't sent one project to us in 2009. Along with the rest of the service-oriented businesses in the world, we were nervous and getting desperate. I sent an instant message to my closest contact at NBC and said, "I'm unabashedly messaging you to try to drum up work. Got anything?" I didn't mind looking desperate to this contact and knew that our relationship could take it. Unfortunately, we don't have this type of open relationship with all our clients and a little more tact is advised when looking to generate business.

The most successful way we've found to ask for work without actually "asking" for work is a simple message to a client:

"We were just reviewing our production schedule for the next quarter. We've really enjoyed working on projects with you and are curious as to what your plans are for next quarter. Please let us know

what you see on the horizon when you get a free moment. We want to make sure we have production bandwidth available for you as the need arises."

(Obviously, this message should be customized to fit your tone and timing. Instead of "next quarter," you may ask about the next "week," "month," or "year.")

The goal of this message is to get an idea of what your client may have coming your way. It also serves as a friendly reminder that you exist and that you are ready and willing to help them when they need you. Essentially, it is a good way to try to drum up work without acting like a desperate sixteen-year-old looking for a date to the prom.

72 STAND IN MANURE, SMELL LIKE MANURE

Inevitably there will come a day when you will find yourself standing in a pile of manure. The longer you stand in the manure, the more you will begin to stink. It makes no difference whether it is your manure or not; the fact is that you are knee deep in it and you will begin to reek of it.

Sometimes projects go south. It doesn't matter how great a project manager you are, there will come a time over the course of your graphic design career when you find yourself knee deep in a disaster of a project. It could be your fault. It could be your client's fault. Perhaps it is even a third party's fault. Where the fault lies doesn't make any difference—what matters is that the project is off track, your client is frustrated, and you are guilty by association. As a result, everyone begins to smell. To you, your client reeks of manure. In the eyes of your client, your stench is unbearable. All parties involved are frustrated with each other and this is difficult to recover from.

A good friend of mine runs a small design agency in Tennessee. It seems he calls me about once a quarter to pick my brain on an issue he is dealing with. On one particular occasion, he was waist high in a manure pile.

His company had built an online game for Fox's hit show, "American Idol." The game was working great and ready to go live. The only problem was integration of the banner ads into the Flash game: The banner ad company provided ad code to the client. The client sent the code to my friend's programmers. My friend's programmers put it in the game. It didn't work. My friend told the client there was a problem with the banner ad code. The banner ad company told the client that there was a problem with the game.

I'm sure the client didn't know whom to believe. And it really didn't matter who was at fault. Both my friend's company and the banner

ad company looked bad. And to top it all off, the client looked bad too. Everyone involved was standing in manure. In the end, my friend's team figured out the problem, got everything working, and saved the day, but it was too late. They were now associated with a disaster project; the smell of manure had seeped into their pores, and to the client, they smelled worse than a pig farm on a hot summer's day. I doubt that client will be hiring a stinky vendor anytime soon.

Here are a few keys to keeping yourself and your company smelling like roses.

Avoid manure. Communication is the key to avoiding manure. Make sure your client always knows where you stand on projects, what challenges you are confronting, when they will be seeing things, and so forth. If there are third parties involved, make sure you have their contact info from the start of the project. That way, if something goes awry, you can communicate directly with the third party involved instead of using the client as a middleman.

Get out of manure fast. If you have a project that goes haywire, don't delay getting back on track. View your client as a partner in the process and contact them as soon as you realize you are in manure. Explain the situation and ask them, "What can we do to get things rolling smoothly again?" Effective communication can get you out of a manure pile better than anything else.

Send your client some soap. I didn't have to grow up on a farm to know that soap helps when you smell like manure. If you have a project that has gone amuck and your client is getting smelly, there is a good chance that you are getting smelly, too. Soap is the best way to clean off the stink. The kind of soap I'm talking about is something that presents an added benefit for the client. For example, you could add some new features to the project. Discounting pricing always helps put you in a good light, as well. You could also send a gift of some kind to the client. Be creative and do what is appropriate.

Know that when a project goes bad, whether it is your fault or not, you look bad and need to take drastic measures if necessary to begin smelling sweetly once again.

YOU ABSOLUTELY
HAVE A RIGHT
TO FIRE YOUR CLIENT.

73 NEVER FIRE A CLIENT?

I'll start this chapter by saying that you absolutely have a right to fire your client. But the lesson taught to me by one of my first bosses merits some consideration.

While living in Arizona, I worked at a direct marketing agency. The company struggled financially and the leadership was questionable at times. But I did learn a few lessons while enduring my time there. In a discussion about how to work with a difficult client, the president of the company offered up this advice.

"Never fire a client. Just raise the price on them. Then they will either be spending so much with you that they will be worth the pain they inflict on you, or they will not agree to pay the higher prices and they'll leave on their own. Either way, you win."

Certainly this advice is worth considering. We've tried it a couple times with mixed results. In some cases, the client pays the higher fees. In other cases, they go away. And in other instances, the client gets frustrated.

Most of our production team members do some freelance work, and they sometimes outsource work to each other. In one case, one of our current programmers asked one of our ex-programmers for a price quote to do some work for him on a small freelance job. The ex-programmer came back with an estimate that, when broken down into an hourly rate, amounted to $1,000 per hour. Our current programmer who requested the estimate

was frustrated and exclaimed, "If you don't want to do the work, just say so! Don't send an insulting price."

This is the only way the "Never Fire a Client" advice can backfire, so be careful when you follow it. It is definitely not applicable to every scenario. Sometimes it is just better to say "no thanks" to a client than to go through the frustration and turmoil that can come down the pike later. If the client is one you have had for some time, you will have to take that relationship into consideration, as it is likely that more is at stake than just their current business with you (such as potential referrals or bigger, better jobs down the road that may make working with them more worthwhile than it is currently).

74 "WE DECIDED TO GO ANOTHER DIRECTION" MEANS "YOU SUCK"

You put your heart and soul into a proposal. Sometimes you even fly out to see the client and make a fancy pitch. In the end, there are times when you are not selected to do the work. The client tries to let you down easily by telling you, "We decided to go in another direction." If I had a dollar for every time I heard that phrase, I'd be a rich man. We've learned to interpret what the client really means when they say it: "You suck, and we're just trying to let you down easy."

At the start of my business when we would hear that from clients, we would simply say, "Thanks for considering us. Please let us know if we can help you out in the future." Then we'd sit and speculate as to why we weren't chosen to do the work.

Speculation is healthy and can lead to improvement. However, nothing will help you land the next project with that client better than reacting to the facts. And to get the facts, you have to ask.

"Thanks for considering us. It was a pleasure putting the proposal together for you. We are always looking to improve our business and are curious as to what the determining factors were for your choice. Was our price too high? Does the agency you chose have more applicable experience? Any feedback would be very appreciated so that we can prepare ourselves to serve you better in the future. Thanks!"

You likely put several hours into trying to land the project, so you have a right to know why you weren't chosen. If the client truly considers you a viable resource for future projects, they will answer your questions. Your desire to improve your business and react positively to their feedback will also be a feather in your cap, as the client will see your dedication.

These are the most common reasons you will not win a proposal:

Price. Far too often, clients make their choice based completely on price. If you have a budget range from the client and you know they are sending out the project for bid, be sure you are on the low end of the budget so that this factor does not play a part in their decision. If you don't know a budget range, for some ideas see the chapter titled "How to Flush Out a Budget" in Section 5.

Confidence. Another determining factor is confidence. The client simply believes that someone else is more equipped to handle the job. This could be based on company size. It could be based on related experience. It could also be based on a gut feeling. But nothing makes you feel like you suck more than someone else being chosen because they are deemed to be more capable.

Relationship. Our focus on creating relationships has won us numerous projects. On the flip side, we have also lost many projects due to not having a strong relationship with the client. There are times where a request for proposal is sent out with the sole intention of reinforcing a decision to go with their preselected Vendor X. Your proposal is compared to that of the preselected vendor and everyone in the room says, "See, we absolutely should go with Vendor X." In these instances,

the client may not even reply to your inquiry about why you were not chosen. (Come to think of it, in most of these cases the client doesn't even reply to your proposal delivery message.) You have simply been a pawn in their little game. When all other things are equal, the client will choose the person they have the best relationship with almost every time.

Interest Level. One time when we lost a project to another agency, we asked the client why they decided to go in another direction. Their response was disheartening to us. "You guys had a great portfolio. Your price was right on target. It's just that some of the other agencies showed more interest in our project. So we decided to go with one of them." In other words, we failed to express enough enthusiasm to win the job. In order to land work, you must show genuine excitement for the client's project. Your passion will be infectious and help the client feel your willingness to go the extra mile for them.

Don't just roll over and be abused by potential clients who don't choose you. Do everything in your power to improve your bidding process by asking the client for simple feedback as to why you were not selected. They owe you that.

75 THERE ARE SUCH THINGS AS STUPID QUESTIONS

With most of my company's clients located in a different state than where I reside, I do a bit more than my fair share of traveling. One of my favorite places to visit is New York City. I absolutely love the energy in that great city, and I delight in exploring all of the great places to eat. On a side note, if you have never been to the New York area's Junior's restaurants, do yourself a favor and add them to your list of "must eat" places. No need to look at the menu at the Times Square spot; order "Something Different" (featuring a pile of juicy brisket sandwiched between two potato pancakes topped with gravy and applesauce…mmmmmmmmm…) and then polish it off with a slice of delectable "Devil's Food Cheesecake."

During a recent trip, my family and I were "enjoying" questionable service at another Times Square restaurant (not my beloved Junior's). Once I realized that our service level was in question, I became hyper-sensitive to our server's performance. After an overly long wait, she dropped off our food and walked past the table next to us. Surprisingly, she noticed that this guest's Diet Coke was empty. He still had over half of his food left to finish so she asked, "Would you like a refill?"

Perhaps you might consider this adequate service. I, however, considered this an obvious question and a missed opportunity. "OF COURSE, he would like a refill!" I thought. "He still has half his food left to eat and nothing to wash it down with!" Had she brought him a brand new drink without asking first, I am certain he would have appreciated her service all the more. Or at the least, so he'd have the opportunity to respond she could have told him her plan to replenish his soda in advance, saying "I'm going to grab a refill of your drink, I'll be back in a second. Need anything else?"

Being a graphic designer, like being a waiter (and countless other service-oriented professions), is a career path that is filled with opportunities to anticipate the needs of your customers and fill them without asking obvious questions.

For example, a client comes to your office and spends 45 minutes talking to you about their company. You can tell that their voice is getting a little scratchy. Don't ask them if they want some water; find an opportune moment to interject and say, "Just a minute, let me grab a water for you." (We have a mini-fridge in our conference room that is always stocked with handy beverages for this very reason.)

Or perhaps you are talking with a new client. You are excited about the new project and ready to get rolling. Don't ask them questions like, "Are you in a hurry to start this project?" (Nine times out of ten they are in a rush.)

Instead, tell them, "I'm sure you are anxious to get this project going. Here is how the production schedule will play out..."

Likewise, imagine you are at the end of the design phase of a website project and ready to start programming, but the client has a few final tweaks. Don't ask them, "Would you like us to make your changes to the comps and send you a revised version? Or, would you like us to just implement the changes when we build out the site?"

Instead take the initiative and say, "We've taken detailed notes of these changes. Since they are minor, we'll just plan on making them when we build out the functioning website pages."

It is always better to anticipate your client's needs and proactively present your plan to satisfy those needs than it is to ask your client stupid questions. Not only will it save you potential embarrassment, but it will set you up to be a hero in your client's eyes.

76 YOU CAN'T GET MAD AT MATH

We are nearing the end of a two-month long remodel of the main floor of our home. My wife pulled a thread that led to tearing out walls, rerouting plumbing, and redoing electrical. Destruction, dust, and debris are slowly manifesting into a beautiful new kitchen, foyer and family room that our family is looking forward to enjoying. We have learned many lessons throughout the process, one of which is that you can't get mad at math. Two plus two equals four every time. There is no denying it. There is no arguing with it.

When it came time to refinish our hardwood floors during this process, our contractor told us that we would need to be out of the home for 24 hours while the floors dried. As much as we would have preferred not to have the disruption in our lives, there was no denying the fact that it takes 24 hours for the finish to cure. The numbers are the numbers.

At the end of the process, I received the final invoice from the contractor. It was several thousand dollars more than expected. I knew we had made plenty of extra requests along the way; I just didn't know what the final costs of those requests would be. Each item was itemized in detail:

- Custom wood floor vents $100 each x 6 = $600
- Replace silver hinges on all doors $35 x 5 = $175
- Add crown molding to living room $350
- Assist kitchen cabinet installers 2 hours @ $65/hour = $130
- Etc.

While reviewing the itemized list of requests, services, and hours, it became clear that we owed the full amount and my initial sticker shock dissipated. The math was the math. There was no arguing with

it. There was no getting mad at it. Explaining the math behind a production request can often diffuse an otherwise emotional situation.

Some time ago, our agency had a retainer with TD Ameritrade. We had created some branding elements, marketing materials, and presentations during the course of the retainer. Our design team created one of the PowerPoint decks that was an astonishingly large 1,820 pages. The production cycle had lasted a few weeks and the team was one day away from completion of the final document when an unwelcome request came in from the client. "Can you change..." They had asked for a global change to the design style that would require modifications on all 1,820 pages.

Charged with emotion and fear, our lead designer came to me in a panic, "This is going to take forever! What do we say to them? We don't want them to get mad if we say we can't do it. We don't want to stay up all night for the next couple nights to get this finished." I explained to her this math principle and together we crafted a "you can't get mad at math" email to the client.

Joe,

We are excited to be wrapping up this project. We're all proud of the work completed.

Thank you for the change request. We understand that design changes happen, and we know that there are a lot of decision-makers that you are striving to please.

Needless to say, this is a big request and we have very little time left. Your requested change will need to be made to all 1,820 slides in the presentation. If we work as fast as possible and have no glitches along the way, we might be able to complete it in 30 seconds per slide. That totals 54,600 seconds (or 910 minutes or 15 hours). We have only three business hours left before the deadline. We just don't see how we can accommodate this request and retain a high level of quality in the process. We hope you understand.

We look forward to your response.

Thanks!

Janet

Off the email went and we eagerly awaited the clients reaction. Within just a few minutes they replied, "We understand it is big request and the timeline is tight. Thank you for your explanation. Do what you can."

There was no anger. They weren't upset with us. The math was the math, and spelling it out for them helped them see things our way. We made as many changes as we could within the time available and the client was satisfied with our efforts.

Oftentimes, a client or boss does not understand what really goes on behind the scenes in a project. Many people seem to think that Adobe created a magic "Make Website" button and out pops amazing comps. When requests come in that seem unreasonable, give a mathematical response a try. It may just diffuse an emotional time bomb.

77 YOU HAVE 65 SECONDS TO LAND A JOB

A design student at a local university approached me once and asked for some tips. This student was graduating soon and was preparing to begin spamming out résumés. We receive an enormous amount of resumes from people wanting to work at our agency. I offered the student a little advice on our unofficial process: You have about 65 seconds to land a job.

1st: We skim the email letter; hopefully it is custom written for our agency. (Takes about 5 seconds.)
If the candidate passes that...

2nd: We look at the résumé; hopefully we will find a PDF attached. Is it nicely designed? Is there a custom logo? Did they pay attention to typography? (Takes about 10 seconds.)
If the candidate passes that...

3rd: We actually read the résumé, looking for buzzwords of skills and experience that we feel would add value to our business. (Takes about 20 seconds.)
If the candidate passes that...

4th: We look for a link to a website portfolio. We want to see digital samples online with a custom domain name. We're not a fan of email-attachment samples or generic online gallery templates. (Takes about 30 seconds to 1 minute.)
If the candidate passes that...

5th: We look for salary requirements in the cover letter or email. If we don't find them we ask our office manager to email the candidate to ask for a salary range.
If the candidate passes that...

6th: We ask our office manager to set up an interview and we flag the candidate's email to help us remember them.
If the candidate passes that...

7th: We have an interview.
If the candidate passes that...

8th: The candidate gets a job!

I assume that the way we plow through the onslaught of résumés coming to our agency is not dissimilar to most other agencies. So take care in writing a custom email, preparing your résumé, and creating an eye-catching portfolio website. You likely have only a few seconds of the hiring manager's time, so make them count!

78 HOW TO ASK FOR A RAISE WITHOUT ASKING FOR A RAISE

I've asked for a raise only once in my career, and in retrospect, I was an idiot for doing so. The company I was with was struggling. The board of directors had just ousted the CEO, and one of the board members had been put in charge. Like a junior-minded, brainless employee, I decided that I should go plead my case as to why I felt I should be earning more money. The new company head heard my case and took it under consideration. A few short weeks later, I was laid off along with the rest of my production team. I am confident that my being laid off had nothing to do with me asking for a raise. However, in hindsight, I am certain that I looked like a total dolt for even asking. Why didn't I see the writing on the wall? The company just underwent a total reorganization due to previous bad management. A little patience and willingness to wait for the proverbial dust to settle would have been a better play on my part.

One time, during the Great Recession, one of our team members came to ask for a raise. Our company, like many others, had cash flow but only enough to keep things rolling. Raises and bonuses were not going to happen until we recouped some of the nest egg money that we used to keep everyone employed in the first place. This employee tried a few different approaches. First was the pity party: "I'm living on ramen noodles." Second was the proud party: "I can code circles around everyone in the office." None of these efforts changed the fact that this programmer surprised us with his request. And by not prepping us, he immediately put himself in an adversarial relationship. He was expecting a raise on the spot. We didn't have raises on the mind or in the budget to react positively to the employee's request. In the

end, the employee walked away frustrated and we were left wondering if the employee was going to go look for another job or lose his dedication to our company.

In fact, when you ask for a raise in this manner it almost always creates an awkward situation and a potential contentious relationship with your boss. There is a way, however, to ask for a raise without asking for a raise. Imagine a conversation like this in a brief closed-door meeting.

Employee: "I just wanted to come in and let you know that I love working at this company. The team is great. I love the work. I look forward to coming in every day."

Boss: "That's great to hear. You've been a great contributor to our projects here."

Employee: "I'm glad to hear you say that; I'm working hard. I wanted to talk with you for a minute and let you know that I view myself being here long-term and I was wondering what steps I should be taking to be able to earn future raises and promotions. I'm not asking for a raise now; I want to make sure I earn it. I just want to get on the same page with you about the types of things you are looking for out of me so that when the time comes for raises, I'll deserve one."

Boss: "Great. I appreciate you taking the initiative to ask that. Here are a few things I'd love to see from you…"

Employee (takes notes): "Awesome. I'm going to work on these things. Do you mind if we meet again next month and talk about how I'm progressing with your expectations?"

Boss: "That'd be great. I'd love to chat again. Thanks again for bringing this up."

This type of conversation accomplishes a few things:

First, your boss now knows that you are looking to make more money. But you didn't ask for money, so they are left with that on their radar. Most bosses will take a minute to consider your current salary and may even look at the budget numbers to see what a raise would look like for you (in preparation for the future conversation).

ASKING FOR A RAISE
IS TRICKY BUSINESS.
TIMING AND TECHNIQUE ARE
CRITICAL TO YOUR SUCCESS
IN RECEIVING A RAISE
WITHOUT DAMAGING
A RELATIONSHIP
IN THE PROCESS.

Second, you have paved a way for future salary discussions. This will take the awkwardness out of the raise conversation you will have with your boss in the next month. Your boss knows that you will be bringing up salary adjustments in the near future, so there will be no surprises there.

Third, you and your boss are now on the same team working toward your raise (instead of a being in a contentious and defensive relationship where your boss may feel you are trying to extort more money out of the company budget). You know what the boss is looking for, and your boss is proud that you are working to broaden your contributions to the company.

Asking for a raise is tricky business. Timing and technique are critical to your success in receiving a raise without damaging a relationship in the process.

MIND
YOUR BUSINESS

WORKING AS A DESIGNER
WITHOUT ANY BUSINESS TRAINING
IS LIKE JUMPING FROM AN AIRPLANE
WITHOUT PARACHUTE TRAINING.
SOMETHING BAD IS GOING TO HAPPEN.

79 DO WHAT YOU LOVE; THE MONEY WILL FOLLOW

Not unlike many other graphic designers, I was the kid in high school who could draw. I aced all the art classes and thoroughly enjoyed the creative process. During my first year of college, however, I had yet to decide on a major. I attended Indiana University, which consistently is one of the top-ranked business schools in the country. Many of my friends planned to major in business. Like an unoriginal sheep I followed along, leaving behind my previous plan of studying commercial art (a.k.a. graphic design). My grades and interest in school suffered as I pursued a course of study that I thought would lead to a more financially secure future. I am certain that I spent more time horsing around during my freshman year than I did going to class. But who could blame me? Some of those prebusiness school classes were boring enough to make a snail race seem akin to the Daytona 500.

After nearly flunking out my freshman year, my parents were undoubtedly concerned about my future. They could tell that I was not passionate about my choice of study and they encouraged me to reconsider choosing "art" as a career. My mom brought home a book to help me think things through, titled *Do What You Love, the Money Will Follow: Discovering Your Right Livelihood*, by Marsha Sinetar. I never read it. I still haven't. But the genius title was enough to change the course of my life. I decided to pursue my degree in graphic design. I honestly thought that one day I would be able to grow into a creative director role and have a maximum salary of $45 to $50K. I figured I

would just have to swallow my pride as I watched my business school friends graduate from college with salaries twice that size, and I took solace in the knowledge that at least I would be doing something I loved for a living.

It did not take long for me to learn that it makes absolutely no difference what career path you choose—you can make plenty of money in your career if you are truly passionate about it. If you really love what you do, you will work hard at it. It won't seem like work. Educating yourself on your chosen profession will be a lifelong commitment. Your passion will drive you to grow in your abilities. It is this passion that will drive you toward hard work and persistence, and the combination of those things will lead you to success. The love you have for your career will empower you to become the very best at whatever it is you are doing, and chances are that if you are the very best at it, someone will likely want to pay you big bucks to do it. I know of some very wealthy scrapbookers, dancers, and musicians who stayed true to themselves and followed their dreams.

One of the beautiful things about proceeding through life in this manner is that if you really love what you do for a living, the money thing matters so much less. Who cares how much money you make if you get to go to a job that pays you to be doing something you would be doing for free? This is how I view my career in graphic design. I love it. I work hard at it. I have been persistent. I have been on a never-ending quest of self-education, and—in the end—the money did follow. As my skills grew, I garnered new job offers. As I contributed to the success of companies I worked for, I got raises. By the time I was 28 years old, I was a creative director at Fox with a windowed office overlooking Beverly Hills and I was drawing a salary three times the size of what I thought would be my maximum after decades of work. I started my own business at age 30, a roller

coaster ride that has definitely been filled with more ups than downs, and with notable clients I only dreamed I could serve.

Ironically, after shunning the pursuit of a degree in business to follow my heart and choose a creative career, I now find myself in a businessman's chair in love with my profession. I admit there were times during the transition from designer to creative director to business owner where I lamented having lost the opportunity to manhandle Photoshop day in and day out. I felt like I had promoted myself right out of a career I loved and into a role I had strived to avoid. And then came the epiphany: "I may not create websites and logos anymore. But I still create. Now I am creating a business, a culture, a brand." This thought has driven me to invest my creative energy into something new. And the love I once had for design has been fully transferred to a love for creating a business. And, as the phrase goes, the money has followed me there, too.

I certainly can't promise the same results to everyone reading this. I realize that I have been very fortunate in my circumstances. Choosing a career path that I love has made all the difference in my life. Money could never replace the joy of making a living doing something that seems like the hobby you always dreamed of doing.

MONEY COULD NEVER REPLACE
THE JOY OF MAKING
A LIVING DOING SOMETHING
THAT SEEMS LIKE THE HOBBY
YOU ALWAYS DREAMED
OF DOING.

80 A BUSINESS THAT LOOKS ORDERLY

"A business that looks orderly says to your customer that your people know what they're doing. A business that looks orderly says to your people that you know what you're doing. A business that looks orderly says that while the world may not work, some things can. A business that looks orderly says to your customer that he can trust in the result delivered and assures your people that they can trust in their future with you. A business that looks orderly says that the structure is in place."
—The E-Myth Revisited, *1995, 103*

The *E-Myth Revisited* is one of the few paradigm-shift business books out there, as there are more than a few phrases in the book that have the capacity to be life-changing, some of which have had a huge impact on my career.

I had just hired my first few employees and I was making adjustments to how they operated versus how I operated. One employee liked doing things one way, while I liked doing them another. After reading a part of *The E-Myth Revisited* that spoke of the merits of an orderly business and its impression on potential clients, I realized that what I had was not an orderly business—it was a room full of freelancers, and our clients could sense it. I started right then to try to present a unified message to our clients, with the goal being a consistent, methodical way of operating our company.

I created a little internal website that documented our "orderly standards." It included everything from how to answer the phone to how to deliver a project. The internal site became "the law" for everyone to follow. As a result, our clients from that day on have had a consistent

experience with our company. Whether working directly with me or with the person we hired last week, their experience will be the same.

Even if you are still a one-person show, it is vital to your future success that you set up your methods and "best practices" now, so that in the heat of the moment when business is booming and you are in deep, you have a system in place to carry you through and show your clients that at face value—even though you may be like a duck's feet below the surface—you have it all under control. This will allow them to have confidence in you no matter what. It will also give you confidence in yourself; if you repeatedly carry out your day-to-day business in a way that is precise and orderly, you will soon find that you can take comfort in those consistencies, even on the days when your life and your work feel like a stormy sea at best.

81 MAKING CENTS OF IT ALL

With over 1,500 projects under my belt as a freelancer and business owner, saying that I've experimented with pricing structures may be the understatement of the year. In my early years, nearly everything was based on a fixed bid. As my client list grew, I began landing some hourly gigs, retainers, and some dedicated resource structures. Each of these pricing structures has pros and cons, for you as a designer as well as for your client. Understanding these pricing structures, explaining them clearly to your clients, and choosing the right one for the job can make the difference between a blissful client experience and your worst nightmare.

 Fixed Bid

Fixed-bid pricing is a set scope of work with a fixed price. You tell the client exactly what you are going to do and exactly what it is going to cost. As long as the client stays within the scope of the project, they are charged the price you quoted. In my experience, fixed-bid pricing is the option most commonly used in the graphic design industry.

Pros for you:
You know exactly what you are going to make on the project. If the job takes you less time than you expected, you make more profit.

Cons for you:
Since you are locked into a price, if the job takes you more time than expected, you make less profit (you could even lose money).

Pros for the client:
The client knows exactly what they are going to have to pay, assuming they stay within the project scope. They can reasonably assume that they will be able to stay within their allocated budget for the project.

Cons for the client:
Due to the tricky nature of fixed-bid pricing, you as the design agency will often need to pad your estimate to account for any unforeseen challenges in the project. As a result, the client could end up paying a lot more for a project than if it were priced in a different structure. Additionally, if the client goes out of the scope to a degree that requires you to send them change orders, they can become frustrated and feel like you are nickel-and-diming them.

Things to watch out for:
With fixed-bid pricing, you must clearly define the scope of the project. If you don't have every little detail (deliverables, functionality, design rounds, change rounds, and so on) defined in your proposal, there is a high likelihood that you will eventually get stung by a fixed-bid project.

You must try to help the client adhere to the defined project scope. Unfortunately, no matter what you do to clearly detail the project, there is a chance that the client will come up with something they want you to do that was not included in your scope. Keeping them "in scope" can be a challenging client management task.

When to use it:
Fixed-bid structures are best used when the client knows exactly what they want you to produce and exactly what they are comfortable spending.

 Hourly

You and your client agree on an hourly rate. You track your hours and bill your client in regularly agreed-upon intervals (such as weekly or monthly).

Pros for you:

For every hour you spend on a project, you have something to bill for. This structure eliminates the risk of losing money on a project.

Cons for you:

"Value pricing" doesn't come into play here. If you design a logo in one hour, you are locked into charging your client the agreed-upon hourly rate even though the "value" of the logo to the client far exceeded what they paid for it.

Pros for the client:

The client does not need a clearly defined project scope to begin working with you. They have the flexibility to change their mind on things and add new items to your plate.

Cons for the client:

It can be difficult for the client to know how much they should budget for your services if they pay by the hour.

Things to watch out for:

To help keep your client relationship healthy, it is recommended that you regularly communicate how many hours you are spending for the client's projects. Also, for each request they make, tell them roughly how many hours it will take. Nobody likes to be surprised by a giant bill.

When to use it:

Hourly structures are best used in maintenance situations. Perhaps you have finished a website project and the client would like you to make occasional site updates. Or, you did a stationery package and the client would like you to create business cards for a new employee.

Retainer

Retainers are also based on hours spent on a project. Typically, you give the client a discounted rate for guaranteeing you hours (usually by month). For example, if your standard rate is $100 per hour and you are pitching your client a retainer structure, you could discount the rate based on the number of hours they retain. (If the client retains 20 to 40 hours per month they pay $90 per hour, 41 to 60 hours per month they pay $80 per hour, 61 to 80 hours per month they pay $70 per hour, and so on.) Retainers are purchasing a bucket of hours to be used for the client's requests. Those hours are usually spread across whatever team members are necessary to complete the request.

Pros for you:
You get guaranteed monthly billings. This can give you cash flow and the confidence to allow you to hire new employees or expand your business in other ways against the retainer.

Cons for you:
By reducing your rate based on hours retained, you are also reducing your profit margin. Also, as with the previously mentioned hourly pricing structure, "value pricing" does not apply.

Pros for the client:
By paying a reduced rate for guaranteed hours, the client gets more work for less money.

Cons client:
In this pricing structure, the client has a responsibility to fill the retained hours or they lose them. If they retain 40 hours per month and use only 38 hours, they still pay for the 40 hours.

Things to watch out for:

Since the client is retaining hours, you must be extremely attentive to their needs until the hours are used up. It is also important to keep an accurate accounting of the hours for proper billing.

Oftentimes, a client will have a challenge understanding that they are purchasing a block of hours from you, and that whether they use them or not, you have made arrangements in your business to have those hours available for them. If the client uses more hours than the agreed-upon retainer, they should pay for the extra hours. We typically charge their retained rate plus 10 percent for all extra hours beyond the retainer. (For example, if the client is retaining 80 hours per month and they use 90 hours, they pay $70 per hour for the first 80 hours and then $77 per hour for the extra 10 hours.) The reason for the increased cost attached to extra hours is to accommodate for the unanticipated and unscheduled workload.

When to use it:

Retainers work best when the client knows that they have an ample amount of projects that they will need you to complete over a set amount of time but they are still unclear of the details.

Dedicated Resources

Slightly different from retainers, the dedicated resource structure allocates certain employees to a client for a certain period of time. Retainer structures buy hours. Dedicated resource structures buy people. This structure is usually calculated in "man weeks." You work with the client to determine how long you expect the project to take and dedicate specific employees to the task. The more "man weeks" the client buys, the lower the rate they pay. (For

example, if the agreement dedicates an employee for 4 to 6 "man weeks" they pay $5,000 per week, for 7 to 10 weeks they pay $4,500 per week, for 11 to 14 weeks they pay $4,000 per week, and so on.)

Pros for you:
Like retainers, this structure can give you the cash flow and confidence to expand your business.

Cons for you:
Also like retainers, you are charging a reduced rate, which reduces your profit margin. You also may need to dedicate some of your top performers to a client, thus losing their involvement on other projects.

Pros for the client:
The client pays less money for more work and can build a strong working relationship with your team members as they collaborate closely on the project.

Cons for the client:
For the set term of the agreement, essentially it is as if the client is employing your team members directly. They have a responsibility to keep them busy and get the most of the relationship.

Things to watch out for:
Be sure that you put a legal clause in your agreement with the client that they will not hire away your employee(s). As they build a solid working relationship with your team members, this becomes a risk.

When to use it:
This structure works best for long-term engagements where the scope and feature set of the project is difficult to determine at the start. It is most often seen in software development, and sometimes it will require your employees to work in the offices of your client.

UNDERSTANDING THESE
PRICING STRUCTURES,
EXPLAINING THEM CLEARLY
TO YOUR CLIENTS,
AND CHOOSING THE RIGHT ONE
FOR THE JOB CAN MAKE THE
DIFFERENCE BETWEEN
A BLISSFUL CLIENT EXPERIENCE
AND YOUR WORST NIGHTMARE.

82 HOW TO CALCULATE A BURN RATE

How can you know how much to charge if you don't know how much you cost? I spent a lot of years pulling prices out of thin air. I had no idea what I should be charging, and to be honest, I was willing to work for whatever someone would pay. As my company began to grow, I quickly learned the importance of understanding costs. Knowing your costs can help you massage your pricing and land new clients. It can also help you know how much time to allocate to each project.

I certainly don't claim to be an accountant, and my accountant may read this and think I'm off my rocker. But here's a simple formula to use to calculate your hourly burn rate (that is, what your graphic design business costs you per hour):

Annual Overhead Cost ÷ Annual Production Hours
= Hourly Burn Rate

Here are a couple of scenarios:

Scenario 1:
You are a freelancer working out of your basement. You decide that you should be earning $60,000 per year for your salary. Your utilities (Internet connection, electricity, cell phone, etc.) cost you roughly $300 per month (or $3,600 per year). Your equipment (computer, printer, software upgrades, etc.) costs approximately $5,000 per year. Your business expenses (industry and business group annual fees, car mileage, paper, business licenses, etc.) cost about $2,000 per year. Don't forget to factor in vendor expenses (accountant fees and so on) at a typical rate of $1,500 per year.

$60,000 + $3,600 + $5,000 + $2,000 + $1,500
= $72,100 Total Annual Overhead

The average number of work hours in a calendar year for a full-time employee ranges from 2,080 to 2,096, depending on holidays and specific business practices. We use 2,080 hours as our number. Now, assuming you are self-employed, don't forget that it takes administrative time to run your business (you can't bill a client directly for balancing your checkbook or attending an AIGA meeting). Let's say you spend 10 percent of your time doing "nonproduction" tasks to keep your business running. That leaves you with 1,872 production hours per year that you can bill for if the project pipeline is full. Now you have your numbers. Run them through the formula to figure out what you must charge per hour to "break even."

$72,100 ÷ 1,872 = $38.51

Your hourly burn rate is $38.51. Now you can safely set a rate for your clients and understand where your wiggle room is. But you cannot go below $38.51 per hour without losing money (or paying yourself less than your desired salary of $60,000). You also can make a judgment call on what you want to spend your time doing. I got really crazy at one point and started thinking, "If it takes me three hours to mow my lawn, that will cost me $115.53! I'm better off hiring the neighbor kid to do it for $30…that's $85.53 back in my pocket!"

Scenario 2:
You are a small business with, let's say, five employees (including yourself). Your salary is $70,000 per year, your three designers each make $40,000, and your receptionist makes $20,000 per year (totaling $210,000 in salary costs). You are leasing an office that costs $2,000 per month ($24,000 per year). Your remaining expenses cost roughly $40,000 per year.

$210,000 + $24,000 + $40,000
= $274,000 Total Annual Overhead

Your receptionist's time can't be billed directly to a client, so that person doesn't account for production hours. Each of your designers is fully dedicated to production, so they each account for 2,080 (6,240 production hours). However, you spend only 20 percent of your time

doing billable production work (the rest is spent doing administrative tasks and sales). That gives you only 416 production hours per year (20% of 2,080). Your total production hour number is 6,656 (6,240 + 416). Input them into the formula.

$274,000 ÷ 6,656 = $41.17

Your hourly burn rate is $41.17. What will really drive you nuts is calculating what idle employee time costs you. When your three designers get carried away playing Call of Duty for an hour in the afternoon, it could cost you upwards of $123.51!

How to be profitable:
Now that you have a burn rate, the profitability calculation is easy. Simply tack on a profitability percentage to the hourly burn rate and you will have an hourly rate to charge your clients. If your burn rate is $38.51 and you feel a 20 percent profit margin is fair, then you should charge your customer $46.21 per hour.

$38.51 + $7.702 (20% of $38.51) = $46.21

If your hourly burn rate is $41.17 and you are comfortable with a 50 percent profit margin, then charge your customer $61.76 per hour.

$41.17 + $20.585 (20% of $41.17) = $61.76

This isn't a perfect science and your accountant will likely be able to help you find a much more accurate number. But this simple formula helps us immensely in our bidding process, and hopefully it will help you in your freelance and other business affairs.

83 THE FIXED-BID PRICING DARTBOARD

Trying to figure out how to price your work fairly can be a daunting task. In my experience, most clients prefer working with fixed-bid pricing; they take comfort in knowing exactly what they are going to get for exactly what price. On the designer side, there is comfort in knowing exactly what you are going to charge for the scope of work. Fixed-bid pricing presents several challenges, not the least of which is the fact that you have to base your price on something. When I first started freelancing, that "something" was often hours. I decided to charge around $60 per hour for my time, and then I would ballpark my hours and send an estimate to my client. The problem with this was that I am a very fast designer and production artist. So by charging based on hours, I was charging too little for most of the work I was producing. That left me in a situation where I either needed to up my hourly rate or figure out a new way to price things.

I began trying to price things based on the deliverables. My estimates would include itemized pricing for each of the elements being produced. Take a website for example. I would charge $500 for a home page and $150 for each subpage. Then I'd add up all the pages and come up with a price. It didn't take me too long to learn (the hard way) that this strategy was riddled with problems (see the chapter "Beware of Line-Item Pricing," in this section, for more details).

After experimenting with other strategies, I realized that there is no perfect science to estimating your work. It frequently seems as if you are throwing a dart at a board and seeing where it lands. In some ways this is true. With fixed-bid pricing, you are often throwing out a dart and hoping you land on the board in a quadrant that will generate a profit. While there is no perfect method to estimating your work,

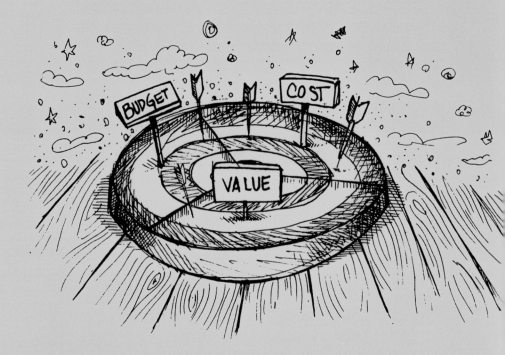

there is a strategy to making sure you are throwing your dart toward the right area of the board.

Fixed-bid pricing is a careful balance between three components: cost, value, and budget. Let's examine each one.

Cost: The first component that must be considered when estimating your work is cost. You must know what your time to create the project will cost. This can be done by either determining a fair hourly rate and adding up the number of hours you expect the project to take, or by figuring out your exact hourly cost (divide your annual overhead by your quantity of production hours available in the year) and then adding a profit margin percentage on top.

Value: The second element for consideration is the fair market value of the project. Just because you can nail a logo design in one hour doesn't mean you should charge the client only $60. There is a value to the logo that far outweighs $60. Every designer should have the book *Graphic Artists Guild Handbook: Pricing & Ethical Guidelines*, by the Graphic Artists Guild. A new issue of the book comes out every few years, and it contains categorized pricing for each type of graphic design service based on survey averages from design professionals nationwide. This is a great place to get an idea of what fair market value is for design work. Please keep in mind when reviewing the survey averages that the size and expertise of the design professionals is not reflected in the pricing. If the survey says a brochure for a medium-size business should cost $8,000 and you are a wet-behind-the-ears college graduate, don't expect to be able to green light a brochure at that price. The objective is to gain a sense of what other people, similar to you, charge for the same types of projects you are trying to land.

Budget: Finally, you must have a sense of what the client's budget is for the project. If you wrongly assume the budget is high, then you may send an estimate that prices you out of getting the project (when you would have been happy charging less and landing the work). If you wrongly assume the budget is low, then you may undercharge for the work and not be able to turn a profit on the project. (For help with figuring out a

client's budget, see the chapter "How to Flush Out a Budget," in this section of the book.)

Now you that have these three components for consideration, it is time for the balancing act. Let's throw a few darts at the board.

A client wants you to complete "Project X."
You expect the project will take you 10 hours at your hourly rate of $60 = $600.

You determine that the project has a fair market value of $2,000 based on industry averages.

And you know that the client has a budget of $1,000 to complete the work.

A simple approach would be to average these three elements and send your client the estimate ($600 + $2,000 + $1,000 = $3,600 ÷ 3 = $1,200).

Unfortunately it is not always as simple as just averaging out the numbers based on the variables. There are times when you must skew toward one of the three components.

A client wants you to complete "Project Y."
You expect the project will take you 100 hours at your hourly rate of $60 = $6,000.

You determine that the project has a fair market value of $15,000 based on industry averages.

And you know that the client has a budget of $7,000 to complete the work.

In this case, if you want to land the work, you must steer your estimate toward the client's budget. My recommendation would be to balance it somewhere in between your hourly cost and the client's budget, say $6,750 or so. You are still way below fair market value but still in a zone where you can turn a profit on the project.

A client wants you to complete "Project Z."
You expect the project will take you 200 hours at your hourly rate of $60 = $12,000.

You determine that the project has a fair market value of $18,000 based on industry averages.

And you know that the client has a budget of $25,000 to complete the work.

In this case you could estimate the project in the $18,000 range. Then, depending on your relationship comfort level, you could let the client know that you did some market research and found that this type of project is costing less than what they had budgeted, and you didn't feel it would be fair to charge them their full budgeted amount. This type of thing usually goes over very well and could be a great way to start off a project.

In the end, there certainly seems to be a dartboard involved in fixed-bid pricing. Use your best judgment on which component you should skew your price toward. The better you understand the project, your client, and their expectations, the easier this will be.

84 BEWARE OF LINE-ITEM PRICING

Most clients will be drawn to fixed-bid pricing. They want to know exactly what the project is going to cost and they expect you to stay on budget. From the designer's side, fixed-bid pricing isn't altogether bad, since you will know exactly how much you are going to make on the project.

When I first started freelancing, I worked exclusively via fixed-bid pricing scales. A client would send me the specs for a project, and I would attach pricing to the project and gain the client's approval for that amount. I would be meticulous in this, breaking down each item the project would entail in minute detail.

First, I would figure out how long the whole job would take, and then I would break it out into itemized pricing. For example, if a client wants a logo design along with a stationery package, I would estimate that I would need about two days of production to complete the whole project. So let's say that I attach a cost of $2,000 to the project. Then, in order to help the client get an idea of where the costs lie, I would spread out the $2,000 across all the elements of the project.

Option A
Logo Design = $800
Business Card Design = $400
Letterhead Design = $400
Envelope Design = $400
Total = $2,000

Each of these items would be explained in the proposal so the client knew exactly what they were getting for each element. I felt cool. This line-item pricing looked legit and organized. Look at me! I'm a graphic designer sending out fancy bids.

WARNING: BEWARE OF ESTIMATING THINGS THIS WAY!

I've been burned more times than I'd like to admit by this pricing strategy. The client will look at this breakdown and decide that they can live without the letterhead and envelopes and then ask to pull those elements from the project, leaving me with $1,200 to do a job that is probably still worth closer to the $2,000 mark than the $1,200 I will now be making.

The realities of this project is that most of the design work is done in the "Logo Design" phase. You put the brain power into this part, and as you are designing the logos you are making mental considerations for how the designs will convert into the other stationery elements. Also, once you design the business cards, the letterhead and envelope will be a piece of cake. The truth of the matter is that the cost breakdown for this project would be something closer to this.

Option B
Logo Design = $1,600
Business Card Design = $200
Letterhead Design = $100
Envelope Design = $100
Total = $2,000

However, with this line-item pricing the client will look at it and possibly balk at the $1,600 logo price. Most small businesses would rather have their cousin's friend's brother design their logo on trade for a new pair of sneakers than pay $1,600 for their logo design. So, you shouldn't send line-item pricing this way, either.

In the end, sending the client one lump-sum price like Option C is better than the previous options, but this isn't a great solution either, since breaking out the costs helps the client swallow a big bill easier (kind of like when you go to get your car fixed at an auto repair shop).

Option C
Logo, Business Card, Letterhead, and Envelope Design = $2,000
Total = $2,000

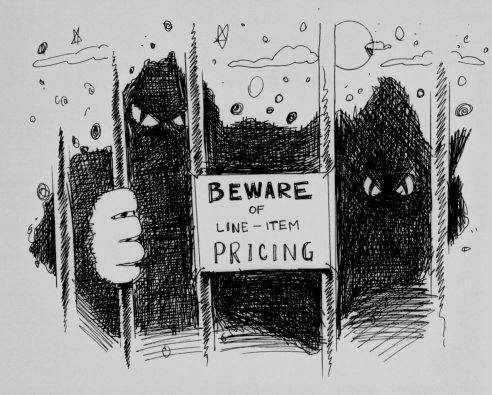

So what is a designer to do? You will need to break out pricing more in line with the realities of the project. Detail out exactly what the client is going to get (deliverables) and then break down the pricing in this fashion.

Option D
Project Management = $300
Design = $1,000
Production = $700
Total = $2,000

"Project Management" includes deliveries, phone calls, and administrative elements required to execute on the project. "Design" covers the creative tasks required to succeed on the project. And "Production" is for creation of press-ready files. With this strategy, the pricing is itemized so that the client can understand how you arrived at the total price. But none of the itemized elements can be removed from the project (as they could in Option A) without requiring you to send a revised estimate to the client.

There will be times when a client will force you to break down a project as in Option A; they want to know exactly what each item will cost. If you must do so to win the job, then you must. Be careful when breaking down the price, and ask yourself these critical questions when you look at your numbers: "If the client pulls out any one item of this cost breakdown, will I still be happy with the total price of the job? If they pull an item, will I still be able to execute on the other elements at the individual prices they are quoted?" If you answer no to either question, then rework the numbers until you are satisfied. When a client forces you into itemizing a project, then you have to assume that they are considering pulling out elements. Brace yourself and tread lightly.

If you are forced into an Option A type of estimate and are satisfied with your itemized prices, be sure to cover yourself by mentioning that your pricing takes into consideration economies of scale. For more information about that, please refer to the chapter "Twenty-Piece Chicken McNuggets," in this section of the book.

85 "NO CHARGE" DOESN'T MEAN "FREE"

At the end of 2009, my company green lit our biggest single-dollar project ever. Eight long months later, we were dealing with the biggest project disaster in our company's history. We worked with the client through changing scope and shifting ideas, rolling with the punches all along. After receiving the green light, we submitted changes and restarted the project three times. Each of these times required us to rewrite the proposal, and resulted in us making the decision to eat the work we had completed on previously green-lit elements that were no longer part of the client's strategy moving forward.

Finally, the client requested the fourth change in scope, this time attempting to cut the project in half based on a new investor who was planning to complete some of the elements themselves. In a heated and uncomfortable phone call with the client, we told them that their newly-proposed budget for proposal #4, which was 50 percent of the original budget, did not leave us room to absorb the cost related to items previously green lit in proposals #1, #2, and #3 that were now cancelled. The client said, "We don't see any listing of the costs of those items in proposals #2 or #3." They were right. We had decided to eat those changes for the good of the relationship with the client, but we never documented it to make them aware. We were doing a good deed for our relationship and they had no idea we were doing them any favors; we were receiving absolutely nothing for our generosity.

Most of us have heard the phrase, "Nothing in life is free." I did a little research and couldn't find the origin of this phrase, but I spent a great deal of time pondering its meaning. In graphic design, you may do a lot of work for "no charge," but that does not mean it is "free." You give away your time and energy at "no charge" in hopeful expectation of some reward from your client, such as an improved

relationship, future favors, referrals, and additional projects, to name just a few.

In order to make sure your client is aware of your generous gifts of time, you must document all of the work you complete for the client whether you charge them for it or not. This strategy can be accomplished easily in your proposals and invoices. Perhaps an example will help illustrate this point.

A client comes to you requesting a logo design. You send a simple proposal to create a logo for them at a price of $500. During the design process, you decide to create a business card design to show off how cool the logo is to the client. The client is awed by your killer design skills and asks you to complete press-ready files for the business cards. Since the design is already complete, you decide to throw it in for "free." In order to make sure your client is aware of your generosity, you could add a line to your invoice like this:

Logo Design = $500
Business Card Design ($300 value) = No Charge
Total Amount Due = $500

If you hadn't highlighted this to your client, you would be less likely to be compensated in nonfinancial ways for your good will.

We recently had a client re-sign a retainer agreement with us. Their three-month-long retainer bought 80 hours per month of design and production at a price of $8,000 per month. However, due to budget

constraints heading into their year-end, they asked to reduce the retainer hours by 10 percent. As a gesture of kindness toward the client, we decided to keep their monthly hours the same and just discount our rate. They were grateful for our generosity. But we failed to document our generosity when we sent them the new proposal.

Our proposal stated:

80 hours per month of design and production = $7,200

However, we should have written our proposal like this:
80 hours per month of design and production = $8,000
10% discount = -$800
Total Monthly Rate = $7,200

When this client's retainer expired a few months later, their expectation was to re-sign at $7,200 per month for 80 hours of work, having long forgotten that they were receiving a discounted rate. For us to reinstate our original price of $8,000 for the same quantity of work, it would appear as if we are upping our prices, and our generosity will essentially have done nothing more than backfire on us.

In addition to throwing in free design elements now and then, you might consider offering discounts like these:

Friends and Family Discount: Can be offered to some of your close friends and relatives.

Repeat Customer Discount: Perhaps you offer a discounted rate for a return customer.

Education Discounts: Provided for educational institutions.

Charitable Organization Discount: For charitable organizations, we work for "non-profit" by charging our cost to the client. In other words, we charge them our overhead cost to do work for them, rather than charging them a rate that leaves us profit in the end.

No matter what your system or verbiage turns out to be, the important thing is that you be sure to create proposals and invoices that document your full rate and then reflect the discount in a separate line item.

86 HOW TO FLUSH OUT A BUDGET

Proposals can take a lot of time to create, and if you don't land the project you will never be reimbursed for that time and effort. Asking a client for a budget is sometimes risky; they may think that if they tell you their budget, you will just charge them that price whether the project should cost that much or not. (And in some cases they may be right.)

The problem is that if you don't have a price range from the client, you are bidding blind. You don't know if they want to buy a gourmet meal or a fast-food hamburger. Many people don't have any idea of the time and cost of graphic design. They may be thinking that the website they want to create will cost around $1,000 when in reality their request will cost $10,000.

Here are a few techniques to help you flush out a budget before you go to the costly lengths of creating a full-blown, formal proposal.

The Direct Approach
"OK, John, I think I have all of the specifications for the project. Is there a budget number you are shooting for?"

Chuck a Range
"Similar past projects that we have done have cost between $5,000 and $10,000. Where does your budget fit in that price range?"

Compare Another Product
"We always like to ask about our client's budget to know what features we should pack into the proposal. A Hyundai and a Ferrari will both get you from point A to point B. Are you wanting something really high-end for your project? Or are you shopping for a base model to get things rolling, with the plan to add features later?"

Give a Past Project Example
"I'm not sure where we'll end up price-wise in the proposal because I need to talk to my design team to find out how long they think things will take. But I can tell you that our last project like this came to around $5,000. Is that a rough price range you would be comfortable with?"

Project Quick Sheet
If you are concerned that the client doesn't have sufficient budget to do the project, try sending them a Project Quick Sheet before you create a big multipage formal proposal. The Project Quick Sheet is a simple one-page estimate that includes:

Project Summary (a few sentences describing the project)

Timeline Estimate (approximately how long it will take to complete the project)

Cost Estimate (estimated pricing for the project)
When you send this to the client, you should include a line like this in your email:

"Before detailing the full scope of the project, we wanted to send you a rough estimate to make sure we're on the same page. The attached Project Quick Sheet provides a project summary, timeline, and cost for the project as we understand it. Please let us know if these three items seem in line with your thoughts and we'll get to work on the full-blown proposal that details out the entire project. Thanks!"

These techniques do a great job of either scaring away a client who has no budget or bolstering your confidence in the bid process by knowing your client's budget range.

87 TWENTY-PIECE CHICKEN McNUGGETS

I'll be the first to admit, I got a D in Economics 101 during my freshman year of college. But I assure you it was not because I don't understand economics. It was simply because I was spending way more time goofing around than I spent going to class. In order to earn my D, I really learned only two things. The first was "The Law of Diminishing Returns" (in layman's terms, you are more productive during hour one of the work day compared to hour 20, or the first piece of cheesecake is more satisfying than the 10th piece of cheesecake when eaten in one sitting). The second thing I learned was "Economies of Scale." Let's take a minute to discuss the second.

Economies of scale basically means that unit costs of a product or service go down as volume goes up, as in mass production (that is, the bigger the project, the lower the associated cost per unit).

Here are a few examples of how economies of scale play out in the graphic design industry.

A client approaches you to design a website for their business. You conduct an analysis of their needs and expect the site to be 10 pages. You determine that the price for their 10-page website will be $10,000, accounting for 100 hours of work.

Another client approaches you to design their website, and after a needs analysis you find that their site will require 15 pages (50 percent larger than the 10-page site). After you crunch the numbers with your team, you find that the 15-page site will really take only 10 hours longer than the 10-page site, so you send an estimate for $11,000 (only 10 percent more than the 10-page site).

This is economies of scale in action. Each site requires initial design work to create the overall look and feel. By the time three to five pages are fully programmed, the programmers have enough code to reuse, thus allowing the additional five pages to take very little time to

complete. In fact, the initial design and programming is so labor intensive that a 3- to 5-page website may cost only slightly less than a 10-page website (depending on the complexity of the design).

As another example of economies of scale, maybe you are designing a series of magazine ads. To create the initial concept for the first ad, it may require 80 percent of the creative brain power and design time for the whole project. Thus the additional ads in the series require only a fraction of the time necessary to create the original ad.

As a further example on press, the per-unit print pricing goes down when the volume goes up. For example, a 10,000-piece press run may cost $1.00 per unit ($10,000), and a 1,000-piece press run may cost $10.00 per unit ($10,000). This is due to the labor and set-up time that goes into each project, large or small, as well as the cost of materials going down with volume increase.

Even fast food chains offer economies of scale! When you buy a combo meal, your drink and fries price-per-unit goes down due to discounts based on volume. My favorite example of economies of scale is found in Chicken McNuggets. While a 10-piece Chicken McNuggets costs $3.99 (or 39¢ per Nugget), the 20-piece version is just $4.99. That comes out to only 25¢ per Nugget! Economies of scale can be found everywhere.

My company once had a squirrelly client who kept trying to cut the price on their project. (Actually, we've had many squirrelly clients for that matter.) We sent our original proposal to the client and they requested that we break out all our pricing into line items. We accommodated their request, after which they began cutting items off of the list based on their line-item price. In the end, the scope of work was cut down to fit their budget and we were left with several minimally profitable pieces. After we developed the initial elements they began to cut down the project again. What started as a $200,000 budget was cut to $100,000 and then cut to $50,000. We tried to explain to them "economies of scale," and that the per-unit price found in a $200,000 budget is less than the per-unit price found in a $50,000 budget. They scoured our proposal and said, "Your proposal says nothing about this. It merely shows the line-item prices and we expect you to stick to your proposal." We were left with nothing to say.

To avoid having this ever happen again, we've added a simple line to our proposal.

"This estimate represents a 'package price' based on economies of scale. If elements are added to or removed from the scope of work, a new proposal will be required, as the pricing for other elements could be affected."

This line in your proposal opens up your ability to explain to your client the concept of economies of scale, and empowers you to renegotiate pricing when your client makes attempts to cut items from the scope of the project.

YUMMMY!

88 NONPROFITS FOR NON-PROFIT

There is no shortage of people in the world who think you should do graphic design work for free. After all, it is only time that is being spent to design things, and you are having fun while you do it. It doesn't really "cost" anything, right?

Most designers have pro bono work going on nearly all the time. There is always their brother's logo or their uncle's website under heavy construction. Each of those pro bono jobs seems to lead to referrals for more pro bono jobs. I certainly have done my share of free design work, and my company seems to have a steady stream of charitable organizations requesting our services.

Many charitable organizations run on very tight budgets. Typically the head of these organizations is a master at asking for favors and receiving them. Be aware that one favor usually leads to two. Two favors usually leads to three. And before you know it, you are swallowed up doing a ton of free work to support their organization. Most of these charitable organizations provide admirable services and are worth the consideration of your generous support. However, you have a right to provide those services under your terms. Here are a few ways to consider working with charities.

Service

If you believe in the organization and have the time, providing free graphic design services may be right up your alley. Go for it!

Portfolio Boost

It may be worth your time to provide graphic design services for free if the project will be a great enhancement to your portfolio. Sometimes free design work empowers you to be more creative and more easily control the flow of the project.

One at a Time

I've heard of agencies that limit their charitable client list to a maximum of one or two. This empowers you to easily say "no" when you are being cornered by another charitable organization.

Set Scope of Work

With any project, paid or unpaid, it is critical to clearly define the scope of work. However, with charity work this becomes even more important. You should still create a proposal whether the project has payment or not. In the proposal you must clearly define what work you will be doing for free and what work will require payment. For example, if you agree to design and build a charity's website for free but want to keep from being abused in the future, be sure to clarify that all changes requested after launch of the site will be billed at $X per hour. You don't have to do everything for free.

Nonprofits for Non-Profit

One of my agency's most valued clients is a nonprofit organization that is operated by a multibillionaire. They have been our client for many years and we charge them our cost. We support their nonprofit efforts by providing graphic design services at no profit to us. We have created and maintained several websites and branding initiatives for them, and we bill them by the hour on a monthly basis.

Nonprofit for Profit

Just because a company is a nonprofit does not mean they have no money. Some of the larger charities actually have giant marketing budgets. Don't be afraid to treat a nonprofit like any other client. Just because their business is non-profit doesn't mean that your business has to be.

I strongly encourage providing charitable design services. Charitable giving is part of our society, and service is at the heart of the graphic design profession. Just make sure you stay seated in the captain's chair if you are doing the work for free.

THERE IS NO SHORTAGE
OF PEOPLE IN THE WORLD
WHO THINK YOU SHOULD
DO GRAPHIC DESIGN
WORK FOR FREE.

89 THE CODE OF FAIR PRACTICE

I worked for nearly ten years as a professional graphic designer prior to finding out about the Code of Fair Practice. Maybe you already know about it and I'm the crazy one, but just in case, here is the ever-important information that you must understand.

The Code of Fair Practice was originally written and published by The Joint Ethics Committee in 1948 for the graphic communications industry. It was revised in 1989 and has been used by thousands of artist professionals as a guide to creating equitable business relationships with their clients. Following the articles of the code will help you create "win-win" relationships with your clients as you both agree to engage in an ethical and professional relationship.

The word "artist" is meant to apply to any seller of "art," including graphic design, photography, illustration, and other related professions. For our purposes, the word "buyer" means "client."

The Code of Fair Practice

ARTICLE 1: Negotiations between an artist or the artist's representative and a client shall be conducted only through an authorized buyer.

ARTICLE 2: Orders or agreements between an artist or artist's representative and buyer should be in writing and shall include the specific rights which are being transferred, the specific fee arrangement agreed to by the parties, delivery date, and a summarized description of the work.

ARTICLE 3: All changes or additions not due to the fault of the artist or artist's representative should be billed to the buyer as an additional and separate charge.

ARTICLE 4: There should be no charges to the buyer for revisions or retakes made necessary by errors on the part of the artist or the artist's representative.

ARTICLE 5: If work commissioned by a buyer is postponed or canceled, a "kill-fee" should be negotiated based on time allotted, effort expended, and expenses incurred. In addition, other lost work shall be considered.

ARTICLE 6: Completed work shall be promptly paid for in full and the artwork shall be returned promptly to the artist. Payment due the artist shall not be contingent upon third-party approval or payment.

ARTICLE 7: Alterations shall not be made without consulting the artist. Where alterations or retakes are necessary, the artist shall be given the opportunity of making such changes.

ARTICLE 8: The artist shall notify the buyer of any anticipated delay in delivery. Should the artist fail to keep the contract through unreasonable delay or nonconformance with agreed specifications, it will be considered a breach of contract by the artist. Should the agreed timetable be delayed due to the buyer's failure, the artist should endeavor to adhere as closely as possible to the original schedule as other commitments permit.

ARTICLE 9: Whenever practical, the buyer of artwork shall provide the artist with samples of the reproduced artwork for self-promotion purposes.

ARTICLE 10: There shall be no undisclosed rebates, discounts, gifts, or bonuses requested by or given to buyers by the artist or representative.

ARTICLE 11: Artwork and copyright ownership are vested in the hands of the artist unless agreed to in writing. No works shall be duplicated, archived, or scanned without the artist's prior authorization.

ARTICLE 12: Original artwork, and any material object used to store a computer file containing original artwork, remains the property of the artist unless it is specifically purchased. It is distinct from the purchase of any reproduction rights.(*1) All transactions shall be in writing.

ARTICLE 13: In case of copyright transfers, only specified rights are transferred. All unspecified rights remain vested with the artist. All transactions shall be in writing.

ARTICLE 14: Commissioned artwork is not to be considered as "work for hire" unless agreed to in writing before work begins.

ARTICLE 15: When the price of work is based on limited use and later such work is used more extensively, the artist shall receive additional payment.

ARTICLE 16: Art or photography should not be copied for any use, including client presentation or "comping," without the artist's prior authorization. If exploratory work, comprehensives, or preliminary photographs from an assignment are subsequently chosen for reproduction, the artist's permission shall be secured and the artist shall receive fair additional payment.

ARTICLE 17: If exploratory work, comprehensives, or photographs are bought from an artist with the intention or possibility that another artist will be assigned to do the finished work, this shall be in writing at the time of placing the order.

ARTICLE 18: Electronic rights are separate from traditional media, and shall be separately negotiated. In the absence of a total copyright transfer or a work-for-hire agreement, the right to reproduce artwork in media not yet discovered is subject to negotiation.

ARTICLE 19: All published illustrations and photographs should be accompanied by a line crediting the artist by name, unless otherwise agreed to in writing.

ARTICLE 20: The right of an illustrator to sign work and to have the signature appear in all reproductions should remain intact.

ARTICLE 21: There shall be no plagiarism of any artwork.

ARTICLE 22: If an artist is specifically requested to produce any artwork during unreasonable working hours, fair additional remuneration shall be paid.

ARTICLE 23: All artwork or photography submitted as samples to a buyer should bear the name of the artist or artists responsible for the work. An artist shall not claim authorship of another's work.

ARTICLE 24: All companies that receive artist portfolios, samples, etc., shall be responsible for the return of the portfolio to the artist in the same condition as received.

ARTICLE 25: An artist entering into an agreement with a representative for exclusive representation shall not accept an order from nor permit work to be shown by any other representative. Any agreement that is not intended to be exclusive should set forth the exact restrictions agreed upon between the parties.

ARTICLE 26: Severance of an association between artist and representative should be agreed to in writing. The agreement should take into consideration the length of time the parties have worked together as well as the representative's financial contribution to any ongoing advertising or promotion. No representative should continue to show an artist's samples after the termination of an association.

ARTICLE 27: Examples of an artist's work furnished to a representative or submitted to a prospective buyer shall remain the property of the artist, should not be duplicated without the artist's authorization, and shall be returned promptly to the artist in good condition.

ARTICLE 28:(*2) Interpretation of the Code for the purposes of arbitration shall be in the hands of a body designated to resolve the dispute, and is subject to changes and additions at the discretion of the parent organizations through their appointed representatives on the Committee. Arbitration by a designated body shall be binding among the parties, and decisions may be entered for judgment and execution.

ARTICLE 29: Work on speculation: Contests. Artists and designers who accept speculative assignments (whether directly from a client or by entering a contest or competition) risk losing anticipated fees, expenses, and the potential opportunity to pursue other, rewarding assignments. Each artist shall decide individually whether to enter art contests or design competitions, provide free services, work on speculation, or work on a contingency basis.

*(*1) Artwork ownership, copyright ownership, and ownership and rights transferred after January 1, 1978, are to be in compliance with the Federal Copyright Revision Act of 1976.*

*(*2) The original Article 28 has been deleted and replaced by Article 29.*

Per the contract templates in *The Graphic Artists Guild Handbook: Pricing & Ethical Guidelines,* we include a line in the Terms & Conditions section of our proposals to ensure that both ourselves and our clients agree to adhere to these industry standard guidelines. A simple line like the following will usually suffice:

Code of Fair Practice
The Client and the Designer agree to comply with the provisions of the Code of Fair Practice as published by the Joint Ethics Committee in 1948 and revised in 1989.

One of the beauties of utilizing the Code of Fair Practice in your proposals is that it is not your code. These are industry standard guidelines that have existed since 1948. You didn't invent them and neither did your attorney. While any contract can be modified in writing, and this is no different, beware of any client who requests to change any of these articles. A client who does not agree to abide by the Code of Fair Practice could be a potential nightmare in your future. If a client wants to change any of the legal terms of your contract, consult an attorney to ensure that the terms you agree upon with your client have both parties' interests mutually represented.

90 CONTRACTUAL MUMBO JUMBO

Graphic designers as a collective breed typically dislike the legalities of the business. I'm sure we all would admit that we'd prefer simply creating something really cool versus the reality of life, which sometimes consists of haggling with clients over the contract points of a project. Unfortunately almost every graphic designer I've met claims to be a "freelancer," and as a result they must have some knowledge of how to put together a contract.

For the first several years that my company was in business, our proposals contained no terms and conditions. Somehow we muddled through hundreds of projects without getting into any trouble. Our clients paid. We never had to talk to an attorney. It all seemed too easy. Then the projects started getting bigger, the financials became larger, and the timelines were longer. It became apparent that we needed to become more structured or we were going to get stung by a deceitful client (which inevitably did happen, more than once).

Here is your first step to success: You must own a copy of *The Graphic Artists Guild Handbook: Pricing & Ethical Guidelines*. Purchase the latest edition (a new one comes out every few years). If you don't own it, stop what you are doing right now and order a copy. *The Graphic Artists Guild Handbook* is filled with information to help cultivate and sharpen your business savvy.

Toward the back of each edition of the book is a section called "Standard Contracts & Business Tools." This section discusses in great detail the different contract types, payment issues, negotiation approaches, and legal issues facing designers today. It also contains numerous contracts and forms for you to use as a springboard for your own business. Read that section. Unless you have your own attorney and customized solutions for your contracts, use those guidelines. I know it may be boring at first, but you must educate yourself on standard contract points so you don't open yourself up to potentially getting cheated by a malicious client. They are out there, like Freddy Krueger, just waiting for you to fall asleep.

91 "ETCETERA" HAS NO BUSINESS IN YOUR BUSINESS

Dictionary.com tells us that the word "etcetera" is used to stand for a number of unspecified things or persons. It can also refer to extras or sundries. In other words, you can use it to avoid being specific. Not a great idea for your business.

Any lawyer reading this will likely think, "Of course. You should never put "etc." in your business documentation." Unfortunately, most of us don't have lawyers. My agency completed over 1,500 projects in our first ten years. I just conducted some research on past proposals and found the word "etc." appeared in 80 percent of the proposals we had sent in our first five years! (We have since abandoned this bad habit.) Fortunately, we've never been stung by this practice.

Here are a few embarrassing examples pulled from website and game proposals we've sent to our clients:

*"The page will include standard MySpace features and links (Add to Friends, Add to Favorites, Forums, Comments, **etc.**)."*

*"Users will be able to choose a frame, background, skin, **etc.**, for each of their cases."*

*"Multiple game levels each with their own theme. For example, the user can begin in the Dressing Room and progress through themed levels to eventually arrive at Center Stage—progressive levels can include: Backstage, Make-up, **etc.**"*

*"You could lose one if you run into a creepy object (spider, skull, **etc.**) or a booby trap."*

*"The mini games & training could be graphically represented by tents, race tracks, carnival stands, **etc.**"*

The problem arises when it comes time to interpret exactly what "etc." means. What if the client interprets "etc." to mean, "Creation of video chat technology to be utilized for distribution of the website or game via mobile devices?" If that is not what you meant by the word "etc.," then you're in trouble!

When writing proposals, the word "etcetera" should not be part of your vocabulary. You must clearly define in exact detail what will be a part of the project expectations and how things will be created. While you're at it, be sure to avoid some words and phrases such as *and so on, and so forth, stuff, other things, additional items,* and similar ambiguous phrases that will certainly get you into trouble at some point in your relationship with a client.

92 YOU DON'T HAVE TO SIGN OFF ON THIS

Most of the freelancers and graphic design business owners whom I know are not formally trained in business practices. As a result, being taken advantage of by sneaky clients happens all too frequently. I know for certain that it has happened in my company.

After a few years of existence, our agency had an attorney write up a set of Terms & Conditions to be included in all of our proposals. It cost us $500 and we felt like we were growing up. "Check us out! We hired a lawyer for something."

Most of our prospective clients said nothing about these new additions to our proposals, and we were glad they were there "just in case" something got ugly with a project. We felt protected by our fancy Terms & Conditions.

Our problem, and the problem with most small agencies and freelancers, is that we would agree to throw out our Terms & Conditions anytime a prospective client asked us to. We felt like we had to agree to the terms that our client wanted to have in place in order to gain the green light on the project. We were hungry for the work and, quite frankly, willing to do anything to land it—even if that meant putting ourselves legally into harm's way.

The reality is that when a client sends you new Terms & Conditions to insert into your proposal, YOU DON'T HAVE TO SIGN OFF ON IT. And you are better off not signing off on your client's sometimes lopsided terms than you would be if you landed the project and set yourself up for potential trouble down the road.

An client once approached us with a large project. We were really excited about the project and worked hard to win it. It was a happy day when they gave us a verbal green light. The final

hurdle was that they wanted to remove our Terms & Conditions and insert their own. This project was over $100,000 and our "junior mindset" led us to say, "No problem! Send over your terms and we'll put them into the proposal for sign-off." When their terms came over, we pulled out our 19 terms that filled the space of one page and inserted their custom-written terms that filled three full pages of our proposal (at 9-point type!).

Months later, this client turned out to be a wolf in sheep's clothing, and we needed to get out of the project before it dragged down our whole office culture. We began to review their terms more closely and realized we were in trouble by the legal language contained therein:

6) Vendor represents and warrants that:

(i) it will perform Services in a good, workmanlike, and professional manner consistent with highest industry standards and applicable laws and regulations;

(ii) Services will be performed in strict compliance with the terms of this Agreement;

(iii) neither the performance of Services nor the use of any Work Product, as defined herein, will in any way violate or infringe upon any third party rights, including rights regarding ownership, trade secrets, trademarks, copyright or patents; and

(iv) it will protect, promote and preserve the goodwill associated with the Company trade name and any Company customer and/or vendor relationships in connection with its performance of Services and/or New Services hereunder.

7) In the event of a breach of Section 6, the Company, at its sole option and at the Vendor's sole expense, can either require Vendor to re-perform the Services, which may include modifying the Deliverable, or generate new Deliverable, or refund all amounts paid under this Agreement.

YOU ARE BETTER OFF NOT
WORKING WITH THE CLIENT
THAN SIGNING AN AGREEMENT
THAT TURNS
INTO A NIGHTMARE.

In layman's terms, the above says, "If they don't like our work they can have us redo it or ask for all their money back!" Why in the world would anyone sign off on this? (Yet we did. And many of you reading this would have signed off on it, too. After all, we felt like we had to go along with it in order to land the work). Their terms were filled with additional lopsided legal lines that protected them and put us in a completely submissive position.

A healthy agreement protects the interests of both parties. At some point in your career, a prospective client will undoubtedly present you with Terms & Conditions that smell a little funny. When this inevitably happens, trust your instinct. If it seems lopsided, it probably is lopsided. Remember, YOU DON'T HAVE TO SIGN OFF ON *ANYTHING*. Consult with an attorney. You are better off not working with the client than signing an agreement that turns into a nightmare. After explaining this principle to our office manager, Rachel, she exclaimed, "Stick to your guns and have pride in your company!" (I wish this opinion had been present before we signed off on that nightmare client's terms.)

B.A.M. LISTS

August 2006 was a dark month in our company history. Our work had piled up faster than we were able to staff against it. Our young team of designers and programmers were tasting something at our company that we had not yet experienced: brutally long work hours. The team dubbed this month "Black August."

Most successful agencies have horror stories of frantic all-nighters, racing to hit looming deadlines. Our agency has been in a constant battle to solve this notorious problem and its associated issues: How do you staff up fast enough to manage spikes in the production load, and how do you reduce overhead when the spike is over?

Our solution is the B.A.M. list. B.A.M. stands for "Black August Munitions." It is simply a list of freelancers categorized by their expertise. When we decide that a freelancer has the skills to help our business, we ask them to stop by and fill out all the necessary paperwork (W-9, Confidentiality Agreement, and so one, congruent with their level of potential involvement with our company). By having them complete the necessary paperwork in advance of us needing them for production, there is nothing standing in the way when the time comes for us to use them.

Every time work starts piling up, we determine whether we feel it is a spike or if it is sustainable growth. If it is a spike, we pull out the B.A.M. list. We search for the appropriate freelancer and then bring them in to help manage the load.

So what does this have to do with you?

If you are a business owner or independent freelancer, make a B.A.M. list and distribute it to everyone in your company. Oftentimes, it is an employee buried in work who needs the reminder that there are freelance resources available.

If you are a freelancer looking for work, get on the B.A.M. list of agencies in your area. A simple email containing the following should help get things rolling:

"I am emailing you today because I feel that I would be a great fit to help support your overflow work. I was curious if you had a list of freelancers that you use to support your company; if so, I would love to be added to that list. I'd be happy to swing by your office, briefly show you my portfolio, and sign a nondisclosure agreement or whatever else you would need me to do to be considered for overflow work. It seems every successful agency has times when the workload gets heavy. Next time that happens for you, I would love to be ready to pitch in."

94 ONE LINE THAT CHANGED EVERYTHING ABOUT COLLECTIONS

Getting paid can sometimes be a traumatic experience for a freelancer or a small business. Typically, we email invoices to our clients and they push them through their accounts payable system. If your client is a small business, getting paid on time often has everything to do with whether they have money or not. If you are working with a big corporation, getting paid on time has everything to do with their accounts payable practices.

In my early freelance years, I would send an invoice and then wait for the check to come approximately 30 days later. When the payment didn't show up, I would politely send an email to the client to inquire about the late invoice. The client would then say they needed to check with accounts payable on the payment status. Soon after, I would receive a reply letting me know when to expect payment. I never knew for sure what happened after I hung up the phone with my contact. Did they actually call accounts payable? Did they realize they had never submitted the invoice in the first place?

There was a stretch of a couple years where over half of all invoices we sent were not paid on time. When you are trying to run a business, cash flow is king. When clients pay late, it stings the pocketbook. One particular payment took over six months to collect! First my contact couldn't find the invoice. Then their accounts payable division lost it. Once the accounts payable division finally found it, they sat on it for a few weeks. It was miserable.

We have since changed our entire billing system, which in turn changed our collections. Now we collect 90 percent of our payments on time. The magic happened when we added one simple line to our email as we sent the invoice to the client:

"Please confirm receipt of this invoice so that we can track it properly in our accounting system."

That line is money in the bank, literally! Wait approximately 24 hours and if the client has not replied to your email confirming receipt, then send them an email with this line in it:

"I just wanted to follow up and make sure you received the invoice I sent yesterday. Please let me know when you get a moment."

And if the client doesn't reply to that email, then a phone call is in order. The trick to collecting on time comes by seeing the invoice submission all the way through. You must push that invoice through at the time of submission, rather than waiting until it is finally due.

By getting the client to confirm receipt, it entices the client to actually react to the invoice, to print it out if necessary, and to submit to their accounts payable team. The point is that your clients will be more likely to reply to you and feel an obligation to take the necessary steps to get you paid.

An added bonus is that you rarely have to feel like the repo man trying to collect your late monies. You're simply following up on your friendly email. It is the accounting system you are using that requires confirmation, not you.

Try it. It works!

95 A BUSINESS IS AN ORGANISM THAT WANTS TO DIE

I am looking for a replacement for our art director…again. While employee turnover is not too common at our company, it does happen. We have people who come and work for us for a year or two; they build up their portfolio, get noticed by other firms, and then move on. As I plowed through resumes in search of our new art director, I was reminded that a business is an organism that wants to die. A business often seems like a lemming, doing all it can to jump off the cliff and end its life.

There are times when things are good in a graphic design business. The phone is ringing. Work is piling up. You need a bulldozer to help sort the stacks of money. These times also come with challenges. The workload starts to cause late nights for you and your employees, and the fast-paced production causes things to slip through the cracks. You miss a deadline. Your quality drops on a project or two. Clients begin to be frustrated, and all of a sudden you have grumpy employees who are polishing their résumés and looking for new opportunities. Your success is now killing your business!

Other times, things are obviously rough. The phone is not ringing, causing you and your employees to spend the day twiddling your thumbs, hoping and sometimes praying that you'll get some work. You try some advertising but nothing seems to work. Your lack of success is now killing your business!

Good times, bad times, it doesn't matter: Your business is an organism that wants to die. This may seem like a negative point of view, and perhaps it is, but I found that once I came to this understanding my role seemed clearer. My job as a freelancer-turned-business-owner was to provide 24/7 CPR support for my business. Once I realized that my role was to keep my business alive in spite of its desire to jump off a cliff, things became considerably less stressful.

Instead of being shocked that an employee decides to move on to another company, I think, "It must be time for a little CPR." Rather than getting angry that a client didn't choose us for a big project, I think, "It is time to get out the defibrillator." My expectation is that my business will require a medical diagnosis and a little CPR every day to keep it alive. Every day it seems there is some type of CPR necessary: You need to send out another proposal, find a new employee, call a frustrated client, fix a broken process, talk an employee off a ledge, analyze the financial numbers, design a new marketing piece, replace a broken computer, buy some new software, learn something you don't already know…this is the daily CPR that you provide to your business to keep it alive. Your arms might get tired, but keeping the lemmings on the cliff can be fun if you do it with a positive attitude and a vision of the success that lies ahead.

The real trick in business is getting your business to stay alive without your daily CPR. This requires processes, leadership, and the right team. It took me ten years to get my company to this point and it is truly gratifying.

GOOD TIMES, BAD TIMES,
IT DOESN'T MATTER:
YOUR BUSINESS
IS AN ORGANISM THAT
WANTS TO DIE.

96 IF I'VE GOT A DOLLAR, YOU'VE GOT A DOLLAR, BUT NO PARTNERS

About a year after I started freelancing, the owners of a local design agency asked me to go to lunch. We had a great chat and I walked away surprised at how many similarities there were in what we were doing. They had been in business for a couple years, and we both had entertainment-industry client relationships that had been cultivated from both of us living in Los Angeles during the same years. It seemed we were living parallel lives.

Shortly after our lunch, the owners of this agency took an aggressive approach to try to get me to merge with them. My family was invited to their company party. We wore their agency t-shirts. They broke down the financials and spelled it all out so I could see "how great" it would be. The temptation was great. At the time I was billing a little over $200K per year as a solo freelancer. I knew I had to grow, but had no idea how to do it. The thought of partnering with them would solve a lot of my future problems, and would make it so I didn't have to go through the fear of hiring my own team and growing my business by myself.

I spent a couple weeks mulling over my dilemma. At a get-together with my wife's extended family, I talked with my wife's grandpa about my situation. He is the type of "sage grandpa" who has all the answers from a lifetime of success in business. He heard me out and then shared a story with me about when he was young in his career.

He had worked his way up to where he was running a significant portion of the largest construction business in the Salt Lake City area. He started thinking that he deserved some partnership in the company, and he approached the owner of the construction company with a

proposal for just that. He then shared with me a quote that was the answer to my struggle, "Bill, if I've got a dollar, you've got a dollar, but no partners." The owner of the company was more than willing to treat my wife's grandpa like a partner, but not to bestow legal partnership upon him. My wife's grandfather ended up starting his own construction company, which made him millions of dollars during his working years.

I decided this was my answer. I would proceed with the mindset that I would be better off hanging on to 100 percent of my own thing rather than partnering with another agency and having only a small percentage of something that could potentially grow bigger.

I kept my eye on that agency over the years and even went to lunch with them a couple times to talk shop. It seemed they were doing well, and so were we. Both our agencies grew to the same size, around 15 employees at that time, and both doing cool work for cool clients.

Then, seven years after this agency had courted me, I had lunch with them again. One of the owners had left the company to do other things. The owner that was left behind began to tell me the full scope of their trials. They had not had one profitable year since their inception. My company, on the other hand, had been profitable every year. They were on the brink of closing their doors. We were maintaining profitability in spite of being in the worst economy since the Great Depression. I was overwhelmed with a feeling of gratitude that I had made the right choice all those years earlier. It turns out that this agency closed their doors, while my agency is still thriving.

I have people at my company now who are in the same shoes as my wife's grandfather—deserving of a partnership. I treat them like partners. They share in the profits and decision making of the company. But there is no legal partnership. They have all the upsides of partnership without the liabilities. If I've got a dollar, they've got a dollar.

With a partnership it is easy to get lopsided in contribution. One partner works more hours. Another partner seemingly brings more to the table. How do you decide to fairly distribute dividends? Who wins the debate when you want to shift directions in the company? I'm not saying that partnerships can't work; there are countless examples that show when partnering is the perfect solution. I am just cautioning

you to make sure the merger is mutually beneficial and to work out all the details in advance. This will help save any potential heartache and disappointment down the line.

On the flip side of caution, in 2011 I was approached by Mark Long, the owner of a successful photo restoration company, about partnering together. We started a small design agency utilizing offshore designers to produce low-cost graphic design services for small businesses. While the business presents unique challenges, the partnership has been one of the most rewarding business relationships of my career.

I'm certainly not trying to say you should never partner with anyone. I'm simply saying, "Be careful and choose wisely." The right partner and complementing strengths and weaknesses can certainly lead you to great success.

97 IF YOU WANT TO WIN THE GAME, YOU HAVE TO KNOW THE SCORE

The first time I heard about the E-Myth was straight from the horse's mouth. I had been freelancing for about a year when the acclaimed author Michael Gerber came to our state to speak at a business expo I was attending. He was energetic and filled with wisdom. I was intrigued. Shortly thereafter, I picked up his book *The E-Myth Revisited*. If you are a business owner and have not read it, shame on you. Even if you don't own a business, Mr. Gerber's insights and advice are of great benefit to any working person.

Several parts of the book had a profound impact on me. One is his instruction on creating "Information Systems" for your business. In a very concise explanation, the numbers you track tell you the story of your business.

"In short, the Information System could tell you the things you need to know! The things you don't know now…It tells you when and why you need to change. Without it, you might as well put on a blindfold, have someone turn you around three times, and set out with a dart in your hand, waiting for a signal from the heavens to throw it. Not a very promising game. But one, it seems, most people in small business are determined to play."

—The E-Myth Revisited, *1995, 248–249*

I was inspired. I met with my brand-new office manager and read her a few excerpts from the book. We pulled out a spreadsheet and made up a list of things we would start tracking. I remember saying, "Someday all of this data will tell us a story that will help us make decisions for our business." Several years later, that list of data became a crystal ball for our business. We review the most recent data at the start of each month and have been able to make accurate assumptions as to what the future has in store for us.

Information We Track Monthly

- How much did we bill (revenue)?
- How much did we cost (expenses)?
- How much profit (or loss) did we make?
- How many estimates did we send?
- What was the average cost per estimate?
- How many estimates were green lit?
- What was the average cost per estimate that received a green light?
- How many invoices did we send?
- What was the average cost per invoice?
- How much money are we waiting to collect (receivables)?
- How much money is overdue for payment?
- How many man-hours did it take to complete our projects this month?
- How much did we cost per production hour (the hourly burn rate)?
- How much did each employee cost per hour/per day?
- How much money is in each account at the end of the month?
- How many days before the first of the month did we have enough money green lit to cover costs?

- How many working projects do we have that have yet to be invoiced?
- Who were our first-, second-, and third-largest clients in the month (based on dollars billed)?
- How much did we spend on advertising this month?
- What were our payroll costs?
- How much were overhead costs (excluding payroll)?
- When did employees receive raises and how much did that amount to?

Many of these items are plotted on a line graph. This helps us recognize trends in the data. Over several years of tracking this information, we now know important things about our business, such as

- June, July, August, and September are our busiest months.
- One of those months will be 40 to 60 percent higher than what we bill in January.
- December is always our most expensive month.
- December or January is usually our lowest billing month.
- There is a direct correlation between the number of proposals we send out and the amount of money we bill. (This goes without saying, but we see the hard numbers and can then react appropriately.)
- Money spent on advertising does not have a direct correlation with the amount of money we bill (in the short term).

These are just a few of the things we know about our business from the data we track. This information helps make important business decisions. If you want to win the game, you have to know the score.

98 THERE IS NO SUCH THING AS A "MEET AND GREET"

We've had some embarrassing moments in our company history. A few years ago, we had been asked to participate in the bidding process for a big project for Disney. This was an exciting project with six-figure dollars attached. We were finally starting to feel like we were being asked to play with the big boys. Our team put the proposal together, which got Disney interested enough that they asked us to fly out to Burbank for a "meet and greet." Two of our team members were designated to go; they printed out a few copies of the proposal and jumped on a plane. To their surprise, what was named a "meet and greet" by our Disney contact actually turned out to be a conference room full of executives waiting to hear our team's pitch. The Disney execs expected to be wowed by our organization and preparation. Instead, they were likely joking about our idiocy after our team left. A few copies of a printed proposal and an ad-hoc presentation about how our team would execute on the project were not enough to impress someone's family pet, let alone a group of powerful, intelligent executives.

This experience, combined with a few other awkward meetings, has taught us the valuable lesson that there is no such thing as a "meet and greet." Every meeting, every interaction, every time you have an audience, you should be prepared to present what makes you and/or your company so awesome. This means you should always be prepared with some, any, or all of the following: a presentation, a photo gallery of portfolio samples, a printed portfolio book (don't always assume you'll have a computer or Internet access), a brochure about your

EVERY MEETING,
EVERY INTERACTION,
EVERY TIME
YOU HAVE AN AUDIENCE,
YOU SHOULD BE PREPARED
TO PRESENT WHAT MAKES
YOU AND/OR
YOUR COMPANY
SO AWESOME.

business, a list of questions about your audience's company, or perhaps a diagram of how you approach a typical project. Even a stone tablet with chiseled dreams and goals is better than nothing. Whatever it is, the moral of this story is to ALWAYS BE PREPARED.

In my experience, meet and greets just don't exist. But if you do happen to have that first meeting in the history of design where the only thing that potential client wants to do is shake your hand and talk sports, then at least all of the great tools end up sitting under the table in your laptop bag ready for action if called upon.

99 HOW TO MAKE A CAPABILITIES PRESENTATION

A mere eight years into the creation of my graphic design business and I felt like we were finally getting on the right track with business development. As I originally wrote this a few years ago, I was sitting in JFK Airport heading home from a successful trip that was filled with business meetings with executives at entertainment companies and advertising agencies in New York City. Until this point, we had been fortunate to land work without much effort. New clients would be referred to our company, and we would magically get the green light on projects. Unfortunately, due to the economic downturn of 2008 and 2009, we now had to work hard for work. On this trip we were ready to put our best, most polished foot forward.

A few weeks prior to our trip, we were invited by NBC to give a "capabilities presentation" to one of their marketing teams. At the time we didn't have one prepared so we spent about a week working up our presentation. The fact that we didn't have a canned capabilities presentation at our company after churning successful projects for eight years leads me to believe that many of the freelancers and small design business owners reading this book don't have one either.

The objective of a capabilities presentation is to tell the potential client "Who You Are" and "What You Do." So don't beat around the bush; come right out and tell them. We build our presentations in Apple's Keynote software, but it could just as easily be created in PowerPoint or any other related software. What is important is the flow of information.

Slide 1: Who We Are

Slide 2: "Our Team"
We show a quirky photo of our team, and we share with the client a brief history of our company and the awards we've won. For freelancers,

I don't advise putting a photo of yourself on a slide like this—it might be kind of awkward to be sitting there with a potential client showing off a picture of yourself. In this situation, you can share info about yourself on Slide 1.

Slide 3: Client Logos
We share a few phrases about the clients we have worked with and about how many projects we've done over the years. If you are a free-lancer and don't have anything "fancy" to share, you can skip a slide like this. The next few slides are designed to give your potential client an overview of what you have to offer and show work examples to support your capabilities.

Slide 4: We Do Branding
On the We Do slides like this, we share an overview of the services we provide. In this case, we tell them we design logos and style guides to create a unique "look and feel" for a business.

Slide 5: Branding Example 1
In our presentation, this slide contains four screenshots of a style guide we did for a Fox property. In a few brief seconds, we explain informa-tion about the project and then move on to the next slide.

Slide 6: Branding Example 2

Slide 7: Branding Example 3
Each Example slide contains a few nicely organized screenshots of the example project on the right side of the screen. On the left side of the screen is a bulleted list of five or six key points about the project. Don't bore your client by piling on tons of slides and examples to support each section of What You Do; a couple is all you really need. We feel like three is a good number.

Slide 8: We Do Print Design

Slide 9: Print Example 1

Slide 10: Print Example 2

Slide 11: Print Example 3

Try to select examples that show variety in what you have to offer. For example, in the Print Design section you may show a brochure project for example 1, an annual report for example 2, and a stationery package for example 3.

Slide 12: We Do Web Development

Slide 13: Web Example 1

Slide 14: Web Example 2

Slide 15: Web Example 3

For our Web Development section, we select high-profile projects we've created, while keeping in mind some of the different programming languages and tools we are capable of working with. You want the client to walk away with a good sense of your core skill set.

Slide 16: We Do Online Games

Slide 17: Game Example 1

Slide 18: Game Example 2

Slide 19: Game Example 3

In this section, like with Web Development, we also make an effort to show a variety of programming languages and brands we have worked with.

Slide 20: Summary

To wrap up the capabilities presentation, we have a slide that contains a listing of each category we reviewed with the client, as well as a few bullet points underneath each item detailing what we offer. We briefly run through a few of the items that we feel are of the most interest to the client.

Here are a few things to keep in mind when you give your capabilities presentation to a potential client.

Be respectful of their time. Practice giving the presentation in 3-, 10-, and 15-minute versions. When you sit down with the potential client, ask them how long they have and then give them the appropriate version of the presentation. Don't be too wordy. Even though you may be really excited about the amount and quality of the work you have to show them, your potential client may not share that same enthusiasm.

Be brief and informative as you discuss your capabilities and projects. Focus on results. Good design is always fun to show, but most clients are interested in results. Make sure you have quantifiable results to share about some of the work you show. Phrases like, "The year after we rebranded this client, their company grew by 30 percent," or, "After we launched this site, they had over one million unique visitors in the first week alone," are great things to be able to say as you present to the client. Watch their body language. If they are getting fidgety, not asking questions, or looking at their watch, you may want to hurry things up. A great way to bomb your capabilities presentation is to bore your client and waste their time. You are better off speeding through it and following up with them at a later date. That said, be sure that you have a leave-behind.

We usually leave a brochure with our clients that outlines a few project examples and offers brief information about our company. Yours may just be a simple flyer. Whatever you choose, a creative giveaway is always a good way to leave a positive impact. A freelancer once gave us a custom-printed skateboard with our company logo on it; this type of thing is a great reminder of who they are and the work that they do, and doesn't get thrown away. A capabilities presentation is an awesome way to "sell" your services.

100 FLOODS HAPPEN

The first three of my four self-employment years consisted of me slaving away in my basement. Forty-hour weeks became eighty-hour weeks, and my stress level was through the roof. My wife found and convinced me to hire my first employee, and my mother-in-law found my second employee. It was as if they were bringing home stray puppies for me to adopt.

My basement office was at maximum capacity with three workstations—one in each corner of the room—and a small television in the fourth corner to keep me company late at night. It didn't take long for us to realize that we needed to find some office space. My conservative nature led me to find some cheap space just down the street from my home. We signed a one-year lease and started packing.

Moving day came and we hauled our desks down to the new office. Around mid-afternoon we were ready to move in our equipment. With excitement we dashed back to my home office to get our computers and monitors. At approximately 5:00 P.M. we were finished. Our desks were set up. Our computers were plugged in and ready for a bright new future on Monday morning in our new office space.

Approximately 12 hours later, I was awakened by someone pounding on the front door to my home. I glanced at the clock by my bed: 5:00 A.M., "What is going on?" I thought. I raced to the front door and recognized my neighbor outside. I opened the door and he yelled, "Your basement is flooding, I'm going to get help!" as he ran down the street. At that moment I recognized the sound of rushing water. I charged down to the basement and splashed into two feet of brown water that now covered every inch of the floor. Fortunately, my wonderful neighbors came to the rescue and began helping to move all of the furniture and stored possessions.

At the base of the mountain near my home there is an irrigation reservoir. Sometime in the night, a chain had broken and a gate opened, which allowed the water to rush out of the reservoir. The rushing

water became a river flowing through streets and canals searching for lower ground. The river found my walk-out basement and the water poured through our basement door.

This experience taught me countless life lessons. One of the most important is, "FLOODS HAPPEN, YOU MUST HAVE DAILY BACK-UPS OF YOUR WORK." We didn't. At the time I had no file backups at all. I occasionally feared a hard-drive failure, but never worried about it enough to back up my files on a regular basis. Had my flood happened 12 hours earlier, I would have lost all the work stored on three workstations. All of our current projects would need to have been completely redone. All past projects would have been gone forever. It would have been a disaster and I likely would have thrown in the towel on starting a business and begun looking for a job. I am so grateful that I didn't have to learn this lesson the hard way.

The following week we implemented a regimented file backup strategy. We bought multiple external hard drives and since that day, I keep backup drives onsite and offsite. My office and my home would both have to burn down on the same night for our data to be lost.

There are plenty of ways to back up your data, and nowadays software makes it ridiculously easy. I won't go into the details of backup options. A little online research can reveal many different strategies. Choose something that works for you, but CHOOSE SOMETHING. If you are not backing up your computer files regularly, you could be in for serious and irreversible trouble.

I don't live in a flood plain. My home is in a neighborhood within a developed area. There are even several homes down a large hill from mine that would expect to flood before my home. Nobody expects a flood, fire, or other disaster to happen to them, but believe me, floods happen and lightning strikes. You *must* have daily backups of your work so that you are able to weather the storm when it inevitably comes your way.

101 FLEXIBILITY, NOT FREEDOM

I always chuckle a little when I hear people say something along the lines of, "It must be nice owning a business. I would love the freedom that comes with that." I always think to myself, "Freedom! This is the furthest thing from freedom. I'm a slave!" If you are considering venturing out on your own to freelance or start a business, be prepared to enjoy "flexibility"…but definitely not "freedom." This chapter is dedicated to those of you considering taking the leap and going out on your own, as an effort to prepare you for the flexible yet freedom-less life you will be plunging into.

If you are an ambitious business owner, the day never really ends. There is always a fire to put out or an area that you can find for improvement. In my early freelance years of working 80 hours per week, I used to love the evening hours when clients would be out of the office. The phone would stop ringing and the emails would stop flowing, and I could actually focus and get some work done. Now that I have a team of people in the office, my "office hours" are pretty normal: 40 to 50 hours per week (in office). But as an ambitious business owner, I have the privilege of spending my evenings reading business books, discussing business issues with my wife, and working through general stress management issues. I can't count the number of late-night hours I spend jotting solutions to my problems on scratch paper by my bed, for example. (By the way, many of those solutions became this book.) Don't get me wrong. When you are ambitious, this type of life actually "feeds" you.

The fruits of freelancing or owning a business are many, one of which is flexibility. You have the privilege of deciding which 10 to 12 plus hours per day you want to work. If you want to run an errand or two in the day without asking permission from a boss or company manager, you can. If you want to take your kids to the pool on a summer afternoon, you can. You have the flexibility in your schedule to do that. Just know you'll likely be working later that day to make up

for that lost time. When you work for yourself, there is no "salary" to cover for missed billable hours—what you work for is exactly what you will get, whether for good or for bad.

It is also important to note that for freelancers or business owners, like for Spider-Man, "with great power comes great responsibility." Since your success is based solely on how much you put into it, it will be sometimes difficult to draw the line between working hard and smart versus becoming a workaholic. While nothing great was ever achieved without hard work and enthusiasm, take into consideration your health and your family situation—working 22 hours per day may not be the best thing for you, or it may be just fine. The important thing is to think through all aspects of branching out on your own so that you know going into it where you plan to draw the line—both with yourself and with your clients and your workload.

I'm not trying to paint an ugly picture of freelancing or owning a business. I'm merely trying to help you understand the lifestyle choice that is before you. As for me, I'll choose flexibility over freedom any day of the week.

WHATEVER YOU DO,
NEVER, EVER
DO UNDOCUMENTED WORK...
NEVER, NEVER, NEVER.

102 NEVER DO UNDOCUMENTED WORK

This lesson I've learned many times in my graphic design career. I'm not quite sure why I have to learn it over and over again, since the emotional scarring is so painful. But, whatever you do, never, ever do undocumented work…never, never, never.

Imagine the scenario. You sit in a conference room with your potential clients to discuss their logo, website, and brochure project. Over the course of an hour you amaze them with your ideas, creativity, and personality. You discuss the budget and project scope, and they green light you to begin work right away. A week later they come back to your office to see your initial comps and drop off their initial payment. As you begin to show them your comps of their logo, website, and brochure, they remark, "Wait a minute. We thought you were going to do only the logo. We decided to hold off on the website and brochure." A cold sweat breaks across your clammy forehead. You just spent 20 hours of your week doing comps for a project that you thought was green lit.

I'm not saying you need to create a formal proposal or have a rock-solid employment agreement in place before you can start working with a client or at a new job. I'm simply saying that, by nature, people tend to have problems with memory loss.

The next time you get a request to do any work from a client, take the couple minutes to shoot them an email that details out the project as you understand it to be.

Dear Lucy,

Thanks for the call. I'm ready to jump on the project. Just to make sure we are on the same page, here are the details of the project: (insert details here). I expect these tasks to take approximately XX hours, which equates to about $XXX in fees. I'll plan on including the hours on my next invoice to you. If things start taking longer than expected, I'll keep you posted on the change in my estimated hours. Please let me know if this works for you! I'm getting started right away.

George

As this relates to taking on a new job, it may be surprising how many small business owners don't go through the formality of creating an offer letter. (I believe I've received an offer letter at only two companies during my career.) Since many designers end up landing at small agencies, there is a good chance that you will be extended a verbal offer at some point in your career. Don't let your soon-to-be employer get away with it. Either ask them to send you a letter or email that details the offer, or do it for them.

Dear John,

Thanks for the job offer. I am excited to begin working with you. Just so that we have something in writing, here are the details we discussed: starting salary will be $XX,XXX and the benefits will begin on XX/XX/XXXX. Can't wait to start working together!

Sally

Doing work without documentation is like getting in the fast lane on the way to the poor house. Quick emails like these can be a lifesaver as you review project scope and billing with your clients, or take on a new position with an employer.

103 NEXT WORRY DATE

No surprise: 2009 was a challenging economic year. I was asked by a designer friend whose own business failed, "What do you attribute your survival to?" Immediately I thought of the standard things: good customer service, zero debt, hard work, stress, tears, sweat, hope, luck, faith…we exercised them all during that challenging time. However, one of the things that didn't immediately come to mind, but likely had just as big an impact, was tracking our numbers and reacting to the "Next Worry Date."

I've always been neurotic about my finances. Heck, I'm neurotic about a lot of things. Every day our office manager posts our financial data on a secure site for me to review. The data includes typical things such as

- How much money is in each account?
- How much money are we billing in each of the next three months?
- How much money will we need to meet our expenses in each of the next three months?
- How much money are we waiting to collect (receivables)?

Watching hundreds of thousands of dollars come in and go out of our bank accounts every single month is very stressful. These numbers, along with a few others, provide me with ammunition to help control that stress.

A few years ago I realized that I was making calculations in my head based on the numbers in an attempt to figure out if I should be worrying about money. Then it hit me! Why not figure out the calculation I was making and track the exact next date that I should be worrying about? Here is the **Next Worry Date Formula**:

(**Starting Balance**) *Total cash in the bank*
+ *Total receivables*
+ *Total remaining billings for the current month*
+ *Total remaining billings for next month*
- *Tax money (the money we have set aside to pay our quarterly taxes)*
- *Emergency fund (the money we have set aside for absolute emergencies)*
= *Total Cash Flow*
÷ *Monthly overhead cost*
= *Number of months of cash flow coverage*
- *One month*
= *Next Worry Date (that is, one month before money runs out)*

Here is the **Next Worry Date Formula Example (for a Freelancer)** in action—how the numbers may look if you are a freelancer working out of a home office on, say, August 1st:

$12,300 *Total cash in the bank*
+ **$6,400** *Total receivables*
+ **$5,200** *Total remaining billings for the current month*
+ **$3,500** *Total remaining billings for next month*
- **$3,000** *Tax money—since it is August 1st, you have two $1,500 quarterly tax payments remaining for the year*
- **$1,500** *Emergency fund*
= **$14,400** *Total Cash Flow*
÷ **$6,000** *Monthly overhead cost—let's say you pay yourself $5,000 per month and have $1,000 in additional business expenses*
= **2.4 months** *Number of months of cash flow coverage*
- **One month**
= **1.4 months** *Next Worry Date is one month before money runs out*
= **September 30th** *Next Worry Date*

Since it is August 1st, your Next Worry Date is approximately September 30th. You'll notice that the next worry date is one month before money runs out. You'll also notice that your emergency fund is not included in that month of cash flow. You can't wait until all of the money is gone before you make tough decisions. The month of cash flow and the emergency fund buy you time if and when things inevitably go south at some point in your career as a designer.

This next case is what your **Next Worry Date Formula Example (for a Small Design Agency)** might look like if you are a small design agency of ten people or so. We'll keep the current date as August 1st for the sake of simplicity:

$87,300	*Total cash in the bank*
+ $109,000	*Total receivables*
+ $72,500	*Total remaining billings for the current month*
+ $58,400	*Total remaining billings for next month*
- $12,000	*Tax money—since it is August 1st, you have two $6,000 quarterly tax payments remaining for the year*
- $45,000	*Emergency fund*
= $270,200	*Total Cash Flow*
÷ $65,000	*Monthly overhead cost*
= 4.16 months	*Number of months of cash flow coverage*
- One month	
= 3.16 months	*Next Worry Date is one month before money runs out*
= October 31st	*Next Worry Date*

So, what do you do if on the Next Worry Date you actually have no money as projected? REACT! You have two choices: Either green light some projects or cut costs today! You cannot wait any longer. It takes a little time for financial decisions to unravel, so if you ever hit the Next Worry Date cashless, make immediate decisions. Then continue a constant assessment of where you are financially to keep yourself aware of where things are. This will allow you to tackle each day with confidence and purpose rather than working in a vacuum.

104 NICKELS AND DIMES ARE FOR LEMONADE STANDS

Since the formation of our company, we have sent only two change orders. In an industry riddled with scope creep, this is an unprecedented statistic. Admittedly, this strategy has caused us to lose money on a few projects. However, the quantity of referrals and repeating customers that have flooded our agency as a result of our flexibility has more than made up for these small losses. Nobody likes to be nickel-and-dimed, especially when they are spending large sums of money.

A few years ago we tried out a new accountant during tax season. Things seemed to be going well. They completed our taxes and were wrapping everything up smoothly. Our representative at the accounting firm called me and told me that everything was finished and ready for submission; he offered to bring the documents to my office so that

I could sign everything and they could ship them off. I was grateful for this offer and looked forward to getting our taxes wrapped up.

About a week later we received the invoice from our new accounting firm. Not only was the bill for the tax work twice as much as they had quoted me, but they had included a $25 mileage fee for bringing me the tax documents! I was shocked that they had charged me for something that seemed to be part of what I would consider good customer service. Call me crazy, but a $25 mileage charge has no business showing up on a $3,500 invoice. Suffice it to say, we dropped the accounting firm like it was a cherry bomb on the 4th of July.

Your clients will drop you, as well, if they feel like you are nickel-and-diming them. There is no question about that. The trick is to price things right in the first place. Make sure there is a little bit of padding in your proposed project cost. Then, when a client asks for an extra tweak here and there, you can accommodate them without feeling like you are losing money. It is also advised that you know where you stand financially on each project. Track your costs so that you can go the extra mile when the budget allows, without having to bombard your client with change orders.

105 ONLY TERRORISTS LIKE HOSTAGE SITUATIONS

We had just green lit a project to create an iPhone application for a major Hollywood studio. We were excited about it, as it was our first iPhone app. The only problem was we didn't have any Objective-C programmers on staff. Fortunately for us, we had a great relationship with an agency that specialized in app development. We called and they were more than happy to help us with this cool project. We got a price from them for the pieces we needed assistance with, and they got started.

A few days later, the milestone arrived for designs to be sent to the client. Our outsourced agency said they had the comps ready, but they wouldn't deliver them to us until we paid the first invoice—an invoice they hadn't even sent us yet! To them we said, "Fine, send us the invoice and we'll pay it so we can get the designs from you and stay on schedule." Inside our offices we said, "Do they think we're a bunch of criminals? It's like they are holding the designs hostage until we pay the ransom! We're a successful agency a couple miles down the road from them. Of course we're going to pay!" This experience put a blemish on our relationship and made us feel as if our vender did not trust us.

As a designer you have to take a leap of faith when you start many projects. But trust is a two-way street. You get started working on the designs, trusting that the client will pay. If you force the client to pay you first, then they have to trust that they are going to be satisfied with your work. When our vendor made us pay their ransom, we became the only party in the relationship taking a risk.

At our agency, we typically invoice a portion of the project at the start of production (25 to 50 percent depending on the size of the project). We get started on the work trusting that the client will pay the invoice. There have been times when we've had to halt production

after an unusual delay in payment. There have also been a few times when a client never paid the initial invoice and we've been out our cost to that point of the project.

Make a careful assessment of a new client. If you get a feeling that they may not be trustworthy, then you are absolutely justified in holding work for ransom—or even waiting to begin the project until after you receive initial payment. Just know that sometimes a client with good intentions will be offended by your lack of trust in them.

If you do trust your client, don't tarnish your relationship with them by holding your work hostage until the ransom is paid. If you don't trust your client, then maybe you should take a close look at whether you should be working with them in the first place.

106 OH WHERE, OH WHERE HAS MY $100K GONE? OH WHERE, OH WHERE CAN IT BE?

About two years into my career, I was hired by a direct marketing agency. It was the mid-nineties, and I was the small company's only "web guy." There weren't many "web guys" in existence at the time. The company was affiliated with a private school conglomerate, and many of the projects we did were for those institutions.

I single-handedly project managed, designed, and programmed many of the websites the agency landed. I operated as what I thought to be a one-man show. On one occasion, I found out that the agency was charging the client $22,000 for the website I was creating. The project lasted about four weeks and at the time I was making $28,000 per year. After the project successfully completed, I thought, "Man! This company is making so much money off of me! I deserve a raise! I made them $22,000 in four weeks! That almost covers what they are paying me for an entire year!"

What I have learned after years of running my own business is that it totally doesn't work that way, as much as I wish it did. It just doesn't. When this company billed our client $22,000 and I subtracted my four-week cost to do the work, $2,153.84, it did not leave $19,846.16, even though at the time I thought it did. And that sentiment caused me to waste my energy in frustration for what I was being paid.

A business has many costs that are not known by the employees. When I first started hiring other designers to help me with my abundant freelance work, I often felt overwhelmed by the flow of money in and the flow of money out. Over the years, this constant flow of

money has helped me to gain a better understanding of why the $22,000 website I built was not quite as profitable as I once thought.

Here are a few scenarios based on past phases of my small design agency to help illustrate where all the money goes. Before we get into that, let me take a moment to define each of the expense categories. I've grouped many of the individual elements into bigger categories to help us digest the information more easily.

Expenses

Project: This category reflects things like stock photos, website hosting, and other elements necessary to complete a project for a client.

General: Includes office supplies, networking group dues, subscriptions, client gifts, postage and delivery, and other miscellaneous costs that occur each month.

Insurance: Includes the company's costs for health, dental, liability, and errors and omissions insurance (required by some of our higher profile clients).

Occupancy: This category is for all costs relating to office space, including lease payment, building association fees for common areas, security system, janitorial, telephone, Internet connection, and other types of utilities.

Payroll: Payroll is the most significant cost for most graphic design types of businesses. In these scenarios, this category reflects the wages taken home by the employees.

Payroll Taxes and Processing: The employer is required to pay a matching amount of your social security and Medicare taxes as well as state and federal unemployment tax. This category also includes the costs to an accountant or payroll company for processing payroll checks and taking care of the state and federal tax payments.

Freelancer: It seems we are always using freelancers for some aspects of our businesses. This category represents those fluctuating costs.

Travel: Most of our clients are out of state, which requires travel. For our business development efforts to be successful, we find ourselves making the rounds with out-of-state clients about every other month.

Marketing and Advertising: Magazine ads, direct mail, billboards, or whatever works for your business would be applied to this category.

Monthly Expenses Scenario 1
(Six-person design agency in a 2,000-square-foot office space.)
Project = $3,500
General = $1,500
Insurance = $3,500
Occupancy = $5,750
Payroll = $19,750
Payroll Taxes and Processing = $4,500
Freelancer = $2,500
Travel = $2,750
Marketing and Advertising = $750
Total = $44,500

Monthly Expenses Scenario 2
(Ten-person design agency in 2,000-square-foot office space.)
Project = $2,750
General = $2,750
Insurance = $4,500
Occupancy = $5,750
Payroll = $34,000
Payroll Taxes and Processing = $8,750
Freelancer = $3,000
Travel = $1,500
Marketing and Advertising = $2,000
Total = $65,000

Monthly Expenses Scenario 3
(Fifteen-person design agency in 3,000-square-foot office space.)
Project = $5,500
General = $3,250
Insurance = $6,500

Occupancy = $6,750
Payroll = $51,750
Payroll Taxes and Processing = $18,000
Freelancer = $4,500
Travel = $2,250
Marketing and Advertising = $2,500
Total = $101,000

The above scenarios are accurate costs (with a little rounding of the numbers for easier math) of various stages of growth in my business. So, what do you do with the profits?

The first thing to understand about profits is taxes. Everyone is lumped into a tax bracket based on their income. If you have small profits, you have a small tax bracket. If you have a lot of profits, then your tax bracket is bigger. Tax brackets range from 10 percent to 39 percent of your income. For a business, everything you bill above your expenses is taxed. For the sake of these scenarios, let's say the business is taxed at 30 percent. A business pays these taxes on a quarterly basis.

The second thing to understand about profits is "nest eggs." In order to survive, a company must have some cash reserves. Several different people have recommended that a company like mine should have three- to six-month's worth of cash reserves in the bank. That means if we are costing $101,000 per month (like Scenario 3), we should have somewhere between $303,000 to $606,000 in the bank. The nest-egg money enables a business to ride out things such as late payments (one of our Fortune 10 clients pays in 120 days, regardless of what you request on your invoice), getting stiffed (someday, someone is going to cheat you and not pay for the work you did), and economic turmoil (my company would have died during the 2009 recession if we didn't have a solid nest egg to help us ride through the tough times).

Each month, from our profits we take out 30 percent for taxes and 50 percent to add to our nest egg. That leaves 20 percent to play with. In the past, the 20 percent left goes toward things like computer and software upgrades, office upgrades, hiring new talent to help grow the business, employee parties, employee gifts, and bonuses.

Let's take a look at Scenario 1 again, and this time, we'll look at how the profits play out.

AS A BUSINESS OWNER,
NOTHING HELPS
YOU SLEEP BETTER AT NIGHT
THAN HAVING
MONEY IN THE BANK.
NOTHING.

In Scenario 1, we had a monthly expense of $44,500. Let's say the company billed $60,000 that month. "Wow," you might think, "Let's divide up that remaining $15,500!" Great idea! But first, let's set aside 30 percent for taxes ($4,650) and 50 percent to add to the company nest egg ($7,750). Take those amounts out of the $15,500 and you have only $3,100 of profits left to play with. Even if you structured your company to split that profit evenly between all six people, you'd take home only about $516 each. Nobody is getting rich off of that. So that job I had as the "web guy" those many years ago sort of fit into a scenario such as this one.

Now you might be thinking, "How does anyone get rich owning a business?" Good question. I billed tons of money for years and didn't feel like I had much to show for it. I was keeping tons of money in my business' nest egg based on the paranoia that we would need it to keep the company running off of that nest egg at some point in the future. Then the magic day happened. I looked at the bank accounts and we had a sizable nest egg in place. I had amassed several months' worth of lifesaving money and it was all sitting in my business accounts. We had plenty of work and plenty of money. I set aside the 30 percent of profit each month for taxes and every penny that was left became "extra profit." Those were fun days in our business. We had a sizable nest egg. We had tons of work. And the "extra money" was now piling up. We had lots of bonuses, raises, and employee perks. And I was able to take home lots of money on top of all that. Getting "rich" in business happens. It just takes time to put the money in the right places before the "extra money" becomes available.

I have had several bankers and accountants dig into my company's financials and applaud this financial strategy. They often cite examples of other business owners spending their profits each month on cars, trucks, and other expensive toys while not considering the need for a rainy day, nest egg, or future tax implications. To me, these considerations just makes sense.

My father-in-law used to say, "Spend a little, save a little." Too many people forget the second part of that phrase and operate in a "Spend a lot, save nothing" lifestyle. As a business owner, nothing helps you sleep better at night than having money in the bank. Nothing.

107 DON'T DO ANYTHING YOU CAN PAY SOMEONE $10 PER HOUR TO DO

I was massively burned out at the end of a three-year stretch of freelance slavery. I had so much client work piled on me I couldn't see straight enough to try to figure out how to hire someone to help. I spent every day from early in the morning until late at night with my head down, just trying to get it all done. From time to time, I would leave my cave to attend a networking group of some kind. On one occasion, I sat with a small group of four business owners. We were chatting over the challenges we face in our businesses, and when it came to be my turn I didn't have to dig deep to know what my struggle was. I told them, "I'm buried in work. I'm stressed out of my mind. I don't know how I'm going to get everything done. And, by the way, I have to leave in three minutes and forty-seven seconds. I just have way too much to do." One of the business owners shared this life-changing advice, "Don't do anything you can pay someone $10 per hour to do."

Genius! Why hadn't I thought of it before? Well actually, I had. I was just thinking about it the wrong way. I made the calculation this way: a $10 per hour employee will cost me roughly $25,000 per year. Even though I had plenty of money saved up, I was nervous about the $25,000 commitment.

What I should have been thinking was: A $10-per-hour employee will cost me $200 per week if I start them out at 20 hours per week. I was spending 80 hours a week working. And I was billing $5,000 to $6,000 per week. Even if the $10-per-week, 20-hours-per-week employee

is half as productive as I am, they will save me 10 hours per week. Which means I'll be working 70 hours per week and still be able to net $4,800 to $5,800 per week. And if it doesn't seem to be working out, I can always let them go after a few weeks. So, my real financial risk is about $800 to test out this concept for a month. It is NOT the $25,000 commitment I had assumed it to be.

I made a list of all the things I had to do each week and then separated out the ones that a $10-per-hour employee could handle:

- Answer the phones
- Pay bills
- Go through the mail
- Package up client deliveries
- Make requested client changes
- Test website projects
- Proof print projects
- Run errands
- File paperwork
- Send invoices
- Follow up on late payments
- Make bank deposits
- Balance the checkbook
- Order equipment
- Update spreadsheets
- Gather client assets
- Backup files
- Write blog posts
- Manage social media

After I finished the list, I realized that I was spending a lot more than 20 hours per week doing all these things at the ultimate expense of the design and programming work that I actually could bill for. I decided to go for it. As I've said before, my wife found my first employee and my mother-in-law found my second employee. I was amazed at how much help these first couple employees were. The problem was that these employees were freeing up my time, and that freed-up time was now being filled with new clients and projects that I could bill for. The next logical step was to hire more people, which was an easier decision this time around. By the end of that year, I employed six people and had moved to office space down the road from my home.

At some point, as a successful full-time freelancer, you have to take the plunge and hire someone. Make your own list of things you are doing that can be done by a lower-cost employee. Your goal should be to do only the things you can do, and delegate the rest. Not every employee is going to work out. Look at each new hire through the lens of a simple one-month commitment. Make sure you have enough money set aside to pay them for that one month; if it works out, you'll likely fall in love with them during that month and a long-term commitment to them will become obvious. If it doesn't work out, don't be afraid to cut them loose and try again.

108 "SKIN IN THE GAME" USUALLY MEANS "FREE"

Every year we have several people come into our office with an "idea" that they want us to build. Usually these ideas revolve around being something like "the next Facebook" or "the next Club Penguin." Of course, these people usually have no money and want us to build it in trade for "skin in the game" (that is, a percent ownership in the new business or product). So far, in my own graphic design business, I have yet to agree to build anyone's idea in trade for skin in the game. I also have yet to see any one of these ideas that were pitched to us actually get built (meaning that these same idea people were unsuccessful in getting anyone else to build for them). I'm not saying that you should never pull the trigger on building someone's idea in trade for equity; I suggest only that you consider a few things prior to accepting a "skin in the game" deal.

Got any documentation?
It is a bit humorous to me that most of the people pitching their "idea" to us don't have any documentation in place. There is no business plan, no request for proposal, no strategy document—nothing. This is a big red flag and means you are either getting in at the very ground level, or, more likely, the idea person has no real clue what they are doing, and you should expect to have to create the whole strategy and execution yourself.

In this case, you should hold out for a larger percentage of the company if you agree to build the product in trade for ownership. It is like someone saying, "I have an idea. We should build a rocket ship that flies to the moon, and I'll give you 10 percent if you build it." Sure, flying to the moon is a fun idea. But the idea alone is not worth 90 percent of the ownership since there is SO MUCH work involved in its execution. Be sure to make an accurate assessment of the workload and hold out for an appropriate percentage of ownership.

"Skin in the game" usually means "free"

The stars have to align for something like Facebook to take off the way it did. Do your due diligence. If you are convinced that this person's idea is going to take off and be HUGE, then go for it. But in most cases, there will likely be no return on your investment. In fact, I recommend that you plan on zero return. If the idea is so amazing and exciting that you still want to work on it even if you get nothing in return, then go for it. In certain circumstances, I think it is valid to consider building out someone's idea for potentially zero return.

Portfolio

If the project will be a shining star in your portfolio, it may be worth considering doing it for free. Certain portfolio projects can help you land new work or even break into new industries.

Charity

If the project is for a good cause, it may be worth considering. There is definitely intrinsic value in doing charitable work.

Relationship

If the relationships you build by doing the project have potential value, then it may be worth considering a partnership. Perhaps you feel strongly that these relationships will lead to new and exciting opportunities. In the end, you have to assume you will get no monetary return on your investment, and if you're OK with that, then go for it.

Define roles

If you decide to partner with someone to build an idea, be sure to clearly define the roles. In a good partnership, those roles will be easy to identify. You, as a graphic designer or programmer, will likely be handling the production aspects. This means that your partners should be overseeing the business and marketing elements. Be sure to clearly define and document these roles prior to engaging in the partnership. If there is too much overlap, then you are probably headed for some frustrating power struggles.

It will always be "their idea"

Most people pitching you an idea are looking for a way to get their idea built for free. They are not necessarily looking for a partner in

the truest sense of the word. They just don't have any money or aren't willing to spend their own cash on the idea. You must understand this prior to engaging in the partnership. After all is said and done, from their point of view, the idea will always be their idea and you are just a pawn in the game. If you are OK with this and still want to build the product, then go for it.

A better structure

Spending internal resources costs you money. Whether you are a freelancer, a small team, or a large agency, every hour spent by someone in your company costs you money. You should know what that cost is (divide your total annual overhead by the number of man-hours available, and that is your hourly burn rate). So, let's say your overhead cost is $50 per hour. And you have a two-way partnership with someone to build a product. If it is an equal split, then each partner should put in $25 for every hour spent. Track all the hours and settle up at the end of each month. If the idea person is interested only in you paying for all the development costs but they want to retain most of the ownership in the product, watch out...stormy waters could be ahead for you.

You get what you pay for

This old cliché holds true in most circumstances. If you engage in an unpaid project, it will probably become a pain for you when paying work piles up. In most cases, the unpaid project will take a backseat to the paying work, and your "partner" will grow frustrated with you as you lag in the development of "their rocket ship to the moon."

Your best chance of success is staying focused

In some years, we have managed to enjoy a 40- to 50-percent profit margin at our agency. Every time we are pitched an idea, we have to weigh it against the potential profits in our core business. Usually, a small ownership in an idea that takes us off focus of our core business doesn't make sense. Our agency is already making money. Instead of spending our time and energy going off in another direction to build someone's idea project, we are usually better off spending our time and energy figuring out ways to generate more work for our agency and enjoying a healthy profit margin. Your potential is likely the same.

109 THREE-MONTH "LIFETIME" GUARANTEE

I come from a family where I watched my father work for the same company for more than two decades. Naturally, I expected upon graduating from college that I would find a job and stay there for a while. I loved the idea of improving my skills over time and growing inside of a company.

I quickly learned that job security and a graphic designer's life don't exactly go hand in hand—this realized after I outgrew my first job in about five months and my second job in six months. My third job lasted about a year, and as I was leaving, the management team was busy running the company into the ground. The job after that lasted almost two years before the company became so financially upside down that I was given my computer in lieu of my last paycheck.

Finally I landed at Fox! I had a creative director title, a six-figure salary, and a window office, and I worked for a multibillion-dollar company. During my first week, I remember thinking, "Yay! Finally I landed somewhere stable. I am going to work here for the next ten years or more!" Little did I know that the Fox groups I worked for—Fox Family and Fox Kids—would be sold to Disney six months later, and I would spend the next year and a half watching the company be dismantled as it was absorbed into the Disney organization.

When I ventured off into the world of freelancing, I continued to learn that a designer's future is almost always a cloudy one. My first year started out strong, and then I hit a time in December when I had absolutely no work. I panicked for a few weeks and began polishing up my résumé just in time for things to start picking back up about a month later, followed by a few more years of successful freelancing.

Later, as my agency grew, I hoped that perhaps I could expect a little more stability. I had saved up hundreds of thousands of dollars and was in a better position to weather the storms of a graphic designer's

life. But then the recession hit in 2008 and I watched several hundred thousand of my net worth disappear in a few short months as I subsidized upside-down months and saw assets depreciate.

Thank you for indulging my trip down memory lane. If you've been working as a graphic designer for a few years, your story is likely filled with your own tales of loss and insecurity. What I have learned is that life as a graphic designer really has only about a three-month guarantee. This is because most design-related businesses have about three months' worth of guaranteed future. They know what projects they are working on. They have a pretty good idea of what corporate decisions are being made. Consequently, it is safe to assume that your job is safe for at least three months. Beyond that, who knows?

Economic volatility, fluctuations in client spending, mergers and acquisitions, and corporate restructuring can spell an end to your cushy design job. Enjoy the job while you have it.

While running my design business over the past several years, I have seen the three-month rule apply in a few different ways. When I first began hiring people, I worried about increasing my annual overhead with each salary. I lost sleep at night worrying about how I would be able to pay my new junior designer $30,000 over the course of the year. What I should have been thinking is that I needed to make sure I could afford to pay that employee $7,500 over the next three months (at the time, this was a fraction of the money I already had in the bank). I have since learned, through experience, that the second and third sets of three-month hurdles always seem to take care of themselves, or at least, there is no sense in worrying about them before the fact.

With the cash-flow fluctuations at our agency, we have also learned not to hire on a spike and fire on a dip. What I mean is that hiring a new employee during a busy month may mean letting them go when the following month isn't as busy. But if you ride out a batch of three busy months and the future looks bright, that is the time to consider adding some heads to the team. And if you are a freelancer or small-agency owner, brace yourself financially for up to three lulling months before you begin to decide whether it is time to let people go or throw in the towel (see the chapter "Next Worry Date," earlier in this section, for examples of planning for hard times).

All of this being said, I have employees who have worked for my agency for more than six years. There are certainly exceptions to every rule. My point is that by choosing to be a graphic designer, you'll likely have to learn to live with some occupational volatility. It seems to be part of the package.

BY CHOOSING TO BE
A GRAPHIC DESIGNER,
YOU'LL LIKELY HAVE TO
LEARN TO LIVE WITH SOME
OCCUPATIONAL VOLATILITY.
IT SEEMS TO BE PART
OF THE PACKAGE.

110 "BEING YOUR OWN BOSS," WHATEVER THAT MEANS

Whoever coined the phrase "be your own boss" probably never was one. As a freelancer or business owner, you certainly don't have to ask permission to take a lunch. But don't fool yourself into thinking that "you are your own boss." In fact, as an owner of a successful graphic design business, not only am I not really my own boss, I have about 30 bosses! Every active client we have determines my professional future. Each of these bosses has the right to demand things from me and my team. Sure, you can say "no" to your clients—you can say "no" to your employer, too. But if you say "no" to your clients or your employer too often, they will certainly go looking for someone else who will say "yes."

Additionally, as a freelancer or business owner you get the privilege of "job hunting" nearly every week, as opposed to every few years like a normally employed person. All potential projects require a résumé (we format them as a proposal for work), a salary requirement (we just refer to them as a cost estimate), and an interview (also known as a sales pitch).

If you are employed at a small graphic design business, you must understand that everyone (including the business owner) is on the same team: a team dedicated to satisfying the needs of all the "bosses" and landing as many "jobs" as possible. The only real difference is the roles people play in the company. The business owner is typically the one trafficking the money, but everyone in the company is at the mercy of the clients and the ebb and flow of work.

Don't get me wrong; the benefits of freelancing or owning a business can make it well worth it. Just prepare yourself for a lot of bosses and a lot of job hunting.

⒒ HOW TO BITE THE BULLET

I've been asked several times in my career, "I'm starting to feel like I want to quit my job and try freelancing full-time. How do you know when it is time to bite the bullet and do it?"

When I started my freelance career, I didn't have any other options. During 2002 when I bit the bullet, the economy was still struggling to pull out of the dot bomb and post-9/11 woes. Our group at Fox had been sold to Disney, and hundreds of people were laid off in the transition, including myself. Free-lancing was my only real choice, and fortunately I had a couple key relationships with individuals in decision-making positions who were feeding me enough work to get by.

Throughout the past several years, I have grown to see how fortunate I was to not "go the way of the dodo bird" like so many freelancers do as work dries up. Thankfully, I had a few things in place that helped me survive. Here is some advice to help you know if the time is right for you to bite the bullet. The right combination of these elements can ensure your survival as a freelancer and perhaps help you grow a successful agency of your own.

Money in the Bank: Nothing will help you sleep better than having money in the bank. When I started out I had managed to save about $60,000. At the time I felt like it was barely enough, but in hindsight I realize that it was plenty. I had no overhead other than paying for my family's living expenses.

Lack of cash kills most freelancers. You have to have money to be able to ride out delays in payment and the occasionally client who doesn't pay at all. One of our biggest entertainment industry clients pays their bills in 120 days. That's four months after we invoice them! We can invoice them net 30 and it makes no difference. They pay according to their accounting standards and we can't do anything about it. I suppose we could not do work for them. But this is definitely

the type of client you want to do work for: They supply us with high-profile and high-dollar projects. We have always made sure we have money in the bank to afford us the choice to endure their drawn-out accounting standards.

Three- to six-month's worth of money is usually a good minimum amount to have on hand. Figure out your business and personal monthly cost of living. Multiply that amount by three or six months, and start saving. On top of the three- to six-month's worth of cash in the bank, it is advised to have some open lines of credit in place for a rainy day. At the start you may just want to get a credit card or two. We opened a large business line of credit with our bank several years ago. Keep the balance at zero and view these credit lines as "emergency only" options. Thankfully, we've never had to dip into ours to keep our business afloat. If you ever get to where you are running your freelance business on credit, it might be time to consider finding a full-time job.

A Sugar Daddy: Having a contract, retainer, or long-term project with a client can be all the ammunition you need to feel secure venturing out on your own. An agency down the road from us has had a long-term contract with a large tech company in our area. This contract has employed over half their staff for several years, and provided them with the cash flow necessary to grow and expand their agency in other areas.

At my agency, our biggest annual client changed four times in our first eight-years, however in the early years of my freelance career I had an entertainment industry client who didn't have an internal production team. They outsourced all of their digital media needs to me and provided me with "sugar daddy" cash flow.

Contacts: You cannot know too many people. If you are thinking of freelancing full-time, take a close look at your pool of contacts. Leverage the law of averages. The more people you know, the more people will know you are freelancing, and the more people will give you work. Get involved in networking groups, and don't be bashful in letting people know you are looking for new projects.

Be social online. Connect with everyone you know on both business and personal social media sites. Provide status updates on these sites to help raise awareness of what you are doing.

A Marketing Plan: Figure out how you are going to market your services. Will you advertise in magazines? Online? Through direct mail? Relationship-marketing only? Your marketing plan will be unique to your specific expertise, service offering, and geographic location. Regardless of your situation, you will want to set some money aside to begin the arduous task of experimenting with different strategies until you find what works for you.

Fallback Options: I have a great relationship with every boss I've ever had. Unfortunately, for some of my ex-employees that is not the case. I've been shocked a few times as some of my employees have not just burned the bridge on their way out the door, but more accurately detonated a nuclear missile on the bridge. You never know when you are going to need past relationships. You may even need to put your tail between your legs and ask to get your job back if things don't pan out with your freelancing aspirations.

When you leave your current employer to start your freelance career, be sure to keep your relationship with them intact. Don't be afraid to have a candid discussion with them to let them know you feel it is time to try freelancing, and that if things don't work out you hope they would consider bringing you back on. If you are an asset to their organization, they will more than likely be grateful to have you back. We have had a few employees come back and work with us multiple times. This is not uncommon in today's business world.

Helping Hands: Nobody is truly a "solo" freelancer. In order to succeed, you need relationships with people who can be your helping hands. Begin now by building relationships with people who will help you succeed. If you are a designer, you'll likely need to know some programmers. If you are a programmer, you'll need some designers. Figure out where your shortcomings are and find people who fill in the gaps for you.

Partner Companies: Some of our most important relationships are with printers and web-hosting companies. We can design cool print projects, but if the printer does a bad job, then we look bad. The same goes with web hosting. The coolest site design in the world is a total flop if the server goes down. Be sure to have a few trusted partners in place to ensure your projects achieve their full measure of success.

Mentor: I wish that I had one when I started out—it surely would have helped me avoid many struggles and hard lessons along the way. If you can find someone who you respect, who has been successful in the career track you are venturing into, and who is willing to answer an occasional question from you, then you are one step ahead. Many successful people are happy to impart wisdom, but be sure to be respectful of their time. Success brings with it a multitude of responsibilities, and their time may be very limited. I have been asked to act as a mentor for a couple up-and-coming design agency owners who have one or two employees. Weekly calls and emails not only provide them with support, but they also help me to gain new insights on how to run my business by helping them work through their challenges.

Banker: Talk with a banker and make sure you have all of your financial accounts set up in the best possible manner. Be sure to separate your business accounts from your personal accounts, as this will save you the possibility of an accounting issue down the road. Your bank can also help you put in place payroll once you start having some employees of your own.

Accountant: I've changed accountants a few times during my career. Ask your trusted contacts for referrals and find a good accountant or you'll find yourself changing accountants, too. You'll need an accountant to advise you on quarterly tax payments, as well as to work with you to file your annual tax returns. A good accountant is a great resource to answer all your financial questions. They can also help advise you and set up the

legal structure of your business. (Sole Proprietorship? LLC? Corporation?). Spending a little money on a consultation at the start of your freelance career is an excellent investment; getting things started correctly from the beginning can help save you headaches later on.

Insurance Agent: It doesn't cost much to get a little insurance. I sometimes joke that I "collect insurance." Even a small business insurance policy is something that every freelancer or business owner would be wise to have in their start-up arsenal. If you start growing a company, your insurance agent can help with health insurance and other needs.

Financial Advisor: Once you start finding some success, you'll benefit from working with an experienced and knowledgeable financial advisor. These trusted relationships can help you make smart financial decisions and put your hard-earned money into the right investment vehicles. Many financial advisory firms also provide employee benefits services; as you grow, they can be a great resource to help you put in place retirement savings plans for you and your employees.

Industry Relationships: I love getting to know other people who are doing similar things to what I'm doing. I have had countless lunches with other agency owners and independent freelancers. I also have a group of business owners with whom I meet weekly. I consider it "alcoholics anonymous" for business owners. In these lunches and meetings we provide support for each other, share best practices, and advise one another on business challenges we are facing. Start by inviting people to lunch who wear shoes similar to yours. You'll quickly find that you face the same challenges as many other people.

You don't necessarily need all of these things to be in place in order to get started on your own, although as you progress you will likely find that all of them will become important. Take a look at this list and, if you feel you have enough in place to bolster your courage to take the next step, it might be time to take the plunge and start out on your own.

INDEX

business cards (*continued*)
 presenting designs for, 79–80
 putting portfolio samples on, 203
business degrees, 251, 253
business expenses, 339–344
business lunches, 361
business management, 41, 55–56
business organizations, 20
business partnerships, 310–312
business schools, 251
"Business Services" awards, 35–36
business tools, 295
busy months, 315

C

caffeine, 27
canned communication, 164–171
 accounting information message,
 166
 clickable website delivery message,
 170
 design kickoff message, 167
 green-light message, 166
 logo comp delivery message,
 168–169
 project completion message, 171
 proposal delivery message, 165
 revised comp delivery message,
 169–170
 website comps delivery message,
 167–168
capabilities presentation, 319–322
carbon copying, 162–163
career decisions, 251–253
Carnegie, Dale, 2–4
Carnegie Foundation for the
 Advancement of Teaching, 1
Carnegie Institute of Technology, 1
cash flow, 304, 331, 354

cash reserves, 342
Cc'ing, 162–163
chain reactions, 189–191
Chamber of Commerce, 20
change orders, 143–144, 206–207,
 222–224, 241–243, 335
charitable organizations, 278, 286–287,
 349
Chicago Bears, 37
Chicken McNuggets, 283
cleaning restrooms, 35, 36
clickable website delivery message, 170
client communications. *See also* email
 attention to word choice in,
 175–180, 242–243
 avoiding drama in, 17–18
 being clear/proactive in, 192–193
 canned, 164–171
 face-to-face vs. email/text, 172–173
 following up on, 138–139
 getting feedback on, 52
 importance of, 3–4
 for project updates, 181–182
 regarding missed deadlines,
 184–186, 192
 sample messages, 165–171
 team-style phrasing in, 178–180
 when starting new project, 189–191
client genealogy tree, 213–214
client gifts, 75, 76, 77, 232
client/graphic designer relationship,
 202–204, 213–214, 218, 237–238
clients
 as 800-pound gorilla, 211–212
 accepting feedback from, 66–68,
 206–207
 anticipating needs of, 240
 arguing with, 206
 being rejected by, 236–238

cost estimates, 140–141, 222, 267, 269, 281. *See also* budget; pricing structures

cost vs. contribution, 56

creative briefs, 136, 217

creative directors, 251–252, 253, 352

creative giveaways, 322

creative overview, 135

creativity, 71–72

credit cards, 358

credits, 291

critiques, 11, 43, 65, 105. *See also* feedback

cultural fit, 56

Cylon Raider mode, 26

D

deadlines
handling missed, 184–186, 208–209
handling unrealistic, 23, 146–147
setting clear, 145
strategies for dealing with, 26–28, 70, 81–82, 93–94
time-zone considerations, 198–200

dedicated resources, 141, 261–262

delegating, 122–123, 347

deliverables, 135

delivery emails, 164, 165, 167–170

design agency. *See also* graphic designers
building up forgiveness points for, 208–210
calculating burn rate for, 265–266
clients (*See* clients)
ensuring survival of, 357–361
establishing best practices for, 256
expenses, 339–344
growing client list for, 213–214

hiring employees for, 122, 244–245, 353
importance of teamwork in, 55
landing job with, 244–245
legal issues, 294–295
long hours for owner of, 326–327
Next Worry Date Formula for, 334
as organism that wants to die, 306–308
partnering with another, 310–312
personality styles, 211–212
pricing structures for, 257–262, 267–275
providing daily CPR for, 306–308
as service-based business, 216, 228, 240

design changes, 143–144. *See also* change orders

design competitions, 292

design comps
delivery messages for, 167–168, 169–170
handling client rejection of, 142–143
internal review/critique of, 105
mistaken assumptions about, 89–90
presenting in face-to-face meeting, 78
providing more than expected, 76
requesting feedback on, 220–221
sending via the Internet, 79

design critiques, 11, 43, 65

designers. *See* graphic designers

design industry
Code of Fair Practice, 289–293
deadline-driven nature of, 94, 199. *See also* deadlines
earning/losing forgiveness points in, 208–210

ABOUT THE AUTHOR

Throughout his career, Michael Janda has worked for graphic design firms, direct marketing agencies, and in-house art departments as a designer, art director, creative director, and full-time freelancer.

He is the founder and owner of the acclaimed design agency, Riser. Since its inception in 2002, Riser has provided design and programming services to its A-list clients including Disney, Google, NBC, ABC, Warner Bros., Sony, National Geographic, Fox, TV Guide, and many others.

Michael enjoys time with his wife, Jodi, and their three sons, Max, Mason, and Miles.

For more information, please visit: www.michaeljanda.com.